THE BEST THING ABOUT MY ASS IS THAT IT'S BEHIND ME

THE BEST THING ABOUT MY ASS IS THAT IT'S BEHIND ME

Lisa Ann Walter

 HarperOne
An Imprint of HarperCollinsPublishers

HarperOne

HarperCollins website: http://www.harpercollins.com

HarperCollins®, 📖®, and HarperOne™
are trademarks of HarperCollins Publishers

Designed by Terry McGrath

Elaine Hendrix: Photo by Glenn Campbell
Karina Smirnoff: Photo by ToddOren.com
Rosi Blasi: Photo by TJ Scott
Lea Thompson: Photo by JohnGanun.com

FIRST EDITION

Library of Congress Cataloging-in-Publication Data is available upon request.

ISBN 978-0-06-202574-6

11 12 13 14 15 RRD(H) 10 9 8 7 6 5 4 3 2 1

To my angels . . .

*My music and voice from God, my buddy who's
made me laugh, for real, since he was four—Jordan.*

*My heart and sweetness, my listener and unselfish
soul, my non-pushy genius . . . my girl—Delia.*

*My left-brained, singing, dancing, deep-thinking
yet silly, mischievous, tickle-monkey—Simon.*

*My builder and inventor, my soft soul covered
in toughness twin, cuddle-junkie—Spencer.*

*You are the reason I am who I want to be.
I am so lucky that I got the best gig in the world—
being your mom.*

CONTENTS

THE BEST
THING ABOUT
MY ASS IS
THAT IT'S
BEHIND ME

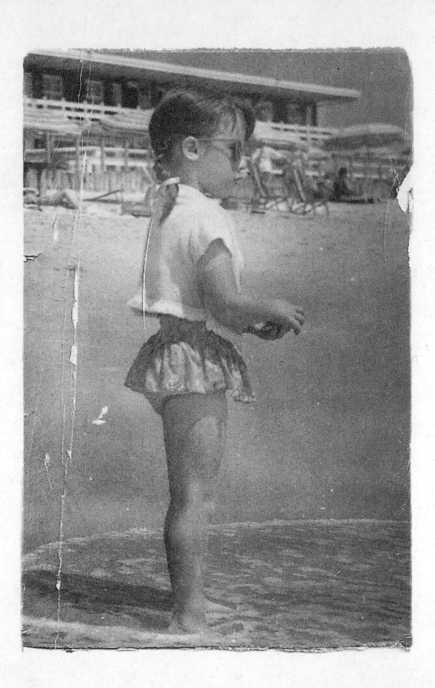

INTRODUCTION

As an American woman, it's my birthright to obsess over every tiny thing that I think is wrong with me—a conclusion supported by loads of TV commercials. In my case, this obsession has generally been pointed directly at my backside. There is a world of evidence that tells us that this is an epic, stupid waste of time and energy.

My ass is still behind me—like my exes and a bunch of other issues—but now I think it's hot.

You have your thing, too—it may not be your ass, but whatever it is, it should be behind you! I'm giving all of us permission to STFU about the stupid stuff. 'Cause, honey . . . I've tried it all. All the stuff "they" tell you will make you feel better about your ass . . . or hair . . . or skin . . . or whatever your version of "your ass" is . . . and the plain dumb fact is . . . our actual selves are JUST FINE.

And who says you have to work that hard to look at yourself from the back? Ignore it.

Honestly, count up the time, money, effort, and commitment American women spend on someone else's idea of the "perfect way" to live, someone else's idea of a "perfect life" in someone else's idea of a "perfect body." Now imagine if we harnessed all that power and turned it toward something else. What could we accomplish? Create world peace! Find alternative energy sources! Cure cancer! (Or at least cellulite?) Here's a thought—maybe we could learn to be happy with the best version of ourselves.

This book is about forgetting that picture you've got in your head of how you're supposed to look and be—the you that's fifteen pounds lighter,[1] presiding over a *Martha Stewart Living* holiday table discussing island getaway options with Raymundo, your Argentine polo-playing lover—forget that you! She belongs in a guilty-pleasure, chick-lit novel that allows you to project yourself out of the tiny, algae-coated pool at your garden apartment complex and onto a yacht on the Riviera. This book is about just enjoying the body you have and the life you're in now. Algae and all.

It's about just being the BEST VERSION OF YOU. Not perfect— but pretty darn good.

Plus, I've added lots of stories from my own life—not just to impress you with all the famous people I've worked with (OK, that's part of it), but mostly so you can benefit from mistakes I've made. Lots of 'em. We all have. So let's just admit that we know how we're f'ing up, laugh about it, and move on.

This is not a "self-improvement" book.

This is "self-maintenance." When your goal is "JUST GOOD ENOUGH."

1. You know, your "mirror body" you. The one you use when you're trying on New Year's Eve dresses and sucking all that Christmas-Cookie Fat in so hard that you faint in the middle of the communal Loehmann's dressing room.

THE SELF-LOATHING BEGINS

"No matter what I look like,
I'll always be ...
the chubby girl."

Chapter 1

SELF-LOATHING IS FOR LOSERS!!

I am a self-loathing expert. If there were a self-loathing Olympics—I'd be on a Wheaties box with a bunch of gold medals hanging around my neck. There's not one part of me that I haven't tried to enhance, reduce, enlarge, shave off, shave down, suck in, suck out, lift, separate, straighten, curl, pluck, bleach, tan, tone down, fluff up, de-wrinkle, or just plain change. And guess what?! Yup. Still find things to self-snark about.

Except for my calves. They're fine. They're the perfect size for my legs and have a "diamond" shape to them. I didn't even know that that was a "thing" or that I should want it. Until Adam Sandler pointed it out at a comedy event in 1990.[1] Who knew Happy Gilmore was a calf freak. Or that he was gonna become such a big star? Had I known, I would have been happy to let him pet them. Of course this was 1990 and I was fifteen, so it would've been unseemly.[2]

1. Clang! D'ja hear that? That was the first shameless celeb reference. And there'll be more. You might wanna wear a hard hat, 'cause names will be dropped.

2. Just go with it. One of the things I hate about myself is my age. Or, more accurately—I hate that my job description involves me having to lie about my age. My kids have been told: "Mommy is twenty-nine. She was twenty-nine when you were born, she'll be twenty-nine when you graduate college." We don't celebrate my birthday anymore. It is now referred to as "Second Mother's Day."

Now, I'm looking at the book jacket right now and, seriously. WTF!? Why do I hate myself? I look pretty darn good. Of course there was a boatload of professional stylists running around plus Rockin' Raul, my insanely talented and entertaining Hair/Makeup Diva . . . and probably some photoshopping going on. OK, definitely some photoshopping. Plus, I wore stockings to cover the lumpy bits and cellulite. Of course I did—I'm on a book cover for God's sake. In full view of everyone at the airport. (Or checkout counter. Or Slurpee machine. I don't know where all they're gonna sell this.)

But overall? . . . not bad! In fact in most parts of the country I'm a babe. Not L.A., mind you. In L.A. I'm sort of a troll. Seriously. In New York, D.C., Atlanta . . . sure—I can still stop traffic if the outfit is right and I'm wearing sunglasses (you know, to hide my alleged age). Hollywood . . . not so much. There's no hard hats miming grabbing my ass when I walk by a construction site out here. Nuh-uh.

+ *In L.A. every other girl that walks down the street's a six-foot-tall blonde who weighs three pounds and two of 'em are tits. Because:*

+ *In L.A. everyone is perfect. If not when they arrive, well then immediately afterwards. I mean like five minutes after the ex–prom queen–slash–wannabe reality star lands at LAX, she jumps in a rental car and goes to a one-hour drive-thru breast-implant store. Jiffy Boob.*

+ *In L.A. you can't find a nice, normal, regular guy. A guy who will love you. And cherish you. And play Spank the Catholic Schoolgirl with you. The trouble is that guys in L.A. are spoiled. L.A. is like a theme park for men. It's "Puss Island." There's always some forty-year-old guy sporting some twenty-year-old girl with three-year-old boobs and lips that still have the tag hanging off of 'em.*

✦ *In L.A. grandmas wear size 2s and have bone-thin yoga
arms. Which is just weird. I'm East Coast Italian. Grandmas
aren't supposed to have bone-thin yoga arms. Grandmas are
supposed to have big fat mamma-jamma arms. That you could
swing from if you wanted to play . . . or take a little nappy
on if you get tired. Or if she's driving you around and she
stops short—she can clothesline you and the swinging arm-fat
works as an airbag. That's how big grandma arms should be.*

So why do I hate me? I mean it's not like I popped outta the womb
this way. But I am a woman in America, so I have to hate myself.
We all do! "But why, Lisa Ann? Why do we have to hate ourselves?"
I hear from the smart, charming, and perfectly attractive—but ter-
ribly confused—women who live in my head.[3] Why? Why the shame
spiral? Why are we all so darn hard on ourselves?

Because if we weren't—our entire economy would collapse! I
mean—even more! You think the Wall Street Meltdown was bad?
Or the Real Estate Death Spiral? The Banker Bailout? Those
are NOTHING compared to the fallout we'll face if the "Beauty
Boycott" ever happens. Think about it—if we start accepting
ourselves, we're looking at a Redken Recession! A Clinique Col-
lapse! The Big Maybelline Crash of 2011! What'll happen to poor
little Sally Hansen?!! And what about all of those unemployed
manicurists wandering the streets with nothing to do? What will
become of them? Not to mention the devastating domino effect.
The bottom would completely drop out of the plastic-Buddha
market! It would spell financial disaster for the entire planet!

3. OK, there go my imaginary backup singers who respond to every statement with
annoying questions. Like the Ike-ettes or the Supremes. Shut up, Supremes, I'm
making broad sweeping generalizations. Wish you guys could see the dance moves,
though—they're fabulous! And the wigs are fierce.

So, if it's on you, they've found a way to make you think it probably sucks. "They," by the way, is the entire Beauty Industrial Complex: Fashion. Fitness. Diet Books. Tabloid and Women's Magazines. Plastic Surgery. Hair Extensions/Color/Maintenance. For the purposes of this book (and feel free to use it in your everyday life from now on) "they" will henceforth be referred to as "The Screaming Meanies" or, even better, "The S/M" . . . you know, to save time. The connection to pain and humiliation is purely incidental.

The self-"improvement" of the American woman is a multi-trillion-dollar industry. "They"—or, sorry . . . "the S/M"—spend vast amounts of money convincing "us" that whatever we are—it's not quite good enough. "The S/M" employ countless numbers of people whose livelihood depends on whether or not you pop for eyelash extensions.

Your mother's in on it too, by the way. You just can't possibly do everything well enough to please your mother. You'll get close, but then she'll decide that no matter what your many accomplishments are, you'd be a better person with a perm.

Even though no one's been able to actually get a perm since 1987.

Now, don't misunderstand me. It's not because your mom hates you—not at all. Your mother harangues you (you heard me! "Harangues"—I got it from my mother!) because she LOVES you. "But, Lisa Ann. That doesn't make sense! Why would haranguing us into a bad perm be a loving thing to do?"[4]

I know, I know. It's a paradox. But, really it's *because* Mom loves you that she cannot let you be happy with yourself. If you're OK just being you, it would mean everything that she was raised to believe

4. There go the backup singers again. I'm going to rename them the "Lis-ettes."

by *her* perm-sporting, Playtex-begirdled mother was just plain wrong! And what would that lead to? An alternate universe where up is down and down is up and cats are dogs—and your mother is wrong?! That must not be! Your mother can't be wrong! Then what? You'll start putting your wet finger into sockets! Touching your "area" willy-nilly! Eating snacks throughout the day, ruining your appetite . . . heeyyyy . . . turns out that one actually is good for you.

But, to be fair, she was right about the part where the world is easier for very pretty people.[5] Moms have seen it in action, and they know that being good-looking is a whole lot easier than not. All moms want the best life for their kids. Doors open easier for the people that "the S/M" have picked as perfect. Moms think we started out perfect—it's the world wants us all to be somebody else. Preferably Angelina Jolie. Don't believe me? If you or I ran around behaving like Angelina Jolie with our current faces, it would get a whole different reaction.

Nothing is off-limits. You can never fix everything enough. The minute you get your head above water about one thing, they let you know that twelve other things about you suck. It's like playing Self-Esteem Whack-A-Mole. *"You're eyelashes aren't thick enough! You need Latisse!"* OK, I'll use Latisse. *"BANG! Now what you need is Fake Bake."* OK, I'll do a couple of Orbitz sessions . . . *"BANG! Good for you, but your pores are HUGE!"* But I just got done with the spray-tanning. I look like an Oompa Loompa . . . *"BANG! Are you spiritually and physically jacked up? You need yoga!"* OK, I'll take yoga. *"BANG!"* No? Pole-dancing? *"BANG! PILATES!"* But I just signed up for pole-dancing! *"BANG! You need BRAZILIAN . . . well, pretty much all things Brazilian. Wax. Blowout. Butt-cheek lift. BANG!"*

5. OK, OK, Mom. You're right about other things, too. (My mother also lives in my head. Yours, too. Well, not MY mother. Or maybe she does. She's awfully loud.)

I give up. Somebody just let me know when "the S/M" invent the final thing, tell me how much it's gonna cost, and I'll write the check.

Bump-its and Botox and Bronzing—Oh My!

How many more things are they going to come up with that we can laser, by the way? Or lasers to do it with?

Fraxel. Elos. Erbium. NLite. Vbeam. CML: All designed to . . . um . . . melt your face off.

Zerona: Skin-tightening/cellulite-reducing/wallet-lightening.

Diode. Alexandrite. YAG. Ruby. EpiLight: Hair removal.

TRIA: In-home hair-removal system. In-home laser. Really? Can also be used to entertain the cat. 'Til all his hair falls out.

Didn't lasers start out being used for space-aged stuff?[6] Then quickly adopted by Dr. No to torture James Bond? Advancing to entertain stoners to the strains of Pink Floyd in planetariums the world over? Now you're aiming it at my "bikini area"? Put on Dark Side of the Moon at least.

Speaking of moon . . .

My Personal Big Issue? My Personal Big Ass

So I grew up hating my ass. For years I'd tell anybody who'd listen—my girlfriends, therapists, bank tellers, strangers on a bus

6. Sorry to get all technical on you. Dad was a physicist for NASA, so I'm up on the lingo.

. . . whoever—that I hate my ass. The only good thing about my ass is that it's behind me and I don't have to look at it all the time. And I'm not the only one who thinks like this. All women hate their ass.

Well, hang on. Let me rephrase. Not *all* women. White women hate their ass. Black women hate their hair.

The End.[7]

Girlfriends will argue with you, like all good gf's should: "Are you kidding? I *wish* I had your ass! I *wish* I looked like you in jeans." Usually they mean it, too.[8] "You're stunning. That guy at the bar was just talking to me to get to you!" You know how we do. But don't be fooled, they snark on themselves, too.

"We get it, we get it," the backup singers harmonize—"We all hate on ourselves! But why should we read this book if you hate yourself as much as we do? Why not get our money back and get our eyebrows threaded at the mall instead?" Well, that's a good question, Lis-ettes. Take five while I give you my answer:

The Olden Days

Remember back in the day? When there were four TV stations and twelve McDonald's? When we traded sex for promotions or marriage (the way God intended). Back before Internet porn—when you

7. Uh-uh—before you start arguing, ask Tyra. Tyra with the big, beautiful booty and a nasty hair-extension habit. She's created a hair monster. They should call her "Weave-en-stein."

8. Sometimes they're just lying to get you to pick one thing from the mountain of wardrobe piled on your bed so ya'll can get to the party before the spinach dip goes. But usually they mean it.

had to buy nudie mags to look at a bunch of nekkid wimmen—we didn't have to hate on ourselves so much.

Men were grateful that you let them cop a feel and liked that there was actually something to feel—because extra fat meant extra BOOBS! Now, with the media telling us that a scientifically engineered figure is the beauty standard—a body type not-found-in-nature. Unless you count the grotto in the backyard of the Playboy Mansion as "nature." It's a sinewy, boy-hipped, rail-thin, hairless body—but with giant Tupperware tatas. (Or, as I like to call them, BFTs—as in: Big. Fake. Tits. You may quote me.) "Normal women" have found lots of reasons to self-loathe!

We wanna look like Pam Anderson!! We wanna look like Carmen Electra!! We wanna look like Brooklyn Decker! But most of us still look like . . . well, us.[9]

How did we get such unrealistic expectations about how we should reasonably expect to look? Or be? Or how the world sees us?

Let me theorize for a minute about where we jumped the track. 'Cause it hasn't been that long since moms wore flowered housecoats and baked delicious comforting things and had slightly doughy body parts that you could cuddle up on. Skeletal figures and skin-tight minis were only for "Glamour Girls." Or, as Grandma Pompa would say, "Putanas." When I was growing up, there was a clear definition between Matriarch and Hooker.

My point is, it's a little easier to rock at being just one thing at a time, but we load up the expectations—like a Costco cart—trying

9. In my case it's because I like to actually prepare and eat actual food. I'm not into space-age bars or food-type products. Or tofu. I don't trust any food that only tastes like what it's sitting next to at the time. I don't want to eat the chameleon of the vegan world.

to be all things to all people. And then, of course, feel like we're less than awesome at most of it!

So it's not just the looks thing . . . Oh no! We, as modern women, are now free to fail miserably across the board! We fail as mothers, daughters, wives, sisters, bosses, employees, firefighters, police officers, even presidential candidates!

Lookit, this whole "You can do it all" thing was a big fat failure. Do it all, by the way, included—although certainly wasn't limited to—

+ *Raising a Happy Family*

+ *Finding a Cure for Cancer*

+ *Sporting Six-Pack Abs and Buns of Steel*

It became clear that those of us who grew up believing we were supposed to "do it all" were going to wind up incredibly disappointed. We tried. Didn't work. So let's just have a couple of laughs about it and gleefully admit our failure.

Believe me, we gave it our best shot. From the 1970s on. Remember the Enjoli perfume commercial? No? Google it![10] It's a sexy, Farrah-haired siren dancing around letting you know all about the multitasking work-bitch she's capable of being 'cause she's a CHICK! A POWER-CHICK! First she's in a business suit; then she's brandishing cookware; then she's in an evening gown—all the while singing, "I can bring home the bacon, fry it up in the pan . . . and never, never, never let you forget you're a man. . . ."

". . . 'Cause I'm an asshole!"

10. While you're at it, google the "Charlie" commercial and check out that Shelley Hack. Boy, that diet the models used back then was effective, huh? White wine and cocaine—two hundred dollars a day to a much slimmer you!

Hey, there's my backup singers! Showing up when I need them for a change! And, OK, I admit I changed up that last word. It's supposed to be *woman,* but c'mon! We were assholes! Thanks Charles of the Ritz! That ad campaign created whole generations of women who tried to be mogul, hausfrau, and hooker all at the same time. BIG FAT FAIL! Plus, we smelled like Enjoli. Bad all around.

Men think we're bitches 'cause of our hormones and stuff. Nope. We're angst-ridden bitches *all the time* because for the past thirty years, twenty-four hours a day, seven days a week—we've been trying to do everything. King Cheez-Its on a cracker, we just need to sit down! Take a Xanax. Relax for five minutes!

I'm telling ya, if it weren't for the multiple orgasms, this whole "woman" thing would be a gyp.

Easy-Bake Ovens and Barbies

How Easy-Bake Ovens and Barbie started the eternal/internal war between the longing for pudding cake and a fourteen-inch waist. And more fun stories about how we teach little girls that they suck.

On my eighth birthday I got my first Barbie. She was sultry and grown-up. This Barbie went to cocktail parties and smoked. The one that—if she'd had parts—would have owned a little Barbie diaphragm.[11] Her plastic breasts stuck out like gunboats, and her tiny waste and itty-bitty bottom didn't strike me as being a physically impossible combination for real live human girls. I just loved the way she looked in her little Barbie clothes. I adored her. I just assumed that when I grew up . . . I'd look like her.

11. Later, Barbie got all "wholesome" and shit. But in the beginning she was two anatomically incorrect steps away from being a tranny hooker.

Then, that Christmas, after much manipulation involving emotional blackmail—"I just know Santa will get me the one thing I asked him for . . . unless . . . Santa doesn't really exist, Mommy"— I got my first Easy-Bake Oven. NOTHING could compare to the gooey goodness of devil's food cake not entirely cooked by a forty-watt bulb. Oh. My. God.

Let's just call this here and now: Easy-Bake gave me the cooking bug. I became not just a lifelong sugar fiend but a lifelong foodie at the exact moment I pulled that tiny tin of pseudo-chocolate goo out of that plastic toy . . . that fountain of goodness. The well from which all delight springs. I had the power TO CREATE MY OWN TREATS!!!! BWAAAA-HAHAHAHAHAAAAA! (*laughs maniacally, rubbing cookie-dough-covered hands together in glee*).

That was it—I was a budding epicurean. Forever more I would be a gourmet. A gourmand. A gastronome. A Culinary Whiz-Kid. I started off by baking—from scratch—a lemon meringue pie for my grandpa because that was his favorite. A ten-year-old working a double boiler and trying to make egg whites "stand in firm peaks" using cream of tartar. I'm talking the real deal.

By thirteen I'd taken over the cooking for all the holidays and family dinners. Mom was busy and, after she and my dad divorced, not that interested in being overwhelmed by big-meal planning. So I did it! Happily! I chopped and stirred and got recipes for Italian stuff from my mom's side and French cuisine (and the proper wine to go with) from my dad's Alsatian side. I'd found something that I was really good at. And it was good news for everyone else, too. Except my ever-growing behind.

But at eight I was just a kid with a fantastic new toy. I happily alternated between dressing and undressing my Barbie dolls and

cooking crap in my Easy-Bake. I was at too young and tender an age to realize that I was internalizing two opposing ideas—waspish waist and pudding cake. These are mutually exclusive. They cannot coexist naturally . . . much like the size of Barbie's bust and the rest of her body. Real-life physics would have her toppling out of her Dream House Kitchen and into her Dream House Cardboard Pool. Of course, now, the advent of breast implants has made it possible for the girl with 2 percent body fat to have the Big Barbie tits—but they're pretty much plastic, too.

However, breast implants weren't prevalent when I was pretending my Barbie was a stripper/highly paid escort. (OK, so I wasn't *that* tender.) I also used to have my one G.I. Joe drive over to the Dream House in his Jeep and roughly date-rape Barbie. She said no. A lot. 'Cause I'm Catholic and that's what hot, good girls are supposed to do. We hadn't gotten the message yet that *no* means no. *No* meant, "That's what I say right up until penetration to prevent you from thinking I'm easy." That way G.I. Joe got to feel like the big-man conqueror and Barbie got to retain her thinly plastic-coated dignity. In case Joe didn't call from the base the next day. Or got sent away on a mission, never to return.[12]

By the way, I've got nothing against breast implants. They're great technology for cancer survivors, pole dancers, and the awkwardly lopsided. What I do object to is the impossible body image they help create. Big boobs should go with a big round butt—again, it is otherwise a phenomenon not found in nature. It's a matched set. Think Jessica Rabbit. Or Simpson.[13]

12. Parts of him found three years later in the doghouse in the backyard. What an ignominious end. From decorated war hero/love stud to abused chew toy.

13. But not for too long, or your mind goes numb.

THROWING THE GENE POOL DICE: IT CAME UP ITALIAN PEAR-SHAPED PEASANT— I CRAPPED OUT!

Only a very small percentage of girls get the Golden Ticket of tall, Swedish-y, big-boobed splendor that opens doors and wallets all over the world. What I got was Italian.[1] Where food is love and love is food. And the food is so damned good!

Look, if I'm English, it's easy to pass up the Shepherd's Pie and the Bangers and Mash. Holy crap, that stuff doesn't even SOUND like good food. It barely sounds like food. It sounds more like extras on the Bunny Ranch's Fetish Menu. There are only so many variations on meat and potatoes. Meat on the bottom, potatoes on top; potatoes on the bottom, meat on top; meat on one side of the plate, potatoes on the other. All right already, we GET it.

But, Italian food . . . oh my god, it's a symphony of flavors. Just the ingredients sound like opera. Risotto. Pomodoro. Broccoli rabe. Mozzarella. I mean you wouldn't want to eat "squid"—but calamari? Hell yeah! Tagliatelle, cappelletti, tortellini, orecchiette, farfalle, rotelle . . . mmm. Sounds like an aria sung by Pavarotti—and those are just names of noodles.

1. And not Sophia Loren Italian. More like Danny DeVito Italian.

These are a people who like to eat. I mean we are the descendents of ancient Romans, the fine folks who invented bulimia for God's sake. They thought it was a good idea to stuff themselves to the point of power-puking.

Italians don't miss an opportunity to connect food with:

+ *Family*

+ *Celebration*

+ *God*

There's a giant pastry called "Easter pie" that consists of hard-boiled eggs, salami, wheat grain—all baked in a pie crust formed to look like a crucifix. Or an Easter basket with real colored Easter eggs coming out the top. That's right, real Easter eggs in a pie full of cold cuts. You heard me.

Christmas Eve features a dinner where you have to cook seven different fishes. And that's before all the other stuff. Most real Italian meals have at least five courses: soup, antipasto, pasta (hence the "anti" pasta. It comes "before" the pasta. It's got nothing against pasta. They're not in a *West Side Story* gang war or anything. It's not a Ristorante Smack-Down. Although I would pay to see that. "In this corner . . . wearing neon yellow . . . and featuring a wallop that hits you twice! It's *Ultimate Food Fight's* reigning champion . . . Hot Pepperoncini"!), meat, then salad and dessert.

This can take upwards of three hours. During none of which the women sit down. They scurry around exchanging serving dishes like hyperactive ants[2] 'til the men and kids literally fat themselves out of their pants. Then the men and kids stay at the table and

2. If ants had big bat-wing flappy arms.

visit—picking at bowls of fruit and picking nuts out of their shells—while the women wash everything. Then the women sit down and eat a cold plate of food in the five minutes before these strunzes[3] decide they're hungry again and it starts all over. I've spent entire holidays where no one's left the table for seven to twelve hours.

The first time I cooked for my Jewish then-husband and his folks, I planned the meal for a week, spent two days preparing the sauce with three meats plus braciola, and deep-fried my own cannoli shells using the end of a broomstick in a big pot of boiling oil, getting third-degree burns.[4] They ate the whole meal in twenty minutes and his mom jumped up to start cleaning. I thought they hated the food. Turns out, this is how most people have family dinner. I had no idea.

"No thanks, I'm full." Four words you never heard uttered in my family. Ever.

Full was when you had to open your pants at the Thanksgiving table and lie down next to it. "Wopping out," I call it.[5] You cannot fight this "Need to Feed." I have it. My mother had it. My nana, my mother's nana, Grandma Pompa . . . she was the worst.

Grandma Pompa, who lived in the same two-bedroom walk-up on Thompson Street in Little Italy from 1914 through the birth of her twelve children—right there on the dining-room table—up 'til she died at the age of ninety-three. The apartment is still in one of my

3. Urban Dictionary definition: Italian slang for "shithead" or "dummy." In case you plan on watching a marathon of *The Sopranos* or *Real Housewives of New Jersey*.

4. By the way—wouldn't have mattered if I'd served brisket and rugelach while belting a rousing rendition of "If I Were a Rich Man." I was still gonna be "The Shiksa."

5. As an Italian, I'm allowed to say "wop," so all you politically correctors out there, just chill, OK?

cousins' name. I think with New York rent control it might be up to 134 bucks a month.

Grandma Pompa, who came to the States from Italy when she was a teen, but the only English she ever learned was a heavily accented rendition of "I scream, you scream, we all scream for ice cream." Sung while my Uncle Tony slid me a fin, folded up like I was a waiter at the *Goodfellas* nightclub, with the muttered warning "Don't tell your sister."

When I finally lost forty pounds at age thirteen and looked "normal" I went to my Grandma Pompa's and was full after the first course of Escarole Soup and Artichoke. I just couldn't face the ziti course, much less the leg of lamb. She started crying in Sicilian that I was dying of "the consumption," and they force-fed me like veal to calm her down.

Italian mothers are like food pushers. They get you hooked on the entryway dishes . . . spaghetti with butter and Parmesan. . . . Then it's on to the hard stuff: baked mostaccioli and rigatoni, chicken Parmesan, Marsala, and piccata . . . Giant platters of hard salami, sopresatta, capicolla (or, in the Brooklyn vernacular, "gab-a-gool"), veal scaloppini and osso buco . . . the first cannoli is always free.

Now you're hooked. You gotta come back for the cheesecake. Now you belong to her. You've got a ricotta monkey on your back and you're jonesing for the cannelloni that only she can make. She told you that the first time she cooked it for you. . . . "No one makes sauce like Mama." And she's right. Your whole life you'll be chasing that first lasagna high.

WEIGHT WATCHERS— THE FAIRY TALE BEGINS!

OR, How I Lost 40 Pounds and Found an Hourglass Figure, Boys, and a Lifetime of Body Self-Loathing Through Chasing the Elusive 110-Pound Unicorn

When I was growing up there was "THE Fat Kid." The one who got generally chased and beaten at recess. Picked last for kickball. Given everyone's lunch leftovers with an insult about being a human garbage disposal. Oh, and no one got written up, sent to the office, or chastised for those remarks. I believe they were encouraged. I think the authorities of the day thought of it as a sort of nasty-comment boot camp. Remind a kid he's fat often enough, maybe he'll get tired of the bullying eventually. It will occur to him, "Heeyyy . . . wait a minute . . . I think I might be fat. That's why people keep saying it. Hmm. I better not be fat anymore. Then they won't say mean things that make me go home crying to my mom. Where she will then reiterate that I am, indeed, fat. And that it's silly to keep trying to beat up the kids who are giving me a beating—especially when I can't catch them."

You remember that kid who wore a T-shirt in the pool like it was some sort of camouflage. Oh, and a face covered in zinc oxide. Well . . . that was me. I was lucky enough to have the one mother who foresaw the death of the ozone layer and its effect on light-eyed

semi-blond white-as-shit kids. There's nothing like a thick layer of white Nos-kote and an extra-large *Josie and the Pussycats* T to make a fat kid feel accepted and cool! By the way, a T-shirt really doesn't hide much. Especially when it's wet. Why do you think the contests are so popular at Spring Break?!

And it's bad enough being the Fat Kid when you're a boy. But, being the "chubby girl"? Hell on earth.

And, because there weren't as many fat kids when I was growing up, they didn't make any clothes for fat kids. Shopping for the "husky" clothes at Sears—which consisted of exactly one choice of Wrangler jeans, two ugly dresses, a "skort" set, and corduroys—it blew. In fact, "husky" just fucking sucks entirely. Don't call a chubby little girl "husky." Ever. Agreed? And, while we're at it, corduroy thighs chafing together could start a small campfire. We don't need to be roasting marshmallows over our flaming thighs.

I didn't start out as "the Fat Kid," mind you. Until I was eight or nine and all the drama started, I was a cute, regular-sized, fairly active kid. The way we all were—before going outside to play became a punishment like it is now. We turned the picnic table over in the backyard and it was our "let's pretend" black-box theater. It was the Starship Enterprise, the Wild West Covered Wagon, a Dream House complete with Nana's old gowns for dress-up.

We played kick ball and Wiffle ball and had contests to see who could swing all the way around the swing set—like a complete 360. Very *Jackass* before our time. We built clubhouses out of old refrigerator crates, and tree houses, and then tore them down when they became rat-infested. We biked to the shopping plaza several miles away and bought Nik-L-Nips and Charleston Chews and had A&Ws at the Hot Shoppe. And biked back home in the dark. We played TV tag and smear the queer[1] until it was dark and in the summertime stayed out even later to catch fireflies and then kill them and wear them—while still lit—on our ring fingers for jewelry. We sledded and snowmanned and rolled down hills.

We did it as four girls together—my year older sister, Laura, and our two best friends, Elinor and Dee, who lived next door and were almost our exact same age. We did it almost entirely without fear—or supervision, for that matter.

By the time I was nine, all of us were growing up without fathers in the new fad of divorce that was sweeping the nation. Overnight, it seemed, guys got mustaches, sports cars, turtlenecks, and new wives, and a generation of unprotected little girls/future bitter women was born.

My mom had several huge traumas happen pretty much all at once. We'd just gotten back from living in Europe where my father was working for two years, and in that time her mother had gotten very sick with leukemia. She died that year, quite young. My mother was devastated. Six months later, my dad left.

1. A game that involved one person holding a ball (or rolled-up jacket—didn't matter). It was really just an excuse for a bunch of kids piling on another kid holding something and rolling him/her down a hill. To us, it had nothing to do with sexuality. We didn't even know what the word meant. For years I thought *queer* meant "person holding the ball." I guess I wasn't entirely off base.

He picked a fight with her every day for two weeks leading up to his announcing that he was leaving. My sister and I heard all of the fights; in fact we'd be awake listening—because it was so odd. My mom didn't really fight my dad—he was in charge. She would certainly complain a lot . . . but not fight. So these two weeks of fighting so loud that it woke us up were weird, and we were afraid.

On the last night that Dad lived at home, we heard Mom scream something about killing herself and heard a scuffle. We made it down the hall and to the kitchen in time to see her holding a butcher knife high above herself, ready to plunge it into her heart. Then my dad knocked her down and the knife out of her hand. To say terrifying is an understatement. He left that night to an apartment that he'd apparently already rented.

The next day he picked my sister and me up at our elementary school and took us to McDonald's and bought us fries. And he cried. Both were singular events in our lives. Picked up, middle of the day . . . by Dad . . . and he cried. The French fries were clearly a bonus. We knew before he said anything that he was going to say he was leaving. In fact what he said was "Um . . . I have something to tell you . . ." and I said, "You're leaving." I was right.

Then he dropped us off at home where my mom answered the door with huge puffy eyes—one of them black. She asked what Dad had said (which would become the coming-back-from-Dad routine for the next four or five years). I told her he said he was leaving and she said, "He'll be back—we're just fighting right now." I said, "I think he's leaving for good. I think he's in love with someone else." I was right. I knew who it was, too. I was nine.

My mom started to be really too damaged to function for the next few years. She was in a town with no family support, Dad got custody of most of her friends, and she didn't want to be single but she hated

dating. And I can't say I blamed her, based on the creeps she introduced us to. She just didn't know how to be without a guy. And, having lived through the "being left for someone young and snacky" experience myself—I'm sure her ego was decidedly bruised. Like going-twelve-rounds-with-Tyson bruised. Ego with an ear bitten off.

First, she was abandoned—literally: no family around, husband gone, her mom dead . . . plus she had to date the legion of newly single '70s douche bags that were currently sprouting up everywhere. Jeez. I was still a kid, but you could tell a tennis-shorts-wearing, divorcée-cruising, Burt Reynolds—mustache-sporting dickhead when you saw one. Yikes. They dragged me and my sister to stupid places like "Parents Without Partners" events. Which were really just key parties with a basement full of sullen preteens playing "levitation" and fingering each other while stealing whiskey sours from upstairs.

As things got worse for her emotionally, she would sometimes binge-drink. A few times she woke us in the middle of the night to sweep the entirety of our dresser tops onto the floor in a crash while yelling that the dishes weren't clean enough and yank us out of the bed to do them. Once she passed out on the living-room floor and in the morning I was afraid to nudge her in case she was dead. Even at the time, I knew she was not to blame. This wasn't the Mom who used to sing show tunes in the car and take us to the Horn and Hardart Automat to eat grilled cheese. She wasn't herself—she was in trouble.

Life became a cycle of school, monkey bars, and kickball at recess, punctuated by taunts about being fat[2]—and a home life filled with lots of playing anywhere I could away from Mom screaming that her husband had left her and her mother was being eaten by worms—she'd scream that as she raged at my sister and me about things that weren't

2. I had started using food-as-comfort big-time. It was no longer "eating." It was "filling the emotional hole."

really the issue, like chores—"MY MOTHER'S BEING EATEN BY WORMS!!!"

Mom's rages were relieved when Mom went on dates. Which was often.[3] I can tell you the entire lineup of Saturday-night CBS programming from that time. I could repeat, verbatim, entire *Carol Burnett* sketches—or *Love, American Style*. I also was trained in comedy by these shows. And by learning that if I was funny, I could stop or lessen Mom's rages.

So, a coping mechanism inspired my career choice. Of course, I can see all this now, from a grown-up, Oprah-fied perspective. It's always shocking when kids discover parents are human. They do great stuff and lousy stuff. What you don't know when you're nine is that the Universe just gives you . . . stuff. Not always in a pretty package—but it can be more awesome than you could ever hope for. What I got in the package was family: a great brother and sister, gorgeous nieces. And comic timing that bought me a Lexus and a house. (Note to self: send Universe a thank you note.)

Weight Watchers

It turns out that the kids at school who called me names weren't the only ones who, apparently, thought I was becoming a bit . . . er . . . chunky.

My dad took me to my first Weight Watchers meeting. I didn't know he had even noticed that I was chubbing out—until I was sitting in front of the place. And then it became clear real quick that Dad thought there was something wrong with the way I looked.

3. She was pretty cute.

After the hundreds of times my mom told me that men would always leave you for someone younger, prettier, and skinnier, I figured I better make the Weight Watchers thing happen as my father clearly planned. So I could become the girl who wouldn't be left. Again. I mean he must've been onto something regarding why men leave. Right? And Dad took JUST ME. NOT MY SISTER, LAURA, JUST ME. AND PAID ME SPECIAL ATTENTION AND I COULD WIN PRAISE FROM HIM FOR A BIG WEIGHT LOSS WEEK!!! Which might've possibly formed some of my opinions regarding my worth as it relates to my weight. Possibly.

My first Weight Watchers meeting I can remember very clearly. I was twelve and had been officially fat for at least three years. My dad picked me up at my house—IN THE MIDDLE OF THE WEEK! I sat in the passenger seat while he explained to me that he was taking me to a place where people got help with . . . well . . . being fat. I think he'd gone for a meeting or two and figured it might help me.

Dad had been a chubby kid and went through phases of getting his six-foot, 230-plus-pound frame down to 185 with crazy hyper-control willpower . . . and a lot of smoking. Then he'd go on work trips to Europe, or on vacation, and binge-eat like a heartbroken chick with a freezer full of Häagen-Dazs. He could also drink more than any man I've ever seen before or since without appearing drunk. Ever. Must've been the French/German heritage.

In any case, this "Weight Watchers" was his newest version of a diet. He only went a few times before he decided he got the message and information and the rest was just a bunch of folks who didn't have the mind-power to control their pie-holes. My dad was a scientist and didn't really believe in overemotionalizing or coddling. Or making excuses. Or whining about stuff that you could control

yourself. If Dad had ever gotten a wild hair and attended a Twelve Step meeting, he would've left after two steps. And perhaps some coffee, joke-telling, and a smoke.

So when he told me he was taking me to a "Weight Watchers" meeting, two things happened. One, it occurred to me that, up 'til that moment, I didn't know why I was getting special Dad time. IN THE MIDDLE OF THE WEEK! We normally only saw him every other weekend. So, I guess he thought I was chubby and it needed to be fixed 'cause he didn't like it—as he didn't like it about himself. Whatev, Dad! I'm in the passenger seat of the Chevy Malibu! Listening to my pick of songs from the eight-track of *Jesus Christ Superstar.* He could've told me that he was going to drop me off to do several hours of road maintenance and I'd have been cool.

And the other important thing that happened was that I figured out right then and there what I could do to get Dad to love me. In fact, to give me his delighted attention the way he did when I amused him with performing, or playing piano, or harmonizing with him . . . or being funny. Get a small fraction of the love he clearly felt for his beautiful and effortlessly thin new, young wife. Get thin and beautiful myself. I did now truly believe that Mom was right. I could diet myself into being the girl that men (my Dad) would love and not leave. And, thus, a comic is born. Bonus! Thanks, Mom and Dad!

So when we pulled into the parking lot of the Four Corners strip mall, where we normally went to the library (and where, years later, I'd meet my first husband in a production of *A Streetcar Named Desire.* Weird), I got out of that car eyeing the blue Weight Watchers logo on the storefront meeting place with a sense of purpose—a mission to create a svelte woman-body from the fat little girl who

walked in next to her dad. Until weigh-in, when he beat it out the door to wait for me 'til the meeting full of sad sacks was done.

I listened to a bunch of stories, was bored, and after an hour left with my stack of pamphlets and "Kids' Diet Plan." I stuck to it like glue. Even the liver once a week, which made me gag and I had to down it with my milk while holding my nose. The next weigh-in, I'd lost four pounds—got a big round of applause.

The next week it was six and I raised my hand second when the group was asked for speaking volunteers. I recounted a story about sneaking some of my sister's Vienna Fingers that my mom let her keep in her room in a jar[4]—out of the way of temptation from Fat Sister. That got an even bigger round of applause. I don't know if it was the fact that I had admitted "cheating" or that I was twelve. Or that I was a better and more entertaining speaker . . . dragging out the part where I snuck into her room, one eye on the door . . . expecting at any moment to be caught! And then describing with great fervor and detail the increased deliciousness of stolen, forbidden, sneaky sweets. But how they loved it.

My twelve-year-old brain was swimming in the success of the weight loss, the paternal attention, and now . . . the adoration of anonymous masses. For doing something . . . that seemed devilishly naughty and unsanctioned. It was really my first stand-up. I got grown-ups approving and laughing and applauding me. It was like a Twelve Step meeting headlined by a preteen Rhoda

4. Mom totally kept this strict diet for me. Bought and cooked all the food—and this was before Weight Watchers had prepared meals! They had "ice milk" or "frozen treat" or something. That was it. Now you can buy the whole diet plan in the freezer section. But back then you had to follow a pamphlet with points and it was hard. So . . . go, Mom!

Morgenstern. But without the team of writers or the sassy ethnic head scarf.

Still I lost weight. 'Cause I was twelve for God's sake and eating a balanced diet for a change. Before my dad left, my mom always cooked for us. But after, with her necessarily increased work schedule, I was left to the comfort of bread with butter and sugar (the trifecta of nasty goodness. Carbs. Fat. Sweet. Mmmmm. I can taste it to this day) and power-eating frosting in a can.

I lost forty pounds at Weight Watchers in between seventh and eighth grade. I came back to school with brand-new mini-boobs and a 36-24-36 figure. And a whole lotta new male attention.

Dad who?

Chapter 4

COLLEGE, BULIMIA & BEER—
WHAT A COMBO!

College is the place where we start to define ourselves. We stop just being someone's child and start meaningfully being responsible for doing our *own* damage to ourselves. It's both liberating and scary. It is the birthplace of both freedom . . . and bad habits.

I went to the Catholic University of America. That's right! I didn't go to "A" Catholic University, but THE Catholic University. I chose Catholic U because they had a great drama department. Or, so it was said. Turns out, it was great if you were a guy or a graduate student. Or a priest who liked to have pretty girls sit on his lap and call him "Father." But that's another story.

When I got to Catholic, girls outnumbered boys by some three to one in the undergraduate drama department. So, with all these girls paying tuition to learn to be actresses, what sorts of shows do you think they did, mostly? The classics. From the Greeks to Shakespeare—they did the classics out the ass. Now, one thing all the "classics" have in common (besides stilted English, broadswords, and a penchant for cross-dressing), is HEAVILY male casts. We're talking twenty juicy parts for guys and maybe two or three roles for women—one of whom is often dressed up as a dude and the other two get to be scullery maids or fat nurses.

One year, they threw the girls a bone and did *Stage Door* ("Stage Bore," "Stage Whore" . . . the jokes wrote themselves!). I got to be in that play. I don't remember my character's name, but I DO remember my line. That's right, line. Singular. "I like hibiscus—good and red—as if you'd been kicked in the mouth by a mule!"

Anyway, I say all that by way of explaining that I wasn't as busy doing the acting thing as I might have been. So, I had plenty of time to be at . . .

The Dining Hall

Nowadays, dining halls are all groovy and shit. There's tofu, extensive salad bars, and loads of organic whatnots.[1] But when I was in school, the dining hall was Carbohydrate Heaven.

In a bad mood? Don't worry. There's plenty of macaroni and cheese, mashed potatoes, white rice, and ambrosia to soothe your eighteen-year-old soul. (Hey, those are mandarin oranges amongst those marshmallows in ambrosia—that's a fruit serving, dammit!!)

Oh—and at night, you can chase down all that white food with pitchers of beer at the Rathskeller, dance to "Rock Lobster," and "Whip It" with all your gay theater-major friends who are pretending they're not gay. (It was the '80s—lots of boys still hid their gayness—or thought they did.)

I indulged. We all did. They've got a name for it—the Freshman 15. And I was on my way to gaining my share of that—and then some. Suddenly, my designer jeans were harder to zip. Lying on the bed,

1. Except for peanuts. Suddenly, there are so many people allergic to peanuts that you can't get a peanut in public anymore. Pretty much anywhere. Sucks for the peanut lovers out there.

spraying myself with Pam to help shimmy into them—none of that was working anymore.

And it wasn't just my jeans I was worried about. All the attention I'd gotten from boys, from my FATHER, from . . . well, everybody . . . I was afraid it would all go away. Now, maybe that might have meant, oh, I don't know . . . "moderation" to somebody else. But moderation has never been my thing. I know, I know. It's the Buddha's key to happiness or enlightenment or whatever. But I am excessive. It's part of what makes me, me, so there it is.

Anyway I was into living an excessive college life. Excessive sleeping, eating, and very excessive drinking.

Then I discovered something. Vomiting. Well, I didn't discover vomiting per se,[2] but vomiting ON PURPOSE. Nowadays, they call it "purging," or bulimia, but I had never heard those terms back then. To me, it was vomiting. Puking. Upchucking. Nothing fancy. Just sticking your finger down your throat, coaxing that gag reflex and . . . presto! That pastrami on rye and pitcher of beer were no longer in me but floating in the bowl of one of the communal dorm toilets.

And I wasn't alone. Oh, no. There was a veritable chorus of puking going on in those bathrooms. Seriously, right after dinner, girls would excuse themselves to "freshen up," and "Bye-bye, brisket! So long, succotash! Later, lasagna!"

I wasn't worried about my health. I didn't understand that I was setting myself up for a lifetime of eating disorders—I'd never even

2. I love the Latin phrases—*per se* is particularly elegant, don't you think? Either that, or it sounds like you're a gang member trying to impress the judicial bench at the criminal court.

heard the term! All I knew was that I could eat a half a pizza at two in the morning, after enjoying a twelve-pack of Meister Bräu, and still fit into my size-28 Levi's.[3] It seemed like the perfect solution!

While it was tough back when I went to college, I can't even begin to imagine the pressure on young women today.

Faux-"Bi" Is the New Varsity Cheerleader!

Good luck, young women of today—not only do you have to compete to get the grades you need to get accepted to the college of your choice, leading to job security and career satisfaction—you also have to be rack-tastic while doing it! Training our girls to be ultra-trampy for the sheer pleasure of a bunch of douche-y guys is frightening. Girls are asking for breast implants as high school graduation gifts! What happened to working for them by stripping—like good, red-blooded Americans have always done?

I mean, really?

This is where we are? We went from "You can have it all!" . . . which, as discussed previously, was unattainable horseshit . . . to "You can have it all . . . but isn't it easier to have someone buy it for you 'cause they're drooling over your nubile, silicon-enhanced tits." And across the country parents thought, "Encourage my little girl to believe that her worth is connected to how many guys want to bang her *Playboy* centerfold body? Yes, please! I'll take two!!" The parents got on board this train. OK, forget the mothers who all

3. My dream was always to be able to wear size 26 jeans. I've made it there only once—in the postdivorce diet-slash-depression-related anorexia phase. Sigh. I could fit into size 26 . . . even 25! There were side effects, though. For instance, my skin-color went from "Almond Beige" to "Primer Grey."

busted their asses to multitask themselves into divorce while spinning the career/family/sex-kitten plates . . . but the fathers? They went along with the overt sexualization of their daughters? Instead of supporting their self-esteem based on their talents, intellect, and just being a good person? *Ew.*

You see how it happens, though. My whole generation was so freaking . . . capable—and that didn't necessarily make life work out the way we wanted. So the following generation isn't nearly as convinced that "Do It All!" is such a good idea. Our daughters have watched us fight the battles at work, get up early for boot camp to stay doable to keep the husband . . . still lose the husband . . . to younger girls who spent less time worrying about being quite so smart—and more time going to pole-dancing class and aspiring to include more Lucite heels in their wardrobe. So they got the message:

Work hard: no man.

Play hard: man.

WARNING: THIS NEXT PART IS WHERE I TURN INTO THAT CRANKY, "GET OFF MY LAWN" LADY.

Today, a hot girl kissing another hot girl is simply de rigueur. What wet T-shirt contests were to Spring Break in my day, auditioning for Girls Gone Wild by groping your sorority sister is now.[4] I did all that 'cause I was young and it was fun; I did not do it because boys have become so spoiled by virtue of their addiction to Internet porn that they've stopped being aroused by normal stuff—like a

4. Fuck Joe Francis, by the way. Poor drunk teenagers embarrassing their grandmas for five bucks' worth of Mardi Gras beads? Really? Hope he has daughters.

really tricked-out ear lick, or a technique-infused brush of breasts up against their chest. Now they need a bevy of nympho-tards reenacting select scenes from *Caligula* in order to be stimulated.

"Blow job? Got three at my Bar Mitzvah. Yeah, that's right—in the Gypsy tent. Right next to the fire-eater. It was bitchin'. I'm now into midget nun amputees. . . ." And girls are so dumb, they're giving 'em out like Tic Tacs! Are you shitting me? I studied by reading up on them in the book I pilfered from my mom's bedside table, *The Total Woman*. Butterfly technique? Practiced it on an ice-cream cone for three years before I finally tried it out. I may have been Catholic and inexperienced, but I was well-read, dammit. You bet your ass my b.j.'s are worth more than eighteen bucks.[5]

Blow jobs aren't about sex when you're young anyway, they're about power. For sixteen, seventeen years you've been told what to do—you have no power, no say. "Clean your room." "Do your homework." So, you get that first dick in your hands you have aaalllll the power in the world! For that thirty seconds—before he jizzes in your eye—you are Sheera, Queen of the Universe. After that it's "Bitch, make me a sandwich" . . . but before . . . ? It's the power that's the turn-on.

Girls have no sense these days! Women have always been competitive for male attention, it's part of our genetic imprint. The standard has become "whoever is the sluttiest hooker in the room is the most desired by the dudes." The dudes don't have to do anything but pass these dumbass girls around to their dude friends. The girls are all in a mad rush to do threesomes, anal beads, Vietnam-

5. For non-Jewish readers: Eighteen dollars, or multiples of eighteen, are traditional Bar/Bat Mitzvah gift amounts. It's good luck. Although a nice watch or pen is also thoughtful. None of which is as appreciated as the b.j., however.

ese Fuck Sling Sessions . . . they're handing over the keys to the castle without so much as an Olive Garden entrée. What the . . . ?

Any bar you go to in L.A. is swarming with ex–prom queens rubbing up on each other on the dance floor in a mad effort to convince the "producers" that line the walls of these places—like oily shelf paper—that they're "gay" but might really be into the "producer"[6] if he could get them an invite to "Hef's Place." Or a walk-on on *CSI: Miami*. Or some blow. Or any combination of the three. My problem with all of this is not the pseudo-sapphic activity—it's that chicks are just pretending to be gay in order to get guys to think they're whory enough to be date-worthy.

Now throw Internet porn as a standard for female behavior into the mix and you get: "Lesbian chic." Where it's cool and happenin' to be all girl-crazy. That is, of course, unless you're a REAL lesbian. You know who I'm talking about. That girl who plays volleyball and wears her hair like Don Draper; that girl in Hush Puppies with a tire gauge in her pocket. That's not the lesbian the frat boy wants kissing on his girlfriend. No, that frat boy wants Megan Fox kissing . . . well, Megan Fox. Fox on fox, is what he wants. These guys won't pay to see k.d. lang kiss Rosie O'Donnell. So, it ain't "lesbianism" that's fascinating. It's "girl-on-girl porn" lesbians.

For the porn novice (or those of you who didn't go to a liberal arts college in New England), "girl on girl" is never the real lesbians either. It's a couple—or three . . . or four—Barbie look-alikes badly acting their way through multiple orgasms and routinely ending the session with "Wow, Tiffany! Those seven screaming orgasms were good and all . . . but what I really need right now is a big penis!

6. Almost always some douche with a parking-lot-franchise-backed trust fund who's never produced anything besides a case of chlamydia.

Oh, look—the Pizza Guy's here! Yaaay!"

Again, not a real dyke in sight. Real lesbians never scream for the Pizza Guy. Real lesbians have active-length nails, usually drive sensible cars with enough room for their rescue dogs, and have beds with big signs over them of a red circle with a line through it across the warning NO DICK.

Now, I have no problem with girls . . . um . . . exploring. Far be it from me to judge. Well, actually—it's kind of my job. As well as my hobby. Judging, that is—not lesbianism. But, as I like to say, "I went to college." It has become a euphemism among my friends for "I went to a few parties where everyone drank enough to share a few of the boys with their friends—so I also fondled some really nice boobs and made out with a couple of hotties." Since then, I've learned that while girls are nice—I like men. A lot. A lot of man, even better.

But mostly I learned that pretending to like some dude's sexual fantasy just to please him is dumb. You can't stay ahead of the freak factor when it comes to dudes. It always winds up with weird shit like midget amputee nun videos! So just make sure it's YOUR freak you're getting on.

Now—get off my lawn!

Chapter 5

I BECOME A MOM—I GET PREGNANT. AND GET MARRIED. TO A GAY(-ISH) GUY!

OK, let me explain, because that title looks like I did all those things in that order and on purpose. I want to make it crystal clear right now that I did not marry a bisexual (or gay-adjacent) man on purpose. And if I had, I would've picked one that dressed better and could wrap a decent Christmas present instead of one who wears work boots and ripped BoSox shirts—but not in a Village People kind of way—and who slaps Sunday Comics around gifts with duct tape. Sad.

No, I met my first husband, Sam, while doing a stage production of *A Streetcar Named Desire* right after graduating college. He was Stanley, I was Stella, and if you know anything about this particular Tennessee Williams play, you know that they are very hot for each other and that all actors playing these roles wind up married.[1] We were no exception after a year of living together, waiting tables on Cape Cod, then moving to Jersey so we could both "make it" as actors in New York City—I did what I've eventually come to learn I do best . . . accidentally get knocked up.

Adulthood comes quick when you spit out a kid, lemme tell ya. The whole process comes as quite a shock. Everyone wants you to

1. Ken Olin and Patricia Wettig. Look it up.

do "Lamaze," first of all. Which, I believe, is French for "OOOOWW-WWWWWWWWWW!" Lamaze was all the rage back in the late '80s. Here's how it went down: You go to class. They show the Wes Craven birthing film. It's great. It's like this San Francisco, holistic couple, having the baby at home. The midwife comes in. They're baking cookies! Kids are running around the bed—little Rainbow and Sunshine—because they're going to witness the miracle of birth!

The woman is making sounds that only dogs can hear with this breathing thing. Now, this signals that the baby is crowning—which does not mean they're playing checkers. It means this kid is ready to rip this woman open like a ripe tomato! So, they slap this poor woman on the bed. And the fat, bearded Woodstock husband from hell is looking down and saying, "Oh my God, honey. It's beautiful! It's so beautiful!" The woman says, weakly, "Really? It's beautiful?" The husband says, "Yes, honey. So beautiful. It's got your hair color." The woman answers, "Really? It's beautiful? . . . GET! IT! OUT!! Get it out of me now!!" Suddenly, Sugar Magnolia turns into the girl from *The Exorcist*. The head spins around, she spits out pea soup and everything. Nasty.

I thought it was hilarious! Until, that is, I got to the emergency room. The woman down the hall from me was bargaining with God. "Make it stop! I'll never fuck again, just please make it stop. I'll be a nun!" At which point I said, "Hey! Any Aborigine in the

bush can do this 'au naturel' thing. Why don't you let me take a look at that drug menu! A little Demerol cocktail, thank you!" The anesthesiologist was my best friend. I told him, "I love you. I'm going to have your baby, next."

So I was poor, married, and a mom within a year of becoming a grown-up, pretty much. We moved from a studio-ish apartment in downtown Jersey City with a rooftop and "lanai" (fire escape) view of the Hudson River to the peaceful, bucolic "burb" of Summit, New Jersey. This is a gorgeous town full of multi-million-dollar mansions, sprawling old Victorians, and a Main Street/Summit Ave. "business district" that included a bank, a high-priced cheese and wine store, the YMCA, and a library. It was a green place without constantly honking cabs, and it reminded me of Maryland where I grew up. I spent the days pushing my baby, Jordan, in his stroller up to "town" and doing most of my errands, shopping, and other assorted crap while holding him under a nursing blanket to hide the fact that he was sucking away on my boob. He nursed constantly. From 6 A.M. 'til 11 P.M., every fifteen minutes. I wish I were kidding. My nipples looked like Vienna sausages.[2]

We couldn't afford a car after the driveshaft fell out of the fifty-dollar Datsun,[3] so if I went to town, I walked—pushing Jordy in his stroller, which wasn't easy because he was a C-section baby. Yes, they did cut him out of me. If you saw his head today, you'd know why. It's only slightly larger than when he was born. One day, recovering from the pre-eclampsia–based weight gain of pregnancy—not to mention the forty-plus pounds I was still carrying

2. They never really went back, either. I constantly look like the famous Farrah poster. Another fun postpregnancy body fact!

3. Yes, that's right. An entire car for fifty bucks. Today you couldn't fill the tank of my SUV for fifty bucks. A whole entire car . . . fifty dollars. And it looked like it.

because that whole "You'll lose weight when you breast-feed" thing never happened for me—I was coming home from a day of errands, walking the narrow sidewalks, getting out of breath going up hills because I was still getting over the effects of the anesthesia, my giant stomach wound hurting like shit.[4] I was still blocks away from the pretty Victorian house where we had a second-floor two-bedroom apartment that I'd decorated with hand-sewn curtains and kitchen towels from the 99¢ Only store. I was huffing and puffing up the last hill when a car full of teenagers skipping class pulled up behind me. One of them yelled out the window, "Hey—look at that FAT ASS!!" The other ones laughed and yelled similar taunts.

It took a second for my brain to catch up. I didn't even have time to yell some dick-withering comment back. I just stopped in my tracks, red-faced and stunned. It had been years since the schoolyard, when this sort of humiliation was a daily event. I'd gotten used to using overt sexuality, humor, and bravado to mask hurt. I'd also spent years connecting my comparable worth to avoiding exactly this type of nasty judgment by starving into a concept of myself that would be desirable, or at least acceptable to these clearly superior people who had such strict rules regarding female bodies. I hadn't ever really fit in. Not really. But I was at least hoping to escape ridicule. The fear that other people were always secretly thinking (and some, apparently, not so secretly) that I was fat and unattractive came rushing back in an instant by virtue of the thoughtless midday adventures of a carload of truants. So, my brain reasoned as I relived that wrenching moment for the rest of the day,

4. Along with "You'll lose weight when you nurse," the promised "Your C-section scar will only be an INCH!" turned out to fall under the category of "Dream Stuff That Happens to Other, Cuter People and Not Me." My scar looked like special effects from *Saw 3D*.

the week, . . . even if people don't say it out loud—I'm fat. Always will be. Fat.

Years later when I was constantly on the road doing stand-up gigs, I was up in the Providence area playing a venue full of similar rich, frat-boy types. Sweatshirts that read "Brown" and "University of Rhode Island" and the like. I had given birth to my second baby, Delia, and was traveling with her; my son, Jordan—now four; and my husband, Sam, who watched them at the hotel while I worked, racing back to my room in between sets to nurse the baby. I went back to work five weeks after having her because we'd just bought our first house for $175,000 on the wrong side of the tracks in Summit and moved in exactly one week after I had the baby. I was incontinent and used Depends while performing so as not to pee on stage. I also leaked breast milk. I was one leaky bitch trying to be funny. But we had seventy-five bucks in the bank and Mama had to work 'cause we needed milk and mortgage money.

College crowds were never my favorite, because they're stupid. And spoiled. At least that's how they appeared to me. I was only a few years out of school myself, but I'd been a grown-up for a good long time by then. My act had never been geared for this group—it was all about being a wife and working mother, the guilt we feel—keeping those plates spinning. They didn't give a shit. They liked it when I talked about music and oral, but other than that . . . eh. But about five minutes into my headlining set,[5] one of these dumb frat boys yelled out, "You're fat!" And this time—five years later—I was prepared. Plus I had a microphone.

"I'm fat?" I asked—real calm.

5. A career that launched with a *Showtime at the Apollo* gig six months after my first gig, where I turned a booing audience around with the line "Oh, yeah? Well the guys in the balcony like me—'cause they're the ones that can see my tits."

"Yeah! You're fat," said jerky college ass, gaining confidence, happy to be taking over the show—glancing around at his friends for nods of congratulations.

"Oohh," I said. "You like thin girls, huh?" Real conversational. Smiling. Nonthreatening. Like a gentle Sicilian cobra. Coiled back. . . . Wait for it . . .

"Yeeahhh, I like skinny girls . . . not like you! You got a big, fat ass!" He had the room now. He was shouting over his giant beer mug, making sure all eyes were on him . . . and so did I.

"Yeah, and you like the girls with the little asses, huh?"

"Yeah, that's right, the smaller the better!" High-fiving the friends now.

"I got you, we all heard you—you like the skinny ass, we all understand . . . The smaller the ass . . . the bigger your tiny dick looks next to it! Drinks on me for MIDGET DICK!! Good luck getting laid for the rest of your college career, Hamster Pants! Give it up for my new friend—he's hung like a Tic Tac!"

Screams of laughter now. The girls high-fiving each other, and the red-faced rich frat boy is shrinking back into his cloak of entitlement and asshole-ness.

Now, understand—I didn't castrate my audience in the normal course of events—or at least if I did it would only be if they started something . . . and I'd warn them first: "You sure you wanna play, dude? I know you've been drinking and you wanna show off for your date—but this is my job. This is all I do. You wanna tangle, I'll dance with you. But it'll end in tears. You take your best shot, but I'll be forced to cut your dick off publicly and you will be sad . . . Come on, bring it . . . Nothing? All of a sudden you're shy? . . . OK

. . . As I was saying. . . ."—So I would only do this as a last resort to a serious heckling infraction as a rule. But I had years building this one up. It exploded out of me like a sneeze, an orgasm—a release of pent-up response to humiliation from years of teasing, mean-spirited criticism disguised as good-natured ribbing.[6] Don't regret it one bit and it was the start of the groundswell movement. More on that in chapter 22—now back to living in the Jersey suburbs:

There were a few boutiques I couldn't afford and a couple of restaurants—one of which I continued to wait tables at until well into my stand-up career. Sam and I would take turns doing shifts—doing trade-offs of the baby in his carry car seat. One of us would walk in, put the car seat on the bar, the other would take off their apron, take the car seat, and hand over the open checks to the other. We did this until we could afford not to.

This wasn't a big deal—as working up to three jobs, plus doing a show, was what I'd done since I was sixteen. It was living in a town with rich people that was weird. Rich ladies, it turns out, have different problems than the ones I had. They worried about things like how to continue to stay hot enough to make their husbands continue to want get the six o'clock train home instead of drinking with the office hotties at the thousand hip bars in Manhattan. They talked about stuff like this at the mommy/baby exercise class I took at the Y.

It was kind of stupid, but I didn't have a sitter and the Y was a lot cheaper than the one gym in town. They had little baby mats there with all these chicks in jogging suits with little babies in little baby jogging suits. A jogging suit for a three-month-old. He can't lift

6. "You really need to eat that cake?"—universal shithead comment from naturally skinny co-workers at office party. Response should universally be "As much as you need charm school, fuck face."

his own head. Where is he going?—Anyway, they were exercising the babies and using their babies as weights followed by sitting around in a circle discussing the new issues they faced as middle-aged, first-time mothers who had traded New York City careers for vegetable gardens, vacation planning, and sporadic episodes of interior designing. I wore Doc Martens and downtown punk gear and sat, mostly slack-jawed, listening to their discussion led by the class instructor, a blond lady in a trim Nike jogging suit, regarding how they felt their lives had changed most:

"I don't have any time to myself anymore."

"I never know what to make for dinner."

"I can't decide between Martha's Vineyard and the Hamptons for July . . ."

When they went around the whole circle and they got to my turn—I was dreading it. How was I going to answer? I hadn't left a high-powered career on Wall Street, or my law practice or partnership in a Madison Avenue advertising company. I got knocked up on my way to trying to be an actress while actually waiting tables. And was currently a new mother, with a new forty pounds of post-baby ass, trying to be an actress while actually waiting tables. And it was my turn.

"What's the biggest challenge in your life?" said smiling blond thin lady.

"Who, me?"

"Yesss!" The crowd encouraged. "What's the biggest change in your life since having a baby?"

"Cradle cap."

They never asked me a question during circle time again. One lady did ask me while we were leaving where I got my "fab distressed leather" jacket. I told her I'd been wearing it for five years, since my sophomore year of college when I spent two whole paychecks on it at Georgetown Leather Design, and the "distressed" was not coincidental. I don't think they'd heard of people actually using their uterus before thirty-five in this particular neck of the woods, so she eyed me warily and maneuvered her pricey Maclaren stroller back to the other ladies with matching jogging suits and the faint onset of crow's feet. After a few months another lady approached and said with that tight-jawed accent of old money, "I don't mean to embaaarrass you . . . but whooo did your lips? They're faaabulous . . ."

"My immigrant ancestors," I answered. And that was it for making friends at the ladies' exercise club in Summit.

So life continued like this—errands, waitressing, nursing, self-loathing, career-stagnating—for six months or so.

And there was a little issue in what I happened to read in my husband's journal.[7]

It turns out he was sorta worried because, although he was thrilled to be a dad, he generally wished I was dead. So that wasn't awesome. It also included the tidbit that he was experiencing that "old sexuality identity crisis again." Which I promptly confronted him with and he promptly denied. We had a reasonably decent marriage for lots of years, although it was always obvious to me that,

7. By "happened to read" I mean climbed on a step stool to reach the top shelf in the back closet and rifled around all the boxes 'til I found it while he was at work because I wanted to know why I seemed to love him so much more than he loved me.

while he loved our children without condition or restraint—I was less of his soul mate and more of his mom. Also not intensely awesome. I hate being the boss in a relationship. But I'm ridiculously bossy,[8] so you can see where this is a problem.

I'm not sure if this is an indication of my feelings of self-worth (or lack of), my preference for good-looking, muscle-y guys, or a reaction to equating "love" with "chasing after a guy who is always just slightly un-gettable" as a result of the whole Daddy issue—but this wasn't even my first foray into gay. In fact, I lost my virginity to a guy who turned out to be gay. I didn't know it at the time, of course. Besides, I loved him, he was hot, and if he spent enormous chunks of time buried in my tits—how in the world could he be gay? I mean, yeah—there was the little issue of his homemade high school collages that prominently featured tons of oiled-up male bodies . . . his deep soulfulness and lack of interest in team sports . . . the book of homosexual erotica in his desk—little tip-offs for someone who was looking for evidence or had just that kind of mind-set . . . but nothing concrete per se.

Sigh. How the hell was I supposed to know? I was seventeen! I didn't understand the rules!

. . . if they wrap presents better than you

. . . if they dress better than all the other guys

. . . if they offer hair, makeup, or wardrobe styling tips—tips that turn out to be good, not just along the lines of "Could you please be sluttier . . ."

Then he's gay. Even if he wants to have sex. A lot. Because it's

8. My second-grade teacher, Ms. Thompros, said so. Often as she was ushering me into the hall to stand facing the corner for "not respecting the rights of others."

become screamingly clear to me in the years since—that men just like to pork. A lot.

And all men like boobs. Even gay men. In fact, that's my new rule:

If they stare at your tits in the first five seconds of meeting you = straight.

If they stare at your face and enjoy your personality for five minutes—then reach out and grab your tits while screaming how much they love your rack = gay.

So I lost my cherry to a really nice, cute, and smart gay guy who I'm still friends with and then, turns out, married a completely different type of team sports–watching but still really cool and supportive bi guy who I'm still great friends with.

I fell in love with my first husband in the parking lot of the theater one night in the first week of rehearsals for *Streetcar*. Some guy driving by yelled something about my figure. (It was good—and by that I mean a nasty sex remark, not a vicious taunt about fat asses.) He heard the dude yell something about my boobs or something, turned around, and said, "Whadj'you say, man?" and took off after the guy revving at the stoplight, like he would kill him. I was smitten. And he was way funny. And always told me that I was talented and cute and sexy. We had great road trips up and down the East Coast and started a family much, much younger than anyone else in our world. But we had tons of fun, lots of laughs, and shared so much hunger for a big life.

If it wasn't for Sam, I wouldn't have a career. He believed in me and thought I was awesome and became my manager and pushed me even when I didn't believe in myself. He made phone calls and booked gigs and told everyone I was the funniest, most talented

woman working in stand-up. He still says that. He's demented, apparently, but it all comes from a good place. And even though the whole "my husband also wants to bone dudes" thing did come as a bit of a shock, I was relieved. I think what I said when he told me after thirteen years together was "You poor thing." What I was thinking was, "Man, if I knew I wanted dick since I was eighteen—which I did—and never got it . . . I'd be cranky." So I wasn't as angry as you think I'd be. I could finally integrate what I read in his journal to how I felt only partly loved by him, and I didn't feel anymore like that was my part—that I was somehow to blame. I mean, I couldn't be any more "penis-owning," could I?

I stayed with Sam for a long time after he came out to me. I was afraid divorce would screw up our kids like it did me. I finally moved out after two years of sleeping in separate bedrooms. Because Whoopi Goldberg said I should. That's no lie. We did my first big studio movie together and spent many long hours sitting next to each other yapping about life and such and I told her what was going on and she promptly tried to fix me up with every man in both the cast and crew and told me, flat out, that I was crazy to think my kids would be happier with a mom who was never going to get laid again. I think, because it was Whoopi saying it, and you tend to believe everything that woman says—I moved out. I didn't make better choices where men were concerned, but I moved out.[9]

I had a great time being a mom, actually. I had nothing to compare it to since it was my only experience upon becoming a grown-up—so I just did what I did, except with a baby! And since Sam and I

9. Whoopi nursed me back from the next heartbreak, too. I called her, crying hysterically, and she said, "I want you to get in the car . . . can you drive? . . . OK, get in the car and come to me." I did. She made me eat and we did spinning class while she cranked Whitney Houston's "It's Not Right, But It's OK." I would kill for that woman.

were the only people we knew[10] with kids, they were kind of fun for everybody! Like Purse Dogs are now. All of our friends liked to have our kids around and we took them everywhere. When we only had Jordan, and he was breast-feeding, I'd take Jord into the city and meet Sam and the three of us would go to see one of the many showcase productions that our actor friends were in and watch it with the baby right there with us. And no one ever knew, because I'd throw him under a blanket and "plug him in." And he didn't make any noise unless the "production" was particularly heinous and then we'd nudge him and he'd fuss so we'd have an excuse to leave.

Turns out kids are convenient!

They also can run and get things for you when the next one comes. I liked to call Jordan "Jumping Monkey Boy" when Delia came along. As long as you make a big deal out of them, they really love it! Just say stuff like, "Oh my gosh! You're such a big helper! Look how strong you are! You make me so proud of you!" And it stays that way throughout their lives—especially the boys.

But there are things about having kids that come as a big surprise. Even more than the kids themselves in my case! Like what happens to your boobs.

I'm not a weirdo about my body being taken over by a parasite. However, people should be warned about what happens to your boobs. I'll tell you what happens to them. Babies suck the life outta them, that's what happens to 'em.

They look great in a push-up bra. Take the bra off they look like Shar-Pei puppies.

10. I mean besides *Ricki Lake* guests.

Well, I guess that's just too dang bad. I was going to have to have Shar-Pei puppie-boobs. Since it was way healthier for my kids, my tits were just gonna have to be comprised of the breast tissue that was left and whatever back fat I could manage to coerce to my front and into my Vicky's Secret shelf bra.

Shoulders back, head high, nipples to the wind!

And since the reduction—they're SWEET!![11]

You may slam-dunk motherhood, but romance? AIIIRRR-BAALLLLL!

Your relationship—according to all the media representation—is supposed to remain looking like an ad for sexy All-Inclusive Resorts. That's what they're busy selling to your husband, too. And this is why you both get disappointed. Because after kids come along it's a lot less Hedonism Bahamas and a lot more Sesame Place in Langford, PA. Not so much endless mai tais and skinny-dipping. Much more retrieving sobbing two-year-olds out of sticky ball pits.

This is another thing no one tells you that you'll fail at and then judge yourself for: your best-laid plans for continuing a snacky, sexy life after kids will all fail. Unless you're rich, then you stand a much better chance. But for those of us who don't have someone who'll feed and bathe and read to and . . . well, you know . . . mother . . . our kids? Forget romance. Hell, you'll be lucky if you can get through a magazine article without constant screaming interruptions.

They don't tell you, as a young mother—surrounded by middle-

11. Honestly, I love my boobs now. I want to do frontal nudity. If only to make all my exes cry.

aged first-time moms with business degrees from Wharton and husbands who bought them million-dollar houses and Tiffany diamond "push presents"[12]—about things you need to know. Like:

Even though you love your kids, you're totally pissed they don't come with snooze buttons.

Don't ever wear leather pants to the PTA meeting. Both the P's and the T's get testy.

If your house is set up all nice for the new baby, take a picture. 'Cause that's the last time it's going to look that way. I don't care if you watch HGTV every day and copy all their design styles . . . You're going to be drinking out of jelly glasses in five years, just like everyone else. They don't tell you you have to be a cheerleader for your kids 24/7. You have to love everything they do. All day long you have to cheer them on. You know what I did for Mother's Day? I had to wear a big, fat, sprayed-gold macaroni necklace one of my twins gave me. For three fucking days! I had to sleep in it or the kid got pouty that I didn't like it. I was afraid I was going to die from that Buddy Ebsen/*Wizard of Oz* disease, where the paint closes up your pores.

And it's completely insane here in L.A. Most of the grown-ups are completely spoiled entitled whiners, so the kids have no limits. A kid graduates from nursery school he gets a Nintendo DS and a Vespa. You know—to get from his nap blankie to finger painting. Seriously, it's full-on retarded out here. They congratulate kids on every single freaking thing they do. They throw a party to celebrate little Dakota's first tetanus vaccination! I'd ask what are they

12. I didn't even know such a thing existed until my Jewish girlfriend told me that your husband was supposed to give you a nice piece of jewelry for giving him children, not to mention wrecking your tits. When I found out years later I asked Sam, "What kind of Jew are you?"

gonna do when they get into the real world—but the real world here includes a staff and a trust fund, so fuck me.

But all moms have to cheerlead. Everything the kids do, you have to love it. And I'm not talking about playing Mozart at five, I'm talking about—they draw a picture that looks like firecrackers blew up Santa Claus and Batman's colonoscopy results and then you've got to divine what it's supposed to be and put it on the refrigerator because that's your job as a mother. I don't know about you, but I'm running out of magnets.

I can handle this shit in the morning. I can be the best little suburban mom there is at breakfast. "Mommy, watch me! Watch me, Mommy!" "Oh my! That's the best jump I've ever seen! You're mommy's little jumper! Go practice jumping outside . . . take a juice box. I love you, precious."

At dinnertime? "Mommy, watch this, watch this, you gotta watch this! This is really good. Mommy. Mommy . . . MOMMY, MOMMY, MOMMY . . . WATCH, WATCH, WATCH . . . MOMMY MOMMY-MOMMYMOMMYMOMMYMOMMYMOMMY . . . ARE YOU WATCHING?? WAAAATCH!" "Yeah, you can stand on one leg now, what are you a fucking flamingo? Why don't you move to Florida? Come back when you win the Nobel Peace Prize! Mommy's got a life to lead, dammit!" And all of a sudden, *you're wrong.*

They don't tell you that being a mom will include stapling a Puritan costume together at three in the morning and feeling like a big fat failure because your orange frosting for the Halloween pumpkin cupcakes was made orange by crushing up Cheetos because you didn't have time to pick up food coloring. And they still talk about it at every bake sale and shame you, so you try to compensate with kick-ass Thanksgiving Pageant gear, but your pipes burst and

the plumber didn't show up until 6 P.M. making you wait all day and also you couldn't afford the repair so you used duct tape and didn't trust the shower so you also have greasy hair. And you've got a Pilgrim hat made out of a coffee tin held to your poor kid's head with twisted pipe cleaners and rubber bands. That's being a mom.

No one tells you that your Christmas/Hanukkah/Easter gifts have "rolled over" to your kids and you will no longer be receiving any. And that your preholiday activities will now include spending your last dime on whatever plastic piece of shit the Japanese/Korean anime geniuses have concocted this year that have created a need so deep in your children for that action figure that you'll find yourself crawling through the dusty bottom shelves of Toys "R" Us the week before Christmas like Indiana Jones after the Ark of the Covenant.

They don't tell you that stuff.

And that each time you let any of them down, your heart dies.

Because the main thing that you're not prepared for is how much you'll love them.

I was never a baby person as a kid, or teen, or even the week before I had the first one. I never ran to the lady who came over with her smelly kids and asked to change them, or feed them or play with them. My sister did—and she became a nurse practitioner, so there ya go. But not me.

But from the minute I held Jordan, an hour after they sliced me open (on my command, as you recall), and rocked him, nursed him—while the orderly came through and mopped up and I didn't even care! My boobs were no longer decorative! They were just out doing their job!—from the moment I sang the Beatles' "Blackbird"

to him . . . I found out how much love I could feel. I thought, "Oh. This is what they mean when they say that a mother could flip a truck over if her kid was pinned underneath it. I could do that." And that's what I tell women who are pregnant: you're never prepared for how much you're going to love them.

And, that other people's kids will still annoy you when they scream at restaurants—not as much, maybe, but it will definitely still stink when other people's kids poop.

They don't tell you that romance will be over in your little life. You can't have romance when you have kids! First of all, if you can stand up and sneeze without wetting your pants, you should mark that day on the calendar. That should be a recognized holiday in your house. That's an event.

And God forbid you try to have a romantic meal with your guy in the house—a little adult conversation . . . a glass of wine . . . Kids run around the table snatching food off your plate like Helen Keller in the fucking *Miracle Worker*. Spoons are flying everywhere, there's mashed potatoes in your hair . . . It's ugly.

Lots of fun little surprises.

And now, I've got four kids. 'Cause I had two with the first husband and you have to have the same amount with each guy or they get all jealous. It's some kind of weird guy law. That's right, FOUR. And two of them are identical twins. My vagina's a clown car.

Used to be people had an assortment of kids, but now four is, like, a shit ton of kids. When people ask how many I have, and I tell them four—they look at me like they're figuring that their assessment of me as Jewish must be wrong because Jews never have more kids than they can comfortably guarantee an Ivy League educa-

tion for. It's not just the strangers silently judging me. I also feel like it's a whole lot of kids. I should live in a shoe.

And the twins are more like ten kids' worth of energy. They're nuts. It's like raising Vikings. The fights, the pillaging . . . the burning of villages. Nuts. I love when people tell you that their dogs are their "children." Really? Because when your dogs go nuts and start biting each other, it's OK to yank 'em by the collar and lock them in the bathroom for a few hours to settle down. Try that with your crazy-ass kids and someone's calling child welfare. Which reminds me, I must go to Petco for supplies . . .

Everybody wants to help you raise your kids. Everybody's got advice for you—like *Parenting* magazine. They give you helpful hints. Here's one of my all-time favorites: "If you're out running errands and the children start acting up, take them home right away and give them a time-out."

I don't know about the folks at *Parenting* magazine, but I'm a working mother; I've got a lot of stuff to do. Unless the people at *Parenting* magazine are willing to come to my house and take care of my kids while I run my errands, I suggest they shut the fuck up.

Of course, being a mom is hot now, very in, very sexy. Thanks to Madonna, and Demi and Gwynny et al. Cougar Moms are the new Asian Girlfriend.

I'm not just a mom, I'm a MILF.[13] I'm tooling around town in my mom-mobile SUV, hair blowing in the wind, rocking out to Hannah Montana and *High School Musical* songs. Which you can never get out of your head once the kids get out of the car, by the way. You're singing them well into your round of errands or your first meet-

13. A MILF is just a soccer mom with fake tits and a spray tan.

ing. Nothing gooses that morning conference call like a few rousing choruses of "Hoedown Throwdown" or "Best of Both Worlds." They're catchy!

Speaking of Miley, when did the Disney gang get so hot? Cap'n Jack Sparrow? Shiver me timbers—totally doable! You wanna share some eyeliner, Johnny? The Disney Channel cartoon Tarzan was disturbingly ripped. What gay animator drew him? He's got abs and biceps, delts, he's like a freaking Bowflex commercial.

I'm not supposed to comment on that stuff anymore, at least not in front of my kids. Well, specifically not in front of my teenage daughter. For years I thought that when we were at her school events and we'd be listening to a band playing and she'd spontaneously hug me, it was because she loved me and was moved by the song that I was clearly enjoying and that I was her young, hip mom and she was proud of me.

Turns out she was just trying to physically restrain me from dancing in front of her friends. You're not allowed to dance once you become a parent. Or sing along to any of the songs on the radio. You are allowed, perhaps, to silently bob your head in time to the music with restraint and gentle elegance. Which is not really my forte. Teen daughters are going to be embarrassed by you no matter what you do. You might as well embrace it. I say, if you're going to embarrass your kids regardless, go all the way. Wait until their friends come over, dig out a muumuu, put some pink foam curlers in your hair, hit the '90s megamix on your iPod, and rock your best Vanilla Ice moves in front of their *16 and Pregnant* viewing party. It's Hammer time!

Chapter 6

BEING A FUNNY CHICK—NOT SUCH A LAUGHING MATTER

When I was a little kid I never remember being congratulated or celebrated for how funny I was . . . I remember being put in the hall a lot by Miss Thompros and standing facing the corner so that I could "think about my lack of respect for classroom time." I never even got the bone thrown at me for being "class clown." I was just that "loud little girl."

I memorized every line of "blue" comedy albums by George Carlin and Richard Pryor. I also would repeat the filthiest jokes I heard to my mom after my parents divorced and she stopped being Catholic. Well, she didn't so much stop as much as she sorta traded it for sleeping in on Sundays following Drinking, Dancing Date-Night Saturdays.[1]

By the time I got to high school, it was apparent that "funny" for girls meant "laughing at every stupid thing a guy says." Bonus points for doing it so hard that beer comes out of your nose (as long as your boobs are also jiggling). It hardly ever means being a wisecracker yourself. Certainly not topping them. That gets you

1. In her defense, she was told by our parish priest that, according to Catholic tenet, she would be married to my dad, in the eyes of God, 'til she died—even if he left her and was currently married to someone else. What he did with his soul was his business, but she was gonna die alone, albeit with her soul intact. So partying it up on the weekend seems at least fair.

dateless on Saturday nights. So every morning, before school, while picking out which trampy shirts I'd successfully hidden from my mother,[2] I'd resolve to be just as quiet as the "popular" girls. I'd vow to giggle and toss my feathered mane and shrug my shoulders in a baby kind of way and never . . . ever . . . be funnier than the football guys that surrounded the "Seal"—the most coveted turf for lockers among the jocks.

I'd blow it every day by second period.

And much like a diet, I would decide that, since I had proven myself to be funny, not cute, I'd just do funny for the rest of the day and try for cute again tomorrow.

This remained my plan pretty much up until after my second divorce.

But at least for a long period of time, I found a way to make obnoxious profitable.

After I moved to New York to get stage work I learned that casting directors generally don't come to your apartment and invite you to have an acting career. Since I was always convinced that I'd never get a job through auditioning until after I lost twenty pounds . . . which never happened . . . I was talked into trying stand-up comedy by some of my best friends from college, Nora Lynch and Becky and Bernie DeLeo. Nora had taken a class in putting an act together and called me and said that if she could do it, I—given my talent for being loud and obnoxious—would be brilliant! Maybe she didn't put it that way exactly, but I got what she meant.

2. Mom was known to claim that some of my slut-wear routinely disappeared on its trip to or from the laundry. Finally I got smart enough to hand-wash the crocheted halter tops and hide them inside one of my Frye boots.

So, figuring I'd already made an entire human being, I thought stand-up would be a cinch. Becky demanded I give her a date by which I'd have an act ready and found a place for me to do an open mic. And she wouldn't let me cancel. Well, not more than three times anyway. She came with me to that first open mic and forced me to go onstage. So you all have her to blame.

And there was no one to make me feel like I was too fat to do it. In fact, in those days, fat was kind of a prerequisite for being a funny chick. Either fat or ugly—or not really either, but acting like you were in your act. Because the rule is that funny women can't be hot, and vice versa, or people get confused and lives are lost. I think it's because guys are afraid that if we have both feminine wiles (sex) and a quick wit (smart/funny), the odds go up that eventually that humor is gonna wind up aimed at their dick size. I dunno—that's all me and my girl comic friends could come up with at the time.

I know it's not that way as much now—and I claim complete responsibility for that. Until I started wearing push-up bras in A clubs around the country, women were told that they "wouldn't be taken seriously" or that "no one will listen to what you're saying" if you dressed hot on stage. I ignored them. I said sexy was part of my power, both onstage and off, and I was using every bit of it when I worked. And, it was working.

I got noticed. Got tons of work. I went from doing my first six-minute set after writing material and performing it at house parties for my friends for the better part of a year to performing that six minutes at open-mic nights around Manhattan. The first time it turned into twenty minutes, 'cause I killed.

Well, it turns out that I was pretty good at this. With winners like: "I'm a mom. All I do is stay home and get fat. I used to have

an exciting life—a job in the city . . . Now my job is checking the refrigerator every fifteen minutes to see if any new food has shown up." (Mime opening the fridge.) "Any Entenmann's yet? Nope? . . ." (Deep Sigh—mime closing fridge.) Giant Laugh.

I was middling[3] within four months of doing my first gig and did a national spot on *It's Showtime at the Apollo* within six. I was good at this. I was a natural-born hambone, first of all—and I really got off on making people laugh. I'm also wicked smart and picked up how to work a set, where to add tags, craft callbacks . . . the rule of three—it's not a suggestion! It's a Comedy Law! And I still shunned what I called the "Ubiquitous Big-Shoulder Girl Comic Blazer." They all wore them. As if to say, "I'm as funny as a dude. Just look at my dumb jacket!" I wore high heels and tight cocktail dresses and big ol' cleavage. And I rocked. I was often told—by men, usually—that although they "didn't usually like female comics,"[4] I was different because I "talked like a guy—but looked like a girl who could get laid whenever she wanted." Ahhh. I was home.

Here's the thing, though. Stand-up Comedy—especially road hell Stand-up Comedy—is a Big Ol' Boys Club if ever there was one. And the boys involved are, generally speaking, funny because they're twisted. Usually by their mother. And every woman after her, because she reminds them of their mother. It's the damage. Makes us funny. We found a way to turn pain into yucks. So the guys you hang with are self-loathing even as they're simultaneously having enormous, applause-fed egos. Being a woman in

3. By "middling" I mean I performed in the "middle" between opener and headliner. Not that I was "kinda sorta OK."

4. Or "comediennnnnes"—we hate that word. Almost as much as "moist."

that atmosphere isn't easy. I mean, it's not hard work like . . . digging ditches or solving crimes, or anything. But it sucks to get hit on by a male comic who think it's a complement to say, "Hey. You're funny," kinda surprised. You always wanna go, "Yeah, thanks! The people standing and clapping and stomping their feet seemed to think so, too."

Men see themselves as the only judges of what CAN be funny, too. I can't tell you how many times I'd be in a writers' room when a woman pitches a joke that the other women laugh at and some guy in the room says, "That's not funny." Not "I don't get it," but "That's not funny." Never mind that the people who happen to have ovaries are doubled over said ovaries in laughter—no. If MEN don't get it, it's NOT FUNNY.

Meanwhile they think some stupid reference to some stupid sports announcer is HiLARious. I just go, "Well, I guess it's funny to them. I get that they're talking about something they're obsessed about. Like I am about Louboutins. I don't care about their horseshit and I don't expect them to care about mine." But I'd never tell them their shit isn't funny.

How starved for content would *America's Funniest Home Videos* be if we cut out all the Racked in the Nuts footage just 'cause half the population doesn't have balls? It'd be three babies falling asleep in their Cocoa Puffs followed by forty-three minutes of Tom Bergeron stretching his clever video lead-ins and audience patter.[5]

5. For the record, I do think it's extremely funny when people get racked in the nuts. Especially when the clip is set up by Tom Bergeron. I also like the Three Stooges. How much lost footage of Stooges getting racked in the nuts must there be? Whoop, whoop, whoop! Hey! Moe! Those are my nuts!

When I was working the clubs, booking my own gigs and all that, I was often told by a club owner,[6] "Sorry, honey, but we already got a woman on the show." I can guarantee you that no male comic EVER heard, "Sorry, dude. We already got a guy on the show." How many comedy shows have you seen that could be billed as "Three White Guys Talking About Their Dicks and Things That Have to Do with Their Dicks?"

So I don't know why, when I showed up in Hollywood, I wasn't more prepared for entrenched "No Gurls Allowed" attitudes. The glass ceiling had been broken, after all! It was a new age—there was Sherry Lansing and . . . Sherry Lansing! I guess I thought that all the stories you hear about the TV and movie industry that feeds on dumb, desperate ex-prom queens leaping onto casting couches or diving under executive desks . . . was—at the very least—slightly exaggerated. Turns out . . . not.

I continued to be the funny (and, by now, over-the-top trampy, halter-top-wearing-sexy) girl who DIDN'T bone the guys I worked for or with. I mean sure—in later years, after my marriage ended, there was the odd drunken blow job or two. And they became legendary. But I never got a gig by trading sex for it. Stupid. What was I thinking? If I'd been fucking my way to the top, I'd be there by now.

6. The same greasy dudes who would later try to pay me gig money in a back room by holding out cash and simultaneously trying to stick one hand down my tits and the other up my skirt. To this day I'm not sure how this was done without mirrors or a trapdoor. I always got rebooked, though.

Chapter 7

MY CAREER: GETTING IN—AND OUT—OF SHAPE FOR WORK

Abrief rundown of my TV and movie résumé, wherein I get to simultaneously share my most intimate stories of self-loathing and shamelessly name-drop at every opportunity: I tend to connect the memorable moments of my career with the friends I made, and kept, during that job—and how fat or skinny I had to be in order to get and keep said job. They don't hire me 'cause I look like Katherine Heigl.[1] However, sometimes a snacky shape helps. Conversely, it sometimes keeps me from getting gigs as well. I've had to gain weight for a few gigs. But mostly they wanted me to lose—or at least it was implied by the fact that the job came with either a mandatory trainer or very small pants I had to fit into.

The FOX Show
My Wildest Dreams
Starting stats: 5'3"/130 lbs.
Ending stats: 5'4"/119 lbs.[2]

1. Or Kate Hudson. Or Katie Holmes. Or Cat Deeley, Kat Von D, or Katy Perry. None of 'em. If you're any kind of Katherine, you're safe having me next to you. I'm like a really funny accessory. I make you look good but never detract from your fabulousness.

2. Yes, I started to lie about my height at the start of my "show biz" career. I always wanted to be taller and I figured this would be a good time to start the rumor. Everyone thought I was at least five-foot-six anyway 'cause I'm always in heels so who cares. The weight loss was less from the rigid diet and training sked the studio insisted on and more from the all-booze/no-food diet I adopted the minute I moved to L.A. You know, fancy parties, stress . . . alcoholism . . . whatevs.

I was yanked from the stage at *Catch a Rising Star* by Scott Simons, who ran Columbia Television—which became Columbia/Tri-Star, run by Jon Feltheimer—which is now Sony Pictures TV. I don't know who runs that. But Feltheimer—or "Feltzy" as I liked to call him when I was young and dumb enough to get away with it—runs Lionsgate. The whole thing.

I don't claim complete credit for that—but many people I worked with went on to run studios and networks. And every child I worked with went on to a big movie career. Again, I'm not claiming complete ownership of their successes. But an occasional card would be nice.

Anyway, my very first job came as a result of the success of a few stand-ups that had TV shows built around their "voice." Since the basis of my act was also the basis of my life—that of a harried and stressed working mother who balanced career, family, and relationship—I guess they figured that I probably reflected that of many women (and families) in America. I agreed with them. The fact that I wasn't perfect was a big part of being "relatable" to the female audience. *Relatable* is a term they use in Hollywood to denote chicks who are not Angelina Jolie. In other words, someone who wouldn't threaten women too much—but who your average guy would still want to bang. Me, Leah Remini . . . Then they want you to take your relatable, perfectly nice-looking body and sex it up in two-day photo shoots with Davis Factor (pics!), hair by Ken Paves, and body by must-have trainer du jour. Oh, and Adderall, human growth hormone . . . whatever works.

Then they all complain because you're cranky. Go figure. I remember the phone call I got about fantastically gifted Margaret Cho when she was shooting her ABC pilot. Janeane Garafolo, who

I adored and was a kind and helpful comedy friend when I first moved to L.A., called and told me that Margaret was super-bummed out because she was being told by her network that she should lose weight. Let me tell you something you might not know about actresses: We want to please. We want to make people like us and hire us—and comics want everyone to love them. Desperately. It's like a comic disease. So with her brand-new network's approval on the line—of course she wanted to make them happy.

Now, Margaret is famously Korean and her face was not going to get any less round through diet and exercise. Margaret—as always—was ahead of her time. Asian is so in now. But really only skinny, nonthreatening, fetishized Asian—so she'd still probably be boned according to network standards.[3] I didn't understand why they wanted her to lose weight! I mean, I'm not a dolt. I know—TV, it adds ten pounds, all of that . . . But she was funny! Janeane Garafolo was funny . . . Why were they being forced to be Uma Thurman? Uma Thurman was Uma Thurman. If we all looked like them . . . wouldn't we stop being "relatable"? But in the meantime, lots of time and attention and money was being thrown at me looking cute. And as a girl who spent a lifetime prancing past store windows and hitting red-carpet-style looks every chance I got,[4] I wasn't hating that!

3. "Network Standards" reflect more than what curse words you can say past family hour. They also dictate who's desirable to them as "The Lead Girl." (Answer? Super Skinny Blondes, Super Skinny Asians, or Curvy Latinas. All twenty-eight years old.) Margaret has detailed this experience in her work, and it's awesome. I'm a huge fan.

4. My mother would eventually notice I wasn't walking next to her, turn around and catch me, and come back to yank my hand, yelling, "Why are you always POSING!!" Answer: Practice!

And I got to go to the gym on the Sony lot and go on a treadmill next to Chevy Chase. And get assigned a personal trainer. Who always wanted me to "run in the hills" since my rental house was in the Hollywood Hills. Lemme tell ya something. I never ran in the hills while I was doing that show. Not once. I hate running. And I'm not a fan of hills. So running in the hills is a lose-lose for me. It hurts my knees and it hurts my tits. And it weakens the muscles that support my tits. And while I never got a job based on my ass being in perfect shape—my perfect tits have landed quite a few gigs. And I'm not guessing. I am basing that on specific producers telling me that.

I also got the first in a series of trainers who got fresh—some to the point of downright molestation.

My girlfriend Nora says that I have a history of being "a victim of my own provocative beauty," as Hardy wrote about Tess of the D'Urbervilles. Which, I think, means that if you joke about your tits and giving oral long enough, a guy's gonna get an idea. So while we were spending time running my reluctant, still-drinking-heavily self up and down stairs, I never would've guessed that these trainers were attracted to me. I didn't think of myself as attractive. Sexy? Maybe. I always figured that while I wasn't a beauty, I looked like a fun ride. And maybe they thought so, too, because more often than not, the trainer I was assigned eventually wound up diving between my legs while they were "rubbing me down" after a workout. Once I had to go from kicking one of these dudes head out from my crotchall area right into a table read for my ABC show.

So I don't have a great track record with trainers and I think I'll stick to dancing, where molestation is mutual and rhythmic. Or more rhythmic, anyway.

Eddie
Starting stats: Still 5'4"/127 lbs.
(I started to cook and eat after FOX series ended.)
Ending stats: 5'4"/115 lbs. Skin-tight wardrobe. 'Nuff said.

I did my first feature, the Whoopi Goldberg basketball movie, *Eddie*—where the funny friend was actually the over-the-top slutty one. In which I spend every lunchtime waiting on Dennis Farina and a bunch of really tall guys who think it's cute that I just get them more steak but never actually eat anything myself. Because I'm crammed into skin-tight mini-dresses and too-small red patent-leather Casadei pumps. I found them at Macy's and had to have them for the character, not realizing that I'd have to spend three days outside of Madison Square Garden walking in those things. I wound up looking like a tired tranny hooker that Whoopi's character took pity on. She'd done a movie or twenty, and she looked at my five-inch stiletto heels[5] when I rolled up to set, all smiling and pleased with myself, and gave me that Whoopi fish eye and stuck her Birkenstock'ed foot out at me. "Mm-hmm." That was it, in that Whoopi way. Boy did I know what she meant after twelve hours on a New York sidewalk. But I still liked being a trampy tart as long as it was next to Whoopi. That happens on occasion for the secondary female role—she gets to act like she bangs everything that moves. The part is similar to the fat funny friend, but the wardrobe is better.

Life's Work
Starting stats: 5'4"/120 lbs.
Ending stats: Drunk and puffy.

5. This is my go-to "crash diet" equation: Great Big Shoes + Great Big Hair = Smaller-Looking Butt. It's like an optical illusion. I highly recommend—as volumizing hair product and Jess Simpson platforms are so much cheaper and easier than the stress and expense of healthy nutrition and exercise.

This was my ABC sitcom. It ran one pretty great season. It followed Roseanne in her final year on air. And since her show was what inspired me to want to do a program that represented all of the experiences that the "Have It All," overwhelmed moms of my generation were having—I was thrilled that we were right behind her on Tuesday night. We got great ratings. Like ones that any network would kill to have these days. Like top ten or twenty every week. Number one in our time slot. Pretty darn cool. Especially since I co-created it with the very talented writer Warren Bell.

It was also a very, very difficult and painful time for me. That happened to be the year that my husband told me he was also interested in men. There was so much intrigue and betrayal and drama that surrounded my experience within that production that even though we had awesome ratings, I honestly sabotaged myself with excessive drinking. I was self-medicating my fears—the fact that my husband had just come out to me and people drive a big wedge between you and the people closest to you to gain more power when you're wheeling and dealing in big-time network TV.

Sure, NOW I know! But then I was not operating in top form. And I truly regret not getting to enjoy and appreciate the awesome experience as much as I could.[6]

The Parent Trap
Starting Stats: Fat
Ending Stats: Fatter[7]

6. Does this count as an "amends"...? Sigh. I thought not.... OK, I have calls to make.

7. A few months before filming started I quit drinking. And discovered Marie Callender's pie.

This is probably the character and movie that I'm best known for. And I couldn't be happier about that. There isn't a day that goes by without someone recognizing me—and instantly feeling like they know and like me—from that movie. I'm so very grateful for the experience, for meeting so many wonderful people on that movie. Many of whom are still a big part of my life. Elaine Hendrix, who played the mean girlfriend—we started a conversation the first day on location at dinner that has turned into a lifelong friendship. I am still good friends with Simon Kunz, who played the butler—and my love interest! Yay, I got one in a movie! And Natasha Richardson was a feisty, funny, and effortlessly elegant dame with a mischievous nature. A true Brit, she never missed an opportunity to make a wry, intelligent comment. And a nice lady on top of it. Tragic and wasteful, her passing.

And Lindsay was a delight and will, no doubt, come through the challenges that she's learning and living through with her soul intact and a depth and maturity that comes from experience. I know, because I was similarly troubled and I finally learned to be able to tell who and what was good for me—and who and what wasn't. So will she. She's just in a much bigger fishbowl and we shouldn't judge. Like I always say, we all have been Lindsay at some point in our life—we just didn't have people fighting to photograph it. Who here didn't chase someone down recklessly in their car? OK, maybe just me—but I'm not going to be the first to throw stones.

And Dennis Quaid . . . oh, my, my, my. God in heaven what a sexy man. The best acting job I ever did was pretending not to be drooling over him 24/7. He was very kind and supportive, and when I shot the scene where the one twin tells me she's the other twin—over three days and seventy-three takes . . . it was very

draining. Because I was reliving the experience of having to go on the road to do stand-up when my baby, Delia, was tiny. And it was really difficult. At one point, I was just sitting in a chair not sure if anything I was doing was working, we'd tried it so many ways— Nancy Meyers is a stunningly great director, in my opinion—and she got a version of how I'd auditioned with the scene, but much, much better. And on the way, we tried every version and variation of how that scene could be played. I was convinced I couldn't act by the end of the second day. That's when Dennis came over to the armchair I was slumped in, put his hands down on the arms on either side of me, leaned close to my face, and said, "I think you're doing a magnificent job." Magnificent. That's what he said. Dennis Quaid. Are you kidding?

Here's another great Dennis Quaid story: One day in the makeup trailer I was having a particularly tough time looking at my face. See, I was supposed to be the sort of sisterly, kind of slumpy housekeeper/nanny—and, as these movies go (and life, really), I couldn't be that cute because that would confuse the audience as to just what the heck was going on in that house with the widow and his young daughter. And I wasn't in top shape when I booked that gig anyway—in fact, my agents had warned me to wear really unattractive clothes and no makeup to the audition. So I did, I put my hair in a ponytail, put on a pair of my then-eleven-year-old son's frumpy, wide-legged, hit-me-just-at-my-ankle jeans, and got the job. I'd be in the hair and makeup trailer at 4 A.M. for two hours of "works" to look not made up at all. I was tired. And I felt ugly. And fat. I'd spent my entire life up to that point convincing myself that if I was heavy, no one would like me, desire me, think I was worthy. From the very first fat girl who was brought to Weight Watchers to this point I'd built up evidence that Fat Lisa was virtually unlovable. So it scared the crap out of me. Weird

thing? I am probably best liked for this part of all the others in my career.[8]

Actually I wound up feeling a lot happier in this comfy wardrobe than I'd ever felt in any production to date. I wanted to write Whoopi and tell her she was right when she showed me her Birkenstocks and said I should never be wearing anything else. They *were* freeing. And I was free to be just warm and nurturing and not get all jumbled up with trying to overcompensate for not feeling like I'd be loved if I wasn't offering sex. Getting to that understanding wasn't so easy, though.

One day in the trailer when I'd been warned not to try to sneak any extra coats of mascara on—in fact my lovely makeup lady, Karen Blynder, had banned me from self-snarking in her presence; she'd even call me in the evening and check to make sure I hadn't said any negative comments about myself since leaving set—isn't that cute?— anyway, I was staring at myself in the makeup mirror at seven in the morning, a little teary and self-loathing, and Dennis had been stand- ing behind me and I didn't know it. This very aware and lovely man stood behind me, put his hands on my arms from behind, looked over my shoulder into the mirror in front of us, and said, "Darlin', if you looked as cute as you do in real life—everyone would say, 'Why doesn't he just look in the kitchen . . . ?'"

Would kill for that man.

Emeril
Starting stats: 5'5" (Higher heels all the time.)
Ending stats: 5'4" (Blew my knee out jitterbugging with Carrie Preston.)[9]
Weight throughout: Size 2. And hungry.

8. Thank you, Nancy Meyers and Charles Shyer. Just for the record. Thank you.

9. Emeril came to my house for a big dinner party that night. He had two giant plates of my lasagna, meatballs, and sausage. I said I was a good cook!

This cast and the executives behind the show were one of the most loving, supportive, and fun groups I've ever had the pleasure of working with. Not only did I get to work with a good friend, Sherri Shepherd—but my friend Tara Karsian became a recurring character and everyone else became like family. From the top—Linda Bloodworth-Thomason and Harry Thomason—down to all of the actors. It was a good "recipe." Har.

Sherri Shepherd Shopping Trip and Crash Cooking Course

Sherri and I go back. Way back. I first met Sherri when I was the MC for the big gala show of a charity event called Swing for Life, a celebrity tennis and golf benefit for very worthy children's groups in Tucson, AZ. It was my third year at this event and I loved going and had a bunch of friends there.

In fact it was there that I met my second husband, the twins' dad, the one who ultimately was the man behind the "perfect storm" of betrayal-based self-loathing that led to my "having enough" and eventually . . . the impetus behind the idea for *Dance Your Ass Off*. So, thank you, "G"! Not for boning the babysitter in my bed while I was off working to pay the mortgage. (You say "Bitter," I say "I didn't pop outta the womb this way, fucker! Men helped"!) No! I thank him for making me so fed up with the way I tried to make myself into someone that he would love, cellulite-free ass and all, that I knew I had to get up out of that series of eighteen-hour sleep days and take care of myself, my kids, and my wounded heart. And *Dance* was the answer.

But I digress. Back to Sherri . . .

I hosted the big event, headlined by none other than Rick Springfield and showcasing a lot of extremely talented—and, at the time, unknown—comics. Sherri was one of them and she was full of sass and lighthearted self-deprecating humor and I just adored her immediately. After her set when she handed the mic off to me, I remember saying, "Wow, usually I'm the biggest rack on a stand-up stage—but she makes me look like a BOY." Yup, Sherri has giant ones. And they're no fun for her.

We continued our relationship throughout the years, talking on the phone and seeing each other occasionally at comedy gigs. When I got back from living in Vancouver for six months where I moved to shoot a great show called *Breaking News* when the twins were three weeks old (that's another story for another time . . .), Sherri and I were cast together as the producing folks behind Emeril Lagasse in his sitcom, *Emeril*.

As I said, this show was an experience of unbelievable warmth and friendship, with talented and supportive people. It was also Robert Urich's last show. Though only Em and the creators, Linda and Harry Thomason, knew it, Robert was experiencing a recurrence of cancer. He would occasionally take a little nap on set and say, "These anticancer meds are kicking my ass . . . I'll be happy when I stop taking them." He was—seriously—the definition of *trouper*.

I've had the great good fortune of working with some of the biggest stars in Hollywood: Whoopi Goldberg, Tom Cruise, Jim Carrey and Jen Aniston, Dennis Quaid and Natasha Richardson, Richard Gere and Jennifer Lopez, Katie Heigl and Ashton Kutcher—and every single one was a hard worker with a great attitude. (Again, another story for another day.)

But Urich was a sex symbol with HISTORY. Robert Urich was a Good Guy and he said something to me once that stuck with me to this day, but I want to finish the Sherri Shepherd story first. I'll get to the Bob Urich Changes My Life moment later.

Emeril (who is without a doubt the nicest man in the world and his wife, Alden, is a peach of a gal) is also a world-class chef. There was something before "Bam!" and the marketing hype—it's more than pots and pans and seasoning salt—this sonofabitch can cook. This was seriously the best food on any set in the history of man. Forget "craft services"—we're not talking hard-boiled eggs and an industrial-sized bucket of Twizzlers—there was a full, restaurant-grade kitchen built right behind our main set. The aromas coming out of it would stop production. Sherri and I could barely work. Sometimes our knees would buckle. Let's put it this way: if there were Smellavision—we'd still be on the air. Now, try being an actress who has to fit into a size-2 wardrobe around all that.

Sherri used to stop for fast food on the way home from work (this was before she knew she had diabetic tendencies). It was not a happy time for Miss Shepherd's body. She was tired of lugging her chest around. Seriously, it's like carrying a six-year-old in your bra—she wanted to lose a few. Why she asked me about good nutrition, I don't know. When I had a tiny wardrobe to fit into, I just didn't eat. I drank and smoked. That's not a good idea. But I do actually know what to do. I just wasn't DOING it at the time. But for some reason—probably because I'm a blowhard—people think I know a lot of stuff.

Sherri said, "Girl, what are you doing that you're so slim?" I said, "Ummmm . . . I don't eat?" She said, "I see you eat, girl, but you eat the vegetables and salad and whatnot." "Yes. That's right. I eat vegetables and salad and lean meat. And occasionally whatnot.

[If *whatnot* means lots of wine, vodka, and cigarettes instead of food.][10] And nothing after work hours."

"Well, I want to do that but I get hungry at night, then I stop at the drive-thru." "Why don't you just make something healthy at home?" I asked. "Girl, I can't be doing all that, I'm tiiiired!" (For the N.Y. upfronts for *Emeril*, I dragged Sherri all the way downtown to see my family's old neighborhood in Little Italy, got pizza on Houston Street, then brought her through Chinatown and tried to make her walk back up to our hotel—the Four Seasons—on 57th Street. She made me get a cab at 23rd Street. Her feet hurt.)[11]

"Plus, I can't cook." Oh. Well. I knew I could fix THAT. So I told Sherri that the way I made the working mom/cooking healthy thing happen was to cook all the good-for-me stuff on Sunday night and put it in plastic containers to be ready for the week so I wouldn't get starving and grab the chips—I could just pop the Chicken with Asian Veggies into the microwave. This led to a plan where I would (a) take Sherri to Costco and get a big-ass box of different-sized Tupperware and (b) bring her back to my house and show her how to make three or four different healthy meals.

First of all, shopping with Sherri Shepherd at Costco is just exactly how you think it would be. What you see on *The View* is what you get.

10. For those of you playing the at-home version of Celebrity (Adjacent) Intervention—I was sober for over two years until 1999 when I started dating the cheater ex-husband. He didn't like that I couldn't control my drinking. That meant I was weak. So I better not identify as a drunk—or he wouldn't love me. So he actually encouraged me to "just have a little." OK, bonus round! How many "just a littles" did it take to go back to "a lot"? Ding ding ding! That's right, contestants! Three! I claim full responsibility for making this dumb choice—not his fault. Mine.

11. She never let me forget it, either. All throughout production. What I loved hearing most when she moved to New York to do *The View,* was that she was biking through Manhattan—even hauling the bike onto the subway. Just . . . Wow.

Anyway, we had a blast marauding our way through the wide aisles at Costco. Causing trouble, knocking shit over. I was trying to teach her as we went through the store what she should buy, reading the labels and warning her off of the "hydrogenated palm oil," while she was harassing the sample ladies. You know—fun!

We got her a giant box of multisize food-storage units (in my house we just call them old ricotta containers) and we lugged it back to my place—the predivorce one with the giant kitchen that I lived in so much that people called my position behind the giant "island" my "station."

I laid out all the stuff we got:

- ✦ *Boneless, skinless chicken breast and flank steak*
- ✦ *Veggies of all kinds*
- ✦ *Brown rice*
- ✦ *Cans of tomatoes*
- ✦ *Giant box of oatmeal*
- ✦ *Salad makings*
- ✦ *Ground beef/turkey for meatloaf*

I then proceeded to cook the Asian Chicken with Veggies, the Oatmeal Breakfast Cookies, the Brown Rice and Steak Salad, and the Meatloaf—while Sherri sat at the island and played with my kids and gossiped with me and my friends and didn't pay one bit of attention.

Then she loaded up the food into the Costco containers and went home.

I think I got took.

But not really, because Sherri prayed over me when I really wanted the job in *Shall We Dance* and when I was in deep depression over my breakup—so I think we're even, 'cause that stuff works. When Sherri Shepherd prays over you, you stay prayed over.

Now, for the Bob Urich Changes My Life moment.

In one of episode of *Emeril*, Burt Reynolds came to guest-star. (OK, I'm going to fully admit to bringing this part up just so I can brag about the fact that The Bandit said I was hot.[12]) Burt Reynolds said that I had a figure that wouldn't quit. And I'm going to go right ahead and assume that he meant that he thought it was sexy and not that it was substantial enough to keep working past the regular business day. Oh. Also Tony Randall said I was built "like a brick shit-house." Right on camera. On *Fox After Breakfast*. Ask Tom Bergeron, he was there. We 'bout died. . . . Oh, and Quaid called me "Chesty" instead of "Chessy." .. . OK, I'm done. For now. When I feel needy and body self-loathing, I'll brag some more. Anyway . . .

Burt and Bob Urich were old friends. In fact, Burt brought Bob Urich out to Hollywood originally, and they told stories for hours about how they were just playboys for a bunch of the old Hollywood dames. I lapped it up like a kitten with a bowl of cream. Robert Urich, as I said before, was a Good Guy. Here's how Bob Urich Changed My Life.

One day while we were shooting, my ex-husband (the one with the babysitter) came to set and was standing off to the side being judge-y and not nice, and I kept shooting him looks and was not

12. My wardrobe that day was a bebe (how do pronounce that, anyway?) red and black houndstooth micro-miniskirt SUIT, with over-the-knee suede, stiletto boots. As if the red and black houndstooth suit wasn't enough!

my usual gregarious, happy self. He had just discovered cigarettes in my dressing room—I am an addictive person and used smoking to not put food into my mouth, as my biggest fear was that he wouldn't love me or have sex with me if I was fat. I'm not sure why I believed that, except that he told me numerous times that that was, in fact, the case.

Anyway, not his fault that I was smoking—that was purely my decision, but I hid it from him 'cause he said it was lying to him and it was just the same as if he cheated. So in his crazy equation, if I smoked, he could screw around. At least, that was his threat. I didn't know that he had already made the jump to whoring around and was just working the math backwards. Don't think for a minute that I haven't figured out what a giant rationalization that was. But at the time, I loved him stupid. And made stupid choices because I did.[13]

So—he found the smokes and proceeded to light them all and leave them burning in my dressing room at CBS Radford—right above Ellen DeGeneres's dressing room by the way. If the place had gone up in flames, we wouldn't have Dance Fridays! When I went back to change and saw the mess, I knew he had gone through my stuff and found the cigs and he was furious.

I was called back to set and there he was standing there smiling at me—like Hannibal Lecter after he ate the liver with the fava beans—I was terrified. I was shaking and being uncharacteristically quiet. Bob came up to me and took the whole scene in silently for a minute. Then he said, "You know, my whole life I took care of everyone around me, in every way. Financially, emotionally, physically. It's a big job. Not many people can do it. You're just like me.

13. Don't you look at me like that—you know I'm not the only one.

I see you do it. You know what I wish for you? That you find some-
one who takes care of you. At the very least, I hope that you can take
care of yourself.".

Bob Urich—duly noted.

Bruce Almighty
Starting stats: 5'4"/123 lbs.
Ending stats: 5'4"/126 . . . 127 . . . ish?[14]

My totally cool and unbelievably talented friend Steve Oedekerk
wrote the screenplay for this movie and wrote a part with me in
mind as Jennifer Aniston's sister. That's gotta make a girl feel good,
huh?—that someone thought that I look enough like that gorgeous
chick to play her sis? Nice. And Steve is truly one of the funniest
dudes ever in the world. He wrote and starred in *Kung Pow: Enter
the Fist* for God's sake. And the residuals from *Bruce Almighty* were
the only thing supporting me when "G" left and didn't hardly pay
any child support for a few years. So good stuff all around. Plus
Jim Carrey is a really nice guy and Steve Carell saved a kid during
a windstorm from a giant, falling fake tree. It was kind of blessed,
that movie—for good reason, I think.

And there was Miss Aniston in the makeup trailer being "one of
us"—as my girlfriends and I say about someone who's real and
you'd trust: "She's one of us." She asked me one day on set, What's
a good recipe for making sausage? She was really into cooking and
wanted to make—seriously—*make* sausage. Like with a sausage

14. The wardrobe was still small—but I was the "sister who's a mom" character and
didn't have to be all that cute. I did have one pair of pants that I fatted myself out
for between wardrobe fittings and two months later when I wore them. I can still
feel the pain when I see the epic cameltoe I was sporting in that particular scene.
OK—go look for it—I'll wait.

maker and shit. I was like, "Who has time to make sausage? I have four kids that I'm wrangling and trying to force-feed a few veggies every once in a while. And a husband that's . . . er . . . difficult to please. [Is that a nice way of saying unbelievably critical? It is? OK, good.] I don't have any time to be cranking out sausage. I recommend Trader Joe's." I probably didn't say it that way, exactly. I probably mumbled, "I buy the premade stuff at T.J.'s" and then went back to twelve hours of wincing while I got my back walked on for the spa scene.[15]

Shall We Dance
Starting stats: 5'4"/123 lbs.
Ending stats: 5'4"
(For real. Dance improved my posture.)/162 lbs.

The most weight I put on—besides being pregnant with the twins—was in the movie *Shall We Dance,* where for the vision of the director—and also to be true to the original Japanese version—I was asked to put on the L.B.'s.

I was sooo excited when I got the call that I was going to be cast in that movie. In fact, I'd auditioned a month before and was stalking my agent about the part for weeks. Finally, my agent called and said that the director, Peter Chelsom, wanted to talk to me at three o'clock and I should make myself available. "Did I get the job?!" I squealed—the only reasonable question an actor has to their rep

15. It was twelve hours of a Japanese chick who didn't understand the English for "It's OK, you don't have to do it full out . . . No, really . . . Ow." If Aniston hadn't given me the heads' up to drink a lot of water to flush the poison floating around my lymph system, I would've died from excessive massage. See? "One of us." She probably took one look at my storebought-sausage-buying ass and figured I didn't have sense to do anything healthy.

every time they audition. "You have to talk to him first . . . it looks good."

I had auditioned for that movie for Richard Hicks, a phenomenal casting director who also happened to have gone to Catholic University while I was there. My manager talked me into going because he made the mistake of telling me that the director hadn't thought I was right, they were looking for someone "heavy." Now, I hate auditioning. Most actors do. We live for the day when the people who decide these things shift their perception of you to "offer only." That rarely happens to women over thirty-five because there's one job and eight hundred of us. It's not uncommon for me to be sitting in a waiting room to audition for a third lead in a TV show with Oscar winners. And I won't name names because I remember how embarrassed I was when it became clear to me that after starring in two network sitcoms that I'd co-created, I was back in the "No one gives a shit what you've done—what are you starring in now?" category. I was back to sitting on a folding chair in a cramped casting-office hallway and sweating it out with everyone else. It's really daunting when you realize that, for the rest of your career, you are going to have to fight it out with lots of really REALLY talented broads.

So on top of the usual audition-process trauma, this audition for *Shall We Dance* was made even worse because I knew that Casting was at best reluctant to see me because I was against the type that the director wanted. Plus it was hot, and I was getting yelled at the whole way there because according to my ex-husband, my "dumb audition" was screwing up the plans of getting to the Grove Shopping Center "on time." On time for what I don't know, because we weren't doing anything—but he had weird and wacky controlling behavior about . . . well . . . everything. Plus he was clearly looking to

build evidence against me to support his previously made decision to bang the aforementioned babysitter.[16]

So I did a fine job with the material, held everyone up for their audition because I was asked to do it a few more times—with great direction from Richard Hicks—and then I asked to make a direct address to the director (on the tape—he wasn't there) because I knew he didn't necessarily want me—so I figured, what the heck.

"Hi, Peter," said I, hoping to sound fun and confident. "I love this part, I AM this part. I loooove dancing and I love eating and I have a bigger ass than JLo." And I turned around and waggled it to prove the point. Winked at the camera and was done. I got back in the car with ex and the twins, got yelled at for the rest of the afternoon, went back home, and got into bed to continue the migraine-induced mega-napping I had been doing for over a month.

The next morning the phone rang so much I finally had to quit ignoring it and answer. It was my manager screaming, "WHERE ARE YOU!! YOU HAVE TO GO TO A CALLBACK WITH THE DIRECTOR RIGHT NOW!!" I was like, "Umm . . . that character is an over-the-top ballroom dancer, I need fake lashes and nails, a hairpiece . . . sequins . . . Give me twenty minutes." And I got to the audition. First. I was there for an hour, literally kissed the man's feet, and felt good about how I'd adjusted to his direction. Then I waited. On Thursday they told me that Miramax had seen my tape, I was a front-runner and had to go to a dance callback the next day. I told my agent to tell them I was out of town and they hadn't caught me—and I'd be available on Monday. I was warned

16. For those of you counting how many times I've mentioned this—better get out an abacus. It'll probably come up again. I'm Sicilian. I'm not a big believer in "forgive and forget."

I might miss out on the part. I said, "I don't care. I haven't taken a ballroom class since I taught them when I was seventeen and I'm going to spend the weekend studying." Which I did. Six, seven hours a day 'til Monday. When I nailed it. My quickstep audition was the same combination I had been practicing . . . hitch turn, lock, double lock passing turn, triple lock . . . even the runs! I had a huge smile on my face for the whole audition.

I was told months later, when I was practicing and on a "dance hold" (which meant I still wasn't guaranteed the job until they saw if I would really put on the weight . . . and if Richard Gere liked me. He did),[17] that the reason Harvey Weinstein liked me was because I looked like I was having the time of my life when I was dancing. Apparently he was looking at the tapes, saw my big cheesy smile, and said, "Stop. Why are you looking any further? That's the character. That's her. Look at her, she loves it." I did.

Anyway I had to eat over ten thousand calories a day to even maintain the weight because I had so many hours of dance rehearsal a day. It's not as much fun as you'd think, eating all day long. First I had to get over my natural inclination to feel guilty and like a bad person. Second, I already had a husband who hated me when I was fat. He said as much. He also said he wouldn't want to sleep with me if I was fat. He said he might occasionally, but if I gained even ten pounds he wouldn't be attracted to me. And here I was, purposefully gaining upwards of fifty. It was the role of my life, though—and I met wonderful people who are still my friends

17. When I met him I was beet red because I had to line my whole body up to his. Naughty bits to naughty bits. He was so cute and said, "Relax, you've got the job." I said, "I just can't believe I'm meeting An Officer and a Gigolo with the Ass That Ate Tokyo." He laughed and crinkled his eyes. I would kill for that man, too. Dennis Quaid and Richard Gere. There are others, but they're pretty good to start the list.

while doing it. Tony Dovolani, Charlotte Jorgensen . . . my main ballroom teachers—but there were many more. Nick Kosovich and Gary McDonald and so many talented people who spent a lifetime dedicated to such a beautiful discipline. This was before they all got so famous on *Dancing with the Stars*. They weren't paid big bucks. Tony hadn't even gotten the caps yet. He was lovely, though. And even though he made me cry almost every day, I loved my training with him. Because he was a perfectionist and I had to get not just good enough to be believable as an amateur, but good enough to lead myself so I wouldn't have to depend on Richard Gere—who was too big a star to have to be bothered with dragging me around the floor. Richard was exceptional, though. And really funny. He took care of me in many ways, including shooing off the big press crews that just happened to all be there the day we shot the scene where he rips the skirt off of my gigantic ass during the competition. Ben Affleck also chose that day to show up. Which I didn't know until I ran off crying during my first exit after the scene. Ran right by Ben Affleck there visiting Jennifer.

I went "back to one" and Richard saw me turning green and asked me if I was OK. "Yeah, fine. I have a little issue about my ass and I just showed it not only to you, but to Access Hollywood, *Entertainment Tonight,* and now Ben Affleck. Hey, why don't we see if Matt Damon and George Clooney are in town! They can come down for the viewing, too!" Richard said, "Hang on a second." He went away, talked for a minute to the producers, stuck his tongue in Nancy O'Dell's ear (well, probably not, but that's the story Nancy is telling), and came back to where I was standing: "They're all gone. They won't be back today. Don't worry. I took care of it."

Would kill for him!

So I had this incredible and unbelievably thrilling creative experience—and my husband was being soul-suckingly hateful.

Years later, when I looked back and told him, "I knew exactly when you started cheating—it was just before I did *Shall We Dance*. And it had nothing to do with me getting fat." He wanted to know how I knew, and I told him that he'd gotten mean. Recently he told me that when he saw me dance with Tony while he was there, he assumed I was sleeping with him on location. I said no, that's what a ballroom relationship looks like. The man's the boss. The woman follows, willingly led by the man. You have to trust him to protect you. It can be mistaken for romantic—and in fact in pro partners often turn out this way. "So," I told him, "I can see why you might think that, but no. He was always great to me—always made me feel great about my bouncy butt—he liked a girl with a big . . . um . . . figure . . . made me feel sexy. But I was with you. Of course I didn't sleep with him. I wish I had now, though."

War of the Worlds
Starting stats: 5'4"/119 lbs.
Ending stats: 5'4"/117 lbs. . . . with sparkly, bedazzled thongs

I was Tom Cruise's slutty friend who wasn't slutty enough to make it on the boat with him away from the aliens. I started out cast as a low-rent bartender that his character, Ray, supposedly messed around with after his night shift[18]—but right after it was shot, I guess they figured there were too many scenes setting up the action before action

18. Hence the blinged-out panties. My first on-camera from Tom's POV was bending over a cooler behind the bar, reaching for a brewski. That's what I wanted the half a billion people who saw this movie to see—what Tom Cruise saw—super-bouncy booty with rhinestones! Sadly . . . scene was cut. But I kept the drawers!

actually happened and that scene would probably be cut. I did get to hang out with him for one whole day of him kissing me up my arm and making me blush with that *Risky Business* smile and criminal charm. And Steven Spielberg wanted me to come back and shoot a different scene where my character runs into Tom's while trying to escape the aliens—so he asked me to bring one of my four kids I kept talking about with Tom. So I did. And I watched Tom be that real-live hero that he keeps turning out to be on his personal time. Not once, but twice.

First time—we had thousands of extras, mostly Hudson, NY, locals, doing the trying-to-get-on-the-ferry scene for five extremely cold, ice-storming nights along the Hudson River. When Tom was running in front of me and my daughter, Delia, we were flanked by lots of stunt people whose job it was to protect Tom from getting trampled. We were safe due to proximity—but many of the extras just had to trust each other, and some of that fear you see on the screen is real. Those extras in my scene are lots and lots of regular people running around ice-covered docks in the middle of winter. One college girl, home for Christmas, got claustrophobic and very terrified. When Tom saw what was going on, he got to her in a second, talked to her about school and her family, calmed her down—even though the A.D. was calling, "Back to one" (which means that we should start that part of the scene over, the cameras were ready to roll)—and stayed with her until she was completely calm and laughing.

I watched the whole exchange, and when he came back to us I said, "So that saving-people thing happens to you all the time, huh? That's not just in movies?" He just shrugged and did that Cruise grin.

I was doing a bit of my own shooting with a little handheld to

have for Delia's birthday, which was that week, and one of Tom's bodyguards saw me with it and came to take it. Tom intervened and said, "She's with me, man, don't worry." He also sang happy birthday to Delia on camera. Twice. Because he didn't like how it came out the first time.

The second time that Tom was a hero was when he and Dakota Fanning and Justin Chatwin, who played his kids and who DID make it on the ferry, were no longer in our shot. Delia and I get stuck behind a line of soldiers with big fat guns. Spielberg told me to really go for it—run at the line of soldiers. I told him that they better really not let me through, then, because if I were really running a red rover to save my kid—those tough guys were going down, because I'd get on the ferry. He believed me and so did the soldier-actors. But, having lost the phalanx of stunt people around us now that Tom was out of the shot, we were surrounded by extras who crushed in around us on "Action." We got almost through, and I was screaming and panicked and yelling and begging to just let my daughter through. "CUT!" yelled Steven. "Perfect, Lisa! That was perfect! Perfect take!!" That coming from Steven Spielberg over his megaphone from his little boat in the middle of the Hudson on that freezing cold night. I told him just afterwards that I could cut my therapy sessions back to only once a week having heard that from him. It was funny, but it was also said in front of Tom—not a great choice in retrospect, but how was I to know.[19]

Anyway, just after the shot, his D.P., Janusz Kaminski,[20] said, "Uh-oh." In the melee Delia had, apparently, gotten bumped in

19. I wasn't even IN therapy—it was just a joke. I may have even said, "I can cut my meds back." And Scientologists have a problem with psychiatry and an even bigger issue with "meds." I didn't know!!

20. Also adorable.

the nose and it was bleeding in the shot. They couldn't use it. Because, I guess, it was OK to assume our characters got sucked up by people-eating Martian machines, but it was too much to have a little girl's nose bleed first. That's actually really a truism in moviemaking: Spielberg knows what he's doing, it turns out. Anyway, Delia was bleeding away, head back, all of my tissues getting stuffed up her face, and they were taking a minute getting to us with ice and medical assistance. Scaling the giant ferry ramp, here comes Tom Cruise. Jeez, I wish my camera had been going then, but I was too busy stemming my daughter's nasal hemorrhage.

He came right over and said, "What's going on? Delia, wha'ja do? Lemme look at that . . ." And he tilted her head back and said, "Aw, that's not too bad. I broke my nose four times wrestling . . . Look," and he turned his head side to side to show her his still ridiculously handsome profile. By this time, I had the camera out and was rolling. "Yeah, I don't look too bad, do I?" He stayed with us and joked with her and made her feel better and hammed it up for my camera. How cool is he? I tell you what—you're nice to my kid? I love you forever.

Nip/Tuck and Drillbit Taylor
Starting and ending stats: Porn blond and mom-o-rexic

I got both jobs probably because I still had that porn blond hair extension slut-do and the newly mom-o-rexic divorce revenge figure.[21] My cleavage got those jobs. Although I did do a better series of fake orgasms in that Nip/Tuck episode than Meg Ryan could dream of doing. And the first cameraman assigned to shoot the multiorgasm scene coincidentally happened to be my very first

21. For the record, I do not recommend this diet plan. It comes with depression naps and "desperation neck"—i.e., Teri Hatcher at the low end of her weight swing.

boyfriend from back East, David. The first guy that seriously made out with me was shooting me groaning my way through three days' worth of scenes. On the best take the director shouted from behind the video monitors, "Perfect! That's the one! Check the gate!" From behind the camera David said, ". . . um . . . flag."[22] I said, "What d'ja do, David . . ."

"Um . . . bumped the camera."

"At what point did you bump it, David?"

"I think we all know when."

"Ah, come on—it's nothing you haven't seen before."

And this is why I love David—he said, "We've all seen it, Lis—it's all over the Internet."[23]

Aaaand, scene.

Killers
Starting stats: 5'4"/123 lbs.
Ending stats: 5'4"/115 lbs.—
but wish I could've eaten more fried chicken and biscuits

I had to be in size-2 Capri pants in a movie shot in Atlanta. A town famous for its food. This was the most self-control I've ever exhibited in my life. But how Tania McComas (makeup) and Sean Flanigan (hair) made me look . . . the best I've ever looked on film? Plus stunt-driving the Mustang and shooting at Ashton? Totally worth it.

The challenge of putting on weight for a movie—especially when you're not as famous as, say, Renee Zellweger—is that people in

22. Short for "flag on the play"—crew slang for "Something got effed up, we need a do-over."

23. Umm . . . it's not. He was joking. That's a different Lisa Ann.

this business like to pigeonhole you. So I looked larger and had a purposefully dowdy wardrobe in *The Parent Trap* . . . then people assumed that's what I always looked like. Once I was thin . . . I got called in for what I have always called the "ingenue's fat funny friend"[24] and was too skinny for that! Nancy Myers called me in to play one of Mel Gibson's secretaries in her movie *What Women Want,* and I'd just gotten done starving and exercising myself into a size 2 for pilot season. She had me do the part several times, then another part . . . Finally she let me read for the psychiatrist—a part that went to Bette Midler eventually. But while I was auditioning she held up a picture of me from *The Parent Trap* era and said, "That's what I wanted!" She meant it as a compliment, but I was just as unemployed. So it's really just a question of staying viable long enough to get so old that there's no body type connected to what "they" let you play. If you're too old for them to think anyone will even think about boning you—what you look like doesn't matter!

Through it all, I have been lucky enough to make lifelong friends all of whom have eaten holiday meals at my house because most actors are mooches who have dicey relationships with their families anyway. That's why they became actors. Damaged. So why go home for Thanksgiving when my food's better than a restaurant's . . . and most of their home-cooked stuff . . . could possibly be? Plus I have kids, which makes it homey—and my friends don't have to pay the airfare to Newark and fight holiday travel hell. So I have tables full of friends from high school all the way through people I just met on the most recent movie or TV show.

24. Rhoda Morgenstern is the prototype. But they're always there. Also known as the "female ear." As in: the chick who will show up when the romantic lead needs someone to bitch about how "INSUFFERABLE THAT MAN IS! . . . Sigh . . ." See also "Sassy Black Friends"—i.e., JackEE in *227.* And "Sassy Fruit-Fly Friend"—i.e., Karen in *Will and Grace.*

Chapter 8

ACTRESSES & THEIR SPECIAL BRAND OF CRAZY: WE'RE NOT INSANE—WE'RE JUST HUNGRY!

As Alec Baldwin's character, Jack Donaghy, says in *30 Rock*—"Actresses have to be ten pounds underweight or fifty pounds over. Anything else is just bad TV."[1]

Hollywood is a size-0 Town. Like it's something to brag about. Who came up with "Size 0" anyway? Who woke up one morning and said, "You know what I'd love to be? Nothing!"

Everyone's heard the horror stories of "crazy stars who SNAP!" People think actresses are crazy. They aren't crazy. They're hungry. Throw 'em a pot roast, watch 'em calm right down.

I have really beautiful friends. And not just because I live in "The Town Where Prom Queens Go to Die."[2] I've always had beautiful friends. I've never felt threatened by having gorgeous friends. In fact, even when I was a teenager and we'd all sneak downtown to D.C. to go dancing, I was the short, curvy girl flanked by a gang of supermodel-looking high school juniors. I didn't care. Because

1. Thank you, Tina Fey. And not just for that brilliant line.

2. Five seconds after they slap a crown on their head, every Prom Queen from every town in America gets on a bus and heads to L.A. to be an "actress." And since only four of them make it, the rest become dental hygienists and massage therapists and waitresses—completely screwing up the Bell Curve of Beauty for the rest of us non–Prom Queens.

I danced all night. You know why? Because when you walk into a club, everyone looks at the hottest girl to see how she reacts when a dude makes his play.

From all over the joint, every male eye watches the one guy brave enough to roll up to the hottie—to see if she's a "smiler" or a "bar bitch." If she turns the first guy down for the dance, no one else approaches her for the rest of the night. 'Cause no guy wants everyone watching his humiliation. And everyone will watch said hottie all night, make no mistake. Because they all are keeping tabs on her to see if her friends have done enough rounds of shooters to oil her up to the point of pulling a *Knocked Up*.[3] On the other hand, I dance with the first guy who asks, even if he resembles Gollum from *Lord of the Rings*. I ain't marrying the dude, it's a dance. And if guys all have seen you be nice to the crooked little troll, you vastly increase your chance of getting Viggo Mortensen interested in your "precious."

So I like all women—beauties included—and here in L.A., most of my new best friends are gorgeous actresses who I've met on different productions and have stayed friends with.

Some are people I talk to every day, have lived at my house after bad breakups, and come to my family events like Christmas and baby showers and graduations . . . even my kids' school shows—which just proves how much they love me. Like Elaine Hendrix, who was the sexy and flawlessly perfect young, hateful girlfriend from *The Parent Trap*. We met on our first day on location and talked for three hours straight during our first dinner. Which spilled into hanging in my room afterwards, taking crazy "trailer whore" photo

3. Based on the movie premise wherein Katherine Heigl enjoys vodka beverages and fucks Shrek.

shoots one bored day on set—which led to co-writing a movie and a true, lifelong friendship where we share all the things girls share. Including our basis for self-loathing.

The fact that anyone could look like her and not spend most hours of the day tolerantly watching the world around her with a mix of pity and superiority is kind of beyond me as she is exactly who I wanted to look like since, well . . . ever.

Turns out that like every other hot chick in L.A., and most of them in America, she hates on herself with as much passion as I do!

So here are a few of my friends, many of whom have enjoyed stardom, male (and female!) adoration, spreads in *Maxim,* and a lifetime of anonymous admiration. They have just as many self-loathing issues as you and I . . . and they're just as stupid.

Stars! They're just like us!

Elaine Hendrix

"What's my biggest physical issue? How WHITE I am. My skin just isn't white, it's translucent. It's one thing to be porcelain white, like Marilyn Monroe—like glowing. I'm so white, I'm see-through. Like you can see veins. Then there's the lovely shade of blue that it turns if the temperature drops below seventy. And the bruising and the freckles.

"Not a fan of my hair, either. And I love my legs because they let me be a good dancer, but they're somewhat long and gangly. And then there's also the whiteness of them.

"I think overall, my view of my looks is that I'm vanilla. Like, there's nothing necessarily wrong with vanilla. But usually people think

of it as something that you put stuff on. Like chocolate sauce. Or sprinkles. Vanilla makes good bases for things—but it's hardly ever special on its own. It needs something to make it sparkle. I'm good enough, but when you compare me to rocky road—I look dull. My boobs look OK 'til you compare me to, say, Penelope Cruz.

"My feet are flat when I compare them to the high arch of Catherine Zeta-Jones.

"My skin is OK until you compare me to someone with real porcelain skin, like Scarlett Johansson. Then I look vanilla. Plain.

"I don't have big full lips like Katherine Heigl. So I feel like I need something like that to be sprinkles on the vanilla—to make me special, to make me pop. And I'd love to have calves like Rosa Blasi. And hair like Angelina Jolie.

"I didn't have a date to my junior *or* senior proms—but yet I was voted Prom Queen my senior year. I think the problem is that we do any of this comparing. In fact you should put together a picture of all of the parts that we envy about each other. You can use my eyes and eyebrows, because I like those."

(For the record, not only I—but all of my friends and everyone in my family—think that Elaine Hendrix is one of the most stunningly beautiful women we have ever met or seen in movies.)

Karina Smirnoff

Karina is a Goddess. She's truly one of the sexiest women I've ever seen. I met her on the first day of dance rehearsals for *Shall We Dance* and have watched her with admiration as she became an adored and respected pro—tops in her field—on *Dancing with the Stars*. Karina has this to say about her "issues."

"I got a deviated septum fixed and then I was *furious* because they didn't reduce the rest of my nose, too. Then my 'team' kept pushing me (not that I didn't make the dumb choice myself) that it was "all about the lips." So I got that lovely "punched in the mouth" look that's all the rage. Then the balance between my nose and lips was all off and they looked too close together. This is how the madness begins, people." Luckily for the few hetero men who get harassed into watching *Dancing with the Stars* and enjoy the magnificent Eastern Beauty with all of her exotic glamour and sex appeal, she was either too smart or too Russian to go full Montag. She stopped when she noticed her face in a rag and thought, "That doesn't look like my face." And, good for her, she liked her original face enough to not want it to look like she took a hatchet to it. See—sometimes the tabloids work on the side of good, not evil! Original lips back in place, Karina has struck a balance of serenity with her labial/nasal ratio. And is still smoking-hot and engaged to a lovely pro-ball player. Maksim who?

Rosa Blasi

Rosa is truly one of the hottest girls I know out here in hot-land. And *Maxim* magazine agreed. She was, in fact, a "Maxim Girl." But the story of the photo shoot for the spread[4] is one of the best examples of out-of-control self-judgment and the havoc it can wreak. Particularly on one's digestive system if one takes a bunch of laxatives in order to flatten a "bloated" tummy. And when I say "bloated," I mean not concave to within a few inches of touching her spine. And when I say "bunch" of laxatives, I mean "shitload" 'cause

the first twelve didn't seem to work. "Shitload" in this case was not only descriptive but quantitative and prophetic as well. The girl positively painted the tiny bathroom in the swanky New York Loft slash Photo Studio. She maintains that the whole stompy, angry supermodel face was based entirely on stomach cramping.

Her "issue" has never been her weight, however. She has what she refers to as "Garage-Door Teeth." Fixing her teeth took two sets of braces and expander and a retainer and lasted longer than most Hollywood marriages. Certainly longer than mine or hers. She has an equally gorgeous sister who also needed braces, but not the

4. I can't be the only one who always felt that that term is redundant.

epic saga series of mouth hardware that she sported from fifteen to thirty-two.

The spreader was the most painful, and she says it was akin to medieval torture and hurt worse than childbirth—the standard to which all women compare pain. After procedures that spanned half of her life she still thought her teeth looked like garage doors that got stuck halfway up. One day on the set of her hit Lifetime drama, *Strong Medicine,* the fact that her teeth were still . . . ahem . . . prominent became glaringly clear. The show that week featured a child actor who was—according to everyone on set—obnoxious. The kid was what we call "smack face" in the biz. Like, so smart-alecky that everyone was annoyed. After a particularly fresh and hammy comment, Rosa turned to the crew and did the whole musical wind-up from the old Looney Tunes cartoons. The crew broke up laughing. And then karma came swinging back with hurricane force. Without missing a beat the kid said real slowly, and with a horrified expression, "Your teeth are HUUUUGE." Ahhh, kids. So honest.

Lea Thompson

Iconic, delightful, eternally young Lea. Lea is an incredibly gifted actress and crazy-talented singer . . . Also, turns out . . . really nice lady. Who spent a lot of years just as twisted up by self-doubt as the rest of us. Really, Lea? You were a teen queen, a pretty-faced, thin, adorable girl who represented the best of American young women . . . Yes, says she. Hated a bunch of stuff. She never liked her eyelids. Her eyelids. Uh-huh.·

I mean, it makes sense as a gal's getting a bit older to want to snip

a big bag of hanging skin off—especially if it gets in the way of a good camera shot or . . . being able to comfortably wear baseball caps—you know . . . really big. But Lea's "overhang"? Apparently has been bugging her since she was, like, twenty. The reason is that it reminded her of what her face was gonna look like when she started looking less like an ingenue who costars with the likes of Tom Cruise and Michael J. Fox and more like her mother. She sees the eye deal in her daughters, too. Three generations of self-loathing. Nothing like tradition!

Like many women, she also has always had a problem with one boob being bigger than the other. The fact that I had to ask which one indicates that it's not as serious an imbalance as she probably thought as a young lady whose job description included getting undressed in front of teams of people who are supposed to make you look delicious. She would often joke when working in productions that she needed at least three departments to create the right décolletage: Wardrobe, Makeup, and Special Effects. Now, I don't need to tell ya'll that most women have one bigger than the other, unless they've been rebooted by medical experts, AND that her perception of the problem was completely out of line with the problem itself. And she knows that now, too.

In fact one of the great things about getting a little older is that you get a better sense of yourself and feel a lot less inferior about most things. As Lea put it: "Your brain, as you get older, lets you

feel better about yourself because there aren't all those hormones in the way that create anxiety and disrupt your confidence. Both men and women gain more balance as they age. Men get more nurturing, they cry at movies . . . and women don't have as much estrogen, so they're a lot less freaked out by little things and more direct and focused . . . Estrogen is the enemy of self-confidence."

The fact that Lea has two teenage daughters who struggle through their own self-image issues has brought this sharply into focus. It saddens her that they waste a second of their vital and lovely youth worrying that they don't measure up . . . that they're not good enough: "I find it tragic that I was so self-conscious that I didn't get to enjoy how beautiful I was. It's so sad to think of all the time that's wasted."

Lea has a great understanding of that indefinable quality that makes for sexy. And it's not symmetrical boobs. "It's that sense of mischief. Sexuality and beauty are so reliant on that little twinkle in the eye—what you look like has almost nothing to do with it."

Don't you just love her? What a dame. Great sense of humor, and looks and acts younger every year. Back to the future indeed.

The point I'm making in this chapter is that everyone—you, me . . . these gorgeous ladies . . . all struggle with the same stupid habit of standing in front of the mirror and picking apart how awesome we are.

How twisted are we?

WHEN STARS JUMP THE SHARK

It's easy to call out celebrities who got a little knife-happy and now look like freaky fun-house versions of their former selves. You see it every day on the racks at the grocery checkout. But I'm too vain to be convinced I might not possibly wind up there myself someday.[1] So it's nicer (as well as more self-serving!) to just list the ladies who look great while still looking like them . . . only slightly older:

Susan Sarandon

Meryl Streep

Glenn Close

Jamie Lee Curtis

Goldie Hawn

Angela Bassett

Sally Field

Annette Bening

Helen Mirren

Emma Thompson

Most of the Brits do, in fact, look more like actual human beings after hitting forty. I guess they figure if they still got work with the original teeth—they must have enough talent to continue to be employed without going down the Joker look-alike route.

1. Although I have warned my family that if I ever start looking like a Batman villain, they're to put two in the back of my head.

Now, I'm going to go out on a limb here and posit the idea that the reason the above-mentioned women are still working has a lot to do with the fact that they look pretty normal. I mean, normal for very wealthy women who can afford the best skin care and trainers and nutritionists, and—yes—cosmetic procedures, of course. But, they don't look like 'aging blow-up dolls. They look like older versions of their younger selves. And fabulous.

I'd bet anybody a gazillion dollars that not one of these dames is a stranger to Botox or Juvéderm or laser facials or whatever "least invasive" forms of enhancement are available at any given time. I'll bet even more money that there is more than one nip and/or tuck amongst them. But they've been smart about it, and so we don't have to spend the first fifteen minutes of any movie they're in wondering, "What the hell did she do to her face? Her lips? Her hairline? Her breasts? Her cheekbones?" Or worse . . . "THAT'S So-and-So?! No way!"

I'm sure none of the actresses who oversurgeried had the goal of becoming unrecognizable. That's the opposite of their goal, in fact. It's much more a really scary illustration of how worthless we make grown-ass women out to be in our culture. Through media—the entertainment industry—we glorify young (and oftentimes stupid as well!) as being the only attractive quality in females.

Case in point: here's a trend that has taken over the country and I'll just come out and say:

IT NEEDS TO END. NOW.

Adult Women with Baby Voices

Seriously, this is an epidemic, and it better quit or someone's gonna wind up hurt. You can't have an adult conversation with somebody

who sounds like Hello Kitty. Or one of the Rugratz. Or Jennifer Tilly.[2] For instance—I never want to have this conversation again (baby voice girl on phone): "Hi . . . ummmm . . . Miss Walter? Tee-Hee . . . heeee. . . . This is Tiffany from Westbrook Laboratory? And your test results seem to be . . . umm . . . (tee-hee) anoma—anoma—anoma— . . . your cells are weeeeird? (barely audible baby whisper) We need you to come in for another ap-point-ment."

Really?

I'm like, "Yeah, Tiffany? Hon? Can I talk to a doctor? Or a nurse, perhaps? Or maybe your mommy? Because if we're discussing a possible cancer diagnosis, I need to talk to a freakin' grown-up!"[3]

It's gotta stop. Between the baby voice and the insistence on going bald eagle—we're gonna wind up creating a whole country full of pedophiles.

But being attractive to menfolk—nonthreatening—ever youthful and dumb—is probably why most of our most gorgeous women continue to mutilate themselves. And it starts here in Hollywood. The super-pulled-back surgery face becomes the norm when you live in a place where women are desperate to keep men attracted to them, creating incredibly unrealistic expectations.

There are A-list actresses who, I think, hit the skids partly because of some very questionable cosmetic procedures. I'm not going to name names because, well, I think it's mean and—full disclosure—

2. No offense to JTill—she baby-talked her way straight to the bank.

3. Listen, I'm not saying it doesn't come in handy. I'll admit I've been known to use it occasionally to get what I want. Like jewelry. Or a network deal. Or out of a speeding ticket. Cops like a little baby-talk sometimes. Not whining and excuses mind you . . . just a touch of helpless female. But use it carefully with the lady officers. Lesbian cops are onto your bullshit and they are not amused.

I still want to work and who knows when some of these girls will get it right again?

To everyone else—let this be a warning to you:

Be like Meryl. Not Montag.

Chapter 10

I'VE "HAD A LITTLE HELP" MYSELF

Now, in the interest of being completely honest—I'm going to go ahead and "confess" to what I've done along these lines. It's more than some and a lot less than others. My reasons for doing each and every one of them seemed very well founded and reasonable . . . at the time. Some even had health necessities attached—like the boob reconstruction and the deviated septum that prompted the nose job. I really had breathing issues. I had a lot of other issues, too. Way more prominent than the nose bump or fat lumps. It was called "self-loathing." And ain't no cannula that can *suck it out,* hypodermic needle that can *smooth it out,* or resurfacing laser that can *zap it out.*

It eventually just . . . *wears its welcome out.*

And in its place you get happy and sexy and confident. And you realize that if there's anyone who doesn't like you with your little flaws? They can *get the fuck out!*

First:

Nose Job

Yeah, I did my nose. I had a bump on it that caught the light and just bugged me when I looked at myself on camera. Now, I didn't go for somebody else's nose. I didn't go in and say give me the Megan Fox or the Taylor Swift. I said . . . I like my nose. I just want MY nose

to look good on camera. So, barely anybody ever noticed that I'd done my nose, because it really is still my nose—only a little better. I still get calls for "ethnics." (Can you believe in today's world they still use that term? But they do. Ethnics. Jesus on a Jet Ski! However, apparently I'm not "ethnic" enough to qualify for "women of color" roles—which happen to usually be the one part for a woman over the "age range" of thirty-five that I'm suited to play. You know, a "character" role. A smart, sassy dame who is large and in charge and doesn't take any shit from the lead male, but not the one that the white guys who write the show think anyone would confuse with the lead—i.e., the under-thirty white woman who the lead guy is supposed to want to bone. Got that? In other words if all TV is *Grey's Anatomy,* I'm always right for the Chandra Wilson part, not the Katie Heigl. Sadly, I'm not entirely black. Although I've gotten to the point where I'm so annoyed with the stupid rules regarding women and stereotypes that I've told my manager to start submitting me for "nonspecific ethnic" roles and if anyone says anything, he's to say I'm North African. (Wiki Sicily—I dare you to tell me different.)

Second:

Boob Job(s)

One thing they usually don't tell you about boob jobs besides the fact that you might very well lose nipple sensation is that almost everybody needs more than one. I've had three. Yeah, it sounds crazy, but after I explain, you'll understand better. My point is, it's not a simple thing—walk in, walk out with bigger (or firmer, or smaller) hooters. It's a fairly complicated operation and the outcome is far from certain. I'm not saying it's wrong (obviously), but it ain't no Swiss picnic either.

My first boob job was not really a typical boob job—so I'm not even counting it as one. There were no implants and no "lift." It was done in New Jersey by a "doctor" after my first two kids sucked the life out of them. This was when they were experimenting with "fat transfers." Taking the fat from where you don't want it and putting it where you do. Well, that sounded too good to be true! Turns out, it was. While it worked for about . . . oh, twenty minutes . . . the fat transferred to my breasts calcified—making it very difficult to get any kind of an accurate mammography. Since my mother had breast cancer when I was in college, I'm kinda sensitive to the whole cancer-screening deals. I'm high risk, already. I gotta be able to have an accurate mammogram.

After having to get four needle biopsies on "questionable" possible tumors, waiting over long, fretful weekends for the results—I was told I had to have the lumps removed so that they could actually see through them to my real live breast tissue to make sure I wasn't getting, you know, real live cancer. Also, one of the calcifications got huge—like the size of an orange and you could actually see the lump visibly in my breast, unless I hitched them up so high that I couldn't comfortably lower my chin.

So. That brings me to (actual) boob job no. 1. To correct the first (kinda) boob job no. 1 so that I could, once again, get mammograms that didn't look like an Etch A Sketch gone wrong. This procedure involved removing the calcified tissue from my breasts—yeah! Ouch!

Only problem was that although there was an oncologist removing lumps and a plastic surgeon putting new, scientifically engineered lumps in—there was still a snafu. It's not uncommon, you know. The Dr. said that it was sort of a mistake as he put the wrong implant in. And upside down, too. So one side went all hinky and

I had like a crease in my left breast. Within a month or so of that operation, he told me I had to have another (boob job no. 2) to take the "wrong" implant out and put a good one in. Not cool. Not cool at all. I was terribly self-conscious about it. So the switch was made—more anesthesia, and the drama that goes with it. Still had denty breast.

That leads me to boob job no. 3, in which, like Goldilocks, I got it Just Right.[1]

Was it worth it? Well, I wish I'd gone straight from kids sucking the life out of them to Good Boob Job, but that wasn't my journey. But for me, it's worth having nice breasts. I mean, take a look at the book jacket! Yeah. It was worth it.

Botox

Yes. I use Botox. It's a miracle drug. Or poison. Miracle Poison. Whatever, it works. I've got four kids! And work in a job that hates grown-up ladies! Leave me alone!

Juvéderm, Restylane, and Other Injectables

Yup, use them, too. And if they come up with anything else that makes me look cute and Dr. Raj Kanodia can stick into my face with his flying wizard wands of beauty—I'll use that, too! I don't care if it's called Egyptian Blue Fuckstick Gel and it comes in a Day-Glo bottle and costs a grand . . . if I look better on camera with them and I make my living on camera, they're part of my job and

1. Well, breast reconstruction specialist Dr. Nikolov got it right. I got a great rack. I mean I would do frontal nudity even if it didn't further the plot or even boost sales in Thailand. I'd do it merely for the "ex" factor. Revenge tits.

I'll use them. Dr. Raj is a GENIUS who does with the injectables what many people have to achieve with the knife. I'm so grateful to him because I want to stave off the knife as long as possible. He can poke me in the face for as long as it's a viable option.

Because he also believes in leaving his patients looking a lot like their actual selves and less like a walking advertisement for Beverly Hills–born desperation.[2] He actually refuses to erase the lines on my forehead completely, even when I get out of hand and ask for a "smoother" brow. Probably because he knows what type of roles I usually get hired to play and gets, as I told him when I first met him, that I'm a character actress and if I stop being able to make faces—I stop being able to write him checks that won't bounce.

He uses a bit here, a bit there, and fills out lines that are a little deeper than I'd like right now. One thing I DO NOT enhance with the injections are my lips. My lips are like my ass, all-natural and all mine. And now they're in style, bitches! See, just goes to show you . . . you live long enough . . . it all comes around . . .

I've done some radio-wave procedure called "Thermage" which was not cheap and did not work. Mostly because a friend of mine[3] did it and she looked great and I was in deep self-loathing mode postdivorce. So the conversation went down like this:

> ME: *You look great!*
> HER: *I got "Thermage."*
> ME: *I want it! What is it?*

2. Dr. Raj also did my rhinoplasty. He's THE nose guy to the stars. He won't do what he calls the "Beverly Hills postage stamp." I went to him way back—when he still did noses I could afford.

3. I won't say who 'cause I'm not outing people's "work." She knows who she is, though. And she's even hotter than when I met her fifteen years ago—so she's doing something right.

Do you see how that last sentence should really have been reversed? "What is it?" first . . . then if it was reasonably priced and *didn't* include using radio waves to burn the dermis layer so that it stimulates your skin to get the message to produce collagen in order to repair the burn—THEN and only then should that sentence be followed with "I want it."

I also got talked into an erbium "peel." Which was even more of the lasering off of my face. I'm talking giant scab-head. They used an anesthesia called Versed—which doesn't actually knock you out. It just makes you forget the pain as it happens. Supposedly. Except it didn't work. And I felt every bit of them lasering off my face. Except I couldn't tell them to stop. So in my Versed-addled brain, I thought I was in hell and that I couldn't make them stop, even though I was alive—and that this was going to be my experience forever: having my face burned off and being completely aware of the pain but unable to get anyone to realize that I was aware. For . . . ever. So I don't recommend that. Plus I was thirty. I didn't even have any wrinkles. What the hell was I doing letting someone talk me into burning my face off? That "doctor" got his license removed about six months after my procedure.

That was singularly the most painful thing I've ever had done besides childbirth. Well, the first two childbirths anyway. It was way more painful than the twins' birth. That was a piece of cake, comparatively—they only weighed about five pounds each and I had a whole *bunch* of drugs that were genuine anesthetics for that. Drugs that rock.

Let's see . . . what else . . . ? Umm . . . oh yeah! Upper blepharoplasty. That's an eye job. Best thing I ever did. Takes the extra skin out. "Opens" your eyes. Great for the camera. Recovery time is nil—in fact I went out to dinner that night and people asked me if I was

using new eyeliner. That was it. In fact, I'm making an appointment for another one in the morning! Thanks for reminding me! Other than that, the only reason I've ever gone under for anything was medical and I was ten. Three times. Stretching operation for my urethra to function right because I have three kidneys and I kept getting bladder infections before my hips spread to make room for all those organs. Yup, three functioning kidneys. Just in case.[4]

That was when they used ether. They held a mask over your face and made you count backwards and you saw a big spiral and knew you were losing consciousness. You woke up with a huge headache that you kept for weeks. It sucked on hot ice. And it was terrifying. You really felt like you were dying. It felt a lot like stories about "heading for the light." I've been terrified of both anesthesia and dying ever since. So I have to really be in emotional pain about something to agree to go under. Even then I struggle with the guilt of risking my life for vanity. Because, truth be told, I don't care more about my looks than I do about being here for my kids. The only reason I ever did any of this stuff was as I mentioned the fabulous combination of self-loathing coupled with a desire to remain employed.

Aaand I got electrolysis on my chin hair years ago. But I prefer tweezing them at stoplights for the bonus of humiliating the kids. (See chapter 5.)

I want to make it clear that I'm not so easily led that I can't draw the line. There are many surgical "enhancements" that are clearly so crazy—so designed to alter our appearance away from normal human person—that I'm absolutely positive I would never do them.

4. Jealous?

More than that—none of you should ever do them, either. Case in point. . . .

Labía Reductíon

Seriously? Cut off our lady-parts? But African genital mutilation is wrong, though; we're still agreed on that, right?

I mean, it's an erogenous zone! It's not just a flap God put there to keep ants out! It exists to feel good! That's its whole point. I mean, yeah, it also keeps out ants, but that's just an extra feature.

Who knew you could have too much of it . . . it's like a guy saying, "You know what, doc. I feel my balls are too big. Couldja trim 'em back just a tad?"[5]

So just 'cause some idiot teenage boys equated larger labia with old or slutty or something, you're coming after my lady-parts now? Hands off![6] Just for the record—I've had a matched set (big lips—top and bottom) since I was a teen and NEVER had any complaints. So the fifteen-year-old girl that my gyno told me came to her office wanting to cut stuff off 'cause it "didn't look right"—oh, darling girls . . . no. You all look just beautiful.

My most recent foray into the wonderful world of cosmetic alteration was last summer when I spent more money than I'd like to admit on a series of Zerona laser treatments to get rid of my cellulite. My mom saw this newfangled treatment machine advertised . . . er, I mean . . . *scientifically researched* . . . on the TV show *The Doctors*. She called me right away to tell me that she'd

5. Let's face it—balls are pretty fugly. But they have a purpose and guys like to brag about how big they are and for us to fondle them. They are, in fact, inflated labia!

6. I mean that figuratively, of course. In actuality—hands on!

seen this magical new device that was touted by the experts as being able to erase cellulite in a few months with a few reasonably priced laser treatments directed at the problem areas. Only trouble was that she couldn't recall the actual name of the laser, or who made it. Or the exact day she saw the episode. So researching this machine was difficult but I googled it like crazy, trolled the "Doctors" website for information, and finally, on a fluke, discovered that my friend Cori Abraham—a big cheese over at the Bravo network (now at Oxygen)—was good friends with Jesse of their show *Workout*, and he not only knew all about this machine but also knew the one doctor in all of Los Angeles who had the thing and was offering treatments.

Well, I called his friend (now a friend of mine, Kelly West—who is a doll and, as is usual in L.A., almost impossibly good-looking) and she was the one who did the treatments and she said, "Come on in!" in a delightful Arkansas accent. Well, if you knew how I felt about Bill Clinton, you'd understand why I was seduced immediately![7] We met and she told me the deal, we set a price and we arranged to do the treatments on alternate days for three weeks straight. Which was a huge time commitment for me but if the end result is that my thighs and butt stopped looking like satellite photos of the crater-y side of the surface of the moon—I'm in.

On the first visit, she handed me a bottle of niacin tablets along with some aspirin and told me I had to take one a day—preferably right after treatment—followed by a bunch of water. And that it might make me "flush." Also that I was to wear a compression garment whenever possible to help in flushing out the fat that the

7. I only met him once. No funny stuff. I'm just a fan—I swear, Hillary, I gave tons of money to your campaign! (She's in charge of the freaking State Department you all. Great, now my phone's gonna be tapped.)

laser was going to melt. Lots of water, niacin, compression tights in the middle of summer—got it. I resolved to follow all the directions to the letter, even the lymphatic massage once a week to help with "drainage" even though it was a two-hour commitment and I seriously didn't have the time. Looking back at what I just wrote, I'm trying hard to remember why losing the dimples in my butt-all region was so all-fired important to me. I mean, it's not like I'm a Vegas showgirl or *Sports Illustrated* swimsuit centerfold. Who cares if I'm lumpy? I mean, at least who cares four thousand dollars' and thirty hours of visits' worth.

Because, as it turns out, I also was supposed to get something called Accent, which is a type of laser, to further improve the appearance of my skin. I'm not sure if one worked better than the other. I'm not sure if they only worked in tandem with each other. I'm not sure if either one of them worked at all, quite frankly. I did see that there was a big improvement in the appearance of cellulite on my thighs and butt. Like at least 50 percent better. But that may have been directly related to the niacin, which turned me a lovely shade of hot pink every time I took it.

The first time I started to turn fluorescent fuchsia on the way home from the office, I called Kelly in a panic. "I'm red as a tomato! I blurted. "And I'm itching my skin off. And my heart's racing a mile a minute, too!!" She remained totally calm. "Yes, that happens sometimes. Remember I told you about the flushing? You need to drink ice water, it'll go away in a bit." "I know," I yelled. "'Flushing.' I heard you! But this is like I'm being eaten alive by fire ants! And I don't have any access to ice water, I'm on Coldwater Canyon. I have a Diet Pepsi! Would that help?" I was willing to dump it on my head while navigating the hills in a mad race towards home and icy relief.

She talked me off the cliff—literally—and I learned to not take the niacin until I got home from treatments. I also learned that while Accent treatments are *expensive* they don't seem to actually *do anything.* And that I'm way too busy to spend that kind of time hoping that the giant, science-fiction-looking, multiarmed laser thingy with the swirling red lights would do anything beyond give me an excuse to lie down for an hour in the middle of the day and provide a pretty light show while I made business calls on an examination table.

If someone comes up with a new magic treatment for cellulite while I still care what I look like naked, I'll probably try that, too. Or maybe cellulite will be one of those beauty standards that surprisingly become the next hot thing. Maybe everybody will want cheesy thighs in the future. Maybe when the world is running out of food. Or maybe just cows, so that people feel nostalgic for cheese in any form—then it'll be coveted. Then people will try to find things to increase the dimpling—to show them off to best advantage. Thigh-high slit skirts and thigh-crater rouge to accent the crevices. Who knows? Weirder things have happened.

SELF-LOATHING— IT TAKES A VILLAGE

We are our own worst enemy.

Chapter 11

"I'M OK—YOU NEED LIPO"

How many times a day do you pick apart a woman's appearance? Really?

OK, now go back and include yourself. Uh-huh. That's what I thought.

I'll admit it. I'll be the first to raise my hand. I mean, you're reading the book, you're onto me. You've seen me snark on Tyra and Prom Queens and Heidi Montag . . . oh, I haven't? Just wait two pages, I get there.

It's not that I think I'm better than anyone else, or that I don't like other women. I'm not a mean girl! I love women and I'm a great girlfriend. In fact, I am loyal to the same girlfriends I've had for decades and they're all beautiful, so it's not like I'm a nasty competitive bitch. I mean crazy loyal. Like as in: "A friend will help you move; a best friend will help you move an ex's body."[1] But, yeah, I can't seem to help the lookism[2] and snark, that is my birthright.

So why do we do this? Here it is: This is genetic. We aren't entirely at fault.

1. I have not actually helped move a body. Although I have planted Magnum-sized condoms in my girlfriend's nightstand when I knew her ex was sneaking in and making off with her stuff during their divorce.

2. Prejudice based solely on looks. As in, we tend to hire, admire, and desire tall, attractive people and distrust, dislike, and dismiss really fugly people. And don't even try to say you haven't ever done this. We all do. We're "lookists." Let's form a support group with steps and free coffee.

Let's go back in time and figure out where all of this gossipy, snarky judgment started. Because we all did it. Even when we were in kindergarten we took a look at the adorable pigtailed imp on the nap rug next to us, peeling glue off of her hand, and said, "Your shirt is stupid. Barney's for babies," and then took her Elmer's bottle for ourselves when she ran off crying, admiring our own, hip, Spice Girls T. Was that rush we felt only because of the glove of glue we successfully peeled off in one chunk? Or because the evil, inner Tim Gunn snark-demon that lives inside of all us got its first taste of fashion superiority. Methinks the latter.

The biological-imprint argument is basically this: that females were genetically suited to have babies and need the biggest, best, strongest male to bring the meat home to their young. In order to get the best and biggest (most able to help her and her children survive) she had to "get" him from the other females. By being the most sexually available, looking the healthiest (shiny hair, white teeth, most fertile figure).[3] In fact, we used to have periods of "heat" just like other animals. Times where we were more willing to receive male "attention" and it was less necessary for the males to chase us until we tripped over a rock in order to nail us.[4]

What happened was that the females with longer periods of "estrus"—heat—were more apt to make more babies as they were getting nailed more often. Until, as Darwinism dictates, the survival of the horniest won. And we still supposedly fight for the attention of the best, strongest males. These days, "strongest"

3. Meaning a ten-inch differential between waist and hips. That ideal still holds, by the way. They've spent our tax dollars confirming that the hourglass figure is the most desirable to males.

4. We still go "in heat" if you pay attention. That week before your period? Chocolate isn't the only thing you crave, lady. Not a coincidence that between ovulation and menstruation is the most fertile point in the cycle.

sometimes means most likely to set up a good 401(k). Sometimes it means being able to fix a leak under the sink. But the good ones are still pretty much fought over.

And some women will still snake whoever's in their way to get a good one. Supposedly, that's the basis for the biological predisposition for competitive, backbiting behavior in women. Also, culturally, overt competitiveness is not encouraged in women as much as men. We aren't normally as encouraged to scream and fight in group activities and be outwardly aggressive as much as boys. Team sports, working together—that's their everyday world. They can also flat-out tell each other the most heinous shit and still consider themselves friends. When a guy gets left by his girlfriend, his best friend will likely respond with "Well, if you could get your brokedy-broke ass to the gym once in a while, maybe she wouldn't have left you, you fat retard." We are more inclined to call the ex a douche bag and extol our gfs' virtues while mixing the mojitos and arranging for a group trip to Vegas or, at the very least, T.G.I. Friday's.

Very seldom are women encouraged to say what we actually think in this culture. At least, not to the face of the person we're thinking it about. We are, however, consumed with conveying details of how said person could improve herself if she were only smart enough to do everything you're currently whispering she should do to several people who will then relay that information back to her while stressing the fact that THEY don't feel this way . . . this is what YOU said. And that they really had her back the whole time and think YOU'RE crazy and probably jealous because she's had a way more successful career and much nicer tits than you could possibly ever dream of having. You know, for instance.

That's the biological rationale. I don't think this holds *entirely*

true—but we know that when guys get competitive over some chick, it usually ends in a bar fight and an appearance on *Judge Judy*. When girls fight, Judge Judy might be involved, possibly even a shirt-tearing YouTube episode. But it will usually be preceded by lots and lots of snarling gossip and rumor-mongering first.[5]

When we have a negative thought, rather than admitting that we might just be jealous of the attention some girl is getting, we launch right into outright bitchfest.

It's evident if you look at the first poor little girl who suddenly sprouts boobs in fifth grade. "She's such a slut" and similar comments follow this girl until, out of disgust and longing for retribution, she either just gives up and becomes a "slut" or puts on weight or hides behind books and big clothes to defend herself against the campaign of two-faced mean-spiritedness that has followed her since she was forced to trade her innocence for leers and innuendo.

I remember when it happened in my daughter's school. I was very interested in the rumors that had begun to circulate around her friend "E," and then I discovered that "E" had moved from training to professional brassiere apparatus. Suddenly it all made sense. That's when I introduced my daughter to feminism and how girls have the power to either elevate each other . . . or destroy. I encouraged her to try the former and share that info about how they were hating on their friend for nothing but the vagaries of hormones. She did. She enlightened her friends about the dangers of girl-on-girl snark attack. I'm so proud. And relieved, because she launched her own set of double-Ds not too long afterwards. Takes after her mother.

5. By the way, my money's always on Judge Judy. Don't let the lace collar fool you. Don't F with JJ. She's an animal.

The summer that I grew boobs was a monumental surprise to everyone—including me. I guess I hadn't even noticed that I'd gone from inflated pointy nipple status to actual breasts until the first assembly of tenth grade when, after a showing of an animated version of George Orwell's *Animal Farm,*[6] Joey Jordan yelled from the back of the house all the way up to where I sat in the two-thousand-seat auditorium, "Hey! Lisa! When'dja grow tits?" A pause. Then a laugh that grew and grew. I sat red-faced until my inner comedian/applause hog took over and I rose, stuck 'em out, and then bowed. Screams, laughter, a standing O. And so a sexy comic is born.

But the truth is that I also learned to equate my sexuality and body image with humor. Self-deprecating humor at that. If I could make jokes—make people laugh AT my body . . . the hot version or the former, fat-ass version—then I was in charge. It became quite clear, however, that people around me, the mean girls in high school—the boys who had just begun to notice my body . . . even the men who had started to yell rude things as they drove past my girlfriends and me walking home from school . . . they all had such a huge ability to affect how I felt about myself. We all learn to judge/value/hate ourselves based on how other people react to us. Often this self-view is firmly in place by high school.

If the super-cool girls complimented my outfit? "Oh. My. God. That shirt is soooo cuuuuute! Where'dja get it?! . . . Mandy's? Omigod—I HAVE to get one. Cute. Cute. Cute. That's the only thing I have to say about you. Cute"? That is good.

If a group of boys walked behind me in the hall? And there were no comments at all? But maybe some laughter? Not good. What are

6. This is before schools got shows like "D.A.R.E. on Ice." Or whatever our tax dollars are paying for these days.

they saying about me? It must be nasty. And not "good" nasty. Bad nasty. Something about my butt.[7]

If a dirty old man was driving past me as I walked home from the public pool? That was . . . mixed. There is big power that comes with being female. And when you discover that you have that power? It is awesome. And scary.

And we can use that power against each other. We can use it for good—or evil.

I have seen us wield our awesome GRRL POWER more often for good, I'm happy to say. I have been the recipient of some pretty powerful girlfriend love. I bet you have too.

My girlfriends are super supportive. Really. When I got dumped, my girlfriends took me out for some "You Don't Need Him, He Was an Asshole, Anyway" cocktails. They told me how beautiful I am and how I've got everything going for me. And how a really great guy wouldn't be bothered by the fact that I had four kids by two different dads running around that I was financially responsible for.[8] And they told me I didn't need him! I can take care of my own needs. OK, but I took care of my own needs for so long—I got carpal tunnel syndrome. If my shower massage had a dental plan, I would've married it.

The breakup ramped up like they do. Everyone saw it coming— including me—I just didn't want to admit it. He was unreachable on business trips. He never wanted to have sex. Let me rephrase: He never wanted to have sex *with me*.

7. Unless it was black or Latino guys. Then, no worries.

8. And other atrocious lies. That's how you know they're your friends. They make you believe that shit.

"Just tell me," I begged him.

"No, it's you. . . . You're crazy."[9]

Because that's what they say.

There were "incidents." Incidents involving Used Condoms and Tissues and DNA testing. Point is, he eventually left.

I literally couldn't eat for six months. Which is insanely helpful for that revenge diet, but not so helpful when you are raising four busy kids and need to occasionally get out of bed from your days' long depression naps.

Look, I don't want to start down the "all guys suck" road. Mind you, some do. As do some women. And ladies, we have to start taking responsibility for our choices because it has become apparent to me that, much as men suspected—we stay very interested in a guy when we're in what my girlfriend Nancy likes to call the "Dick Fog." This is when a guy keeps you *off balance* by being:

> **Unavailable** (cheater, married, asshole)
>
> **Addict** (gambler, boozer, meth-head asshole)
>
> **Arrogant Douchebag** (any guy who thinks he's
> too good for you)

It's my opinion, based on absolutely no scientific research whatsoever, that women have to feel slightly less powerful—*off balance*—in order to stay interested in banging a dude. And being interested in banging him is what keeps you in a position to tolerate how stupid

9. "My ex is crazy" is guy code for "I cheated and she found out." This is uniformly true. When your guy says his ex is crazy, do not EVER repeat this to your girlfriends and say, "No, really. It's true. I've heard stories. She is." No. She isn't. He cheated. She caught him. Period.

they act sometimes. For instance, the screaming at the TV during the Final Four.

Sometimes we get lucky and find a guy just naughty enough to be hot, but not enough to inspire felonious assault on your part. That particular combo usually shows up in movies starring George Clooney. In actual life . . . much rarer occurrence. So we pick assholes . . . and then we are stunned when they behave like assholes. No wonder guys are disgusted with trying to be nice to us.

But we recognize the signs of dick-ness pretty much immediately. If we miss any, our friends will certainly point them out when it becomes clear that we need a kick in the pants. We hear them, agree, decide we're "love addicts," and promptly check our phone for missed texts from said dickhead.

Girlfriends are your barometer for dickhead. Listen. Believe. Trust.

My girlfriend Nora was visiting one night when I was getting dressed up to go to my oldest son's high school theater performance. I worked super hard to look really pretty and had taken time on my hair and makeup . . . asking her which dress did she think looked sexier. By that time, it had been probably five months since my ex and I had sex. So it was always important for me to be pretty for him, just in case he might look at me and think that I might look cute. He came into the bedroom and walked right by me as I stood there expectantly turned toward him for any reaction. He left the room and I turned back to my makeup. Nora started crying. She said, "You know, Lisa. You look really pretty. And I shouldn't have to be the one to tell you that." And that was it. Powerful.

Coming back from the destruction of my self-esteem took awhile. But I did finally start to join the land of the living. I continued

dance class two to three times a week and got in awesome shape. Even after I started eating again. And I finally looked up to see a hot young dude who had been waiting for the minute he had a shot at me after the breakup. And he told me every day how gorgeous and talented and wonderful and sexy I am. And he can't keep his hands off me.

So when people say, "Wow. You look great! What are you doing? You must've lost a lot of weight!"

I say, "Nope. I'm just happy."

Amazing what can happen with a loving man in just five years and twenty thousand compliments.

Chapter 12

THE TRAUMA OF THE TWEEN-AGE GIRL

Every time we are verbally negative about ourselves, we send a message to our daughters—or the young women we influence—that they aren't OK just as they are. Having a teenage daughter myself, I have an awful lot of regret for negative things I said about my body in front of her. It is such a big responsibility and it has so much impact: how we teach our girls to feel about themselves is a direct result of how we view ourselves.

I wish I'd figured this stuff out years ago—but here's a partial list of no-no's:

+ *Don't stand up directly after enjoying your birthday cake and loudly announce that you're not touching cake again until you're over seventy and no one will ever, ever want to see you naked.*

+ *While doing yard work, don't wonder aloud whether sandpaper would be a good loofah for your thigh issue.*

+ *Don't scream at the mirror while trying on bathing suits at Target. Yes, we all know that fluorescent lights are the tool of the devil—but not only is your kid watching, so are the security cameras, and you look like a crazy person. And when I say you, I mean me.*

My serious point is that teenage girls—and much younger—are under more pressure than ever to be rock stars. Reality TV has inspired a generation of girls to expect themselves to look professionally awesome. And their ability to be accepting of anything less than Hot, Thin, Perfect . . . is seriously compromised. And they're getting harder and harder on themselves. I get it. I do. I'm just scared not only for my own daughter—but for all of these girls.

What follows are some exchanges with girls who've written to me about their body images. Seriously, if this shit doesn't break your heart . . . well, I don't' know what you're made of, but it isn't much heart.

. .

Dear Lisa,

Today I received the disheartening news that I was not cast for DYAO. I just wanted to take a minute and personally thank you. When I auditioned in NYC, I left my heart on the floor, and I know you recognized that. Getting that call back was a monumental moment in my life, as this entire journey and process has been. It was the first time, ever, I was viewed and judged by my talent, and personality, not my body. For a dancer, who has struggled their whole life with the concept of body image, this experience is priceless.

I am hurting very much inside, as I finally felt my time to shine was here. But everything happens for a reason.

From the bottom of my heart, I thank you Lisa Ann, for creating this show, and the opportunity for people to change their lives for the better.

With Warmest Regards

The ballerina from Boston

T. R.

. .

Dear T. R.,

Sweetheart. I want you to know that not only did I love you, your dance, your personality . . . but I also loved your body. Your beautiful, delightful, trained body that does such amazing things—lyrical, light, stunning.

You were, truly, one of my top two dancers of everyone we saw in the entire country.

I wish the decision were mine to finalize the cast—but it is up to the network execs (they very strangely didn't get to see the dance/chor footage, just the submission tapes and interviews). But, in the end—your struggle with your self-image was compelling and makes me hate your dance teachers. I think it was a question of you just not coming off very big . . . I know, I know—you have been struggling with 15, 20, now more than 40 pounds that you need to lose—but it isn't as apparent as some other applicants—that's all I can perceive as the issue. But here's the good news:

You're a dancer.

A pro level, gorgeous dancer.

And you should dance. And don't let one freaking person tell you you can't.

I get told no all the time. For this show, in fact. For 5 years. I didn't listen. I pitch shows and audition for roles and get told no,

133

"we need a name," "we don't think that'll sell" etc. Do it for you, even if you have to start your own dance class (maybe for other girls who've been urged towards eating disorders by heartless nasty prejudiced dance teachers?). I'm on your side—I adore you and I'm anxious to hear about your progress. You are part of this show. Your audition, your real one at the studio, will be on the show. I'll make sure of it. Everyone will see what you can do.

My love and support to you always,

Lisa Ann Walter

March 11 at 10:19 A.M.

...............................

Dearest Lisa,

I want you to know how very moved I was by you at the Chicago audition. You have a huge heart. I really heard you when you took me to the side and encouraged me to dance again. As a young dancer I put my body through so much trying to fit the mold but just being at your audition and feeling my soul dance again reminded me that I am here in this body to break the mold! My encounter at the audition and with you has inspired me to revisit dreams of acting, dancing ... and maybe even modeling :) I guess it all depends on the size of the cahones I am growing. LOL. I am back in dance class now and although I didn't make it on the show this season, I will be dancing my ass off here at home. Thank you for being an inspiration! I plan to meet you again—next time on a set somewhere!

D. C.

. .

Dear Lisa,

I'm not sure if you remember me or not, I talked to you on here quite a while ago about my weight and the struggles I'm facing. I'm 17 and I weigh 125 pounds. I absolutely hate my body, I hate the way I look, I'm disgusted with myself, I don't like looking in the mirror. As hard as I try to be positive when I look into it . . . I just can't. I'm obsessed with getting on the scale . . . and I obsess over that number all day and all night. I have had bouts with bulimia . . . and I have tried starving myself until I binge because my body just CAN'T function anymore. I got down to 115 and just couldn't do it anymore and I HAD to eat. I just had to. Then I gained it all back with a snap of my finger. I don't know where my willpower went? It's so hard for me to eat healthy when I see all of my friends eating whatever they want to eat. I get jealous when I hear people give other girls compliments about how skinny they are. I WANT to be that girl that everyone wants to be. Lisa, I won't be happy until I'm the weight I want to be . . . and I just CAN'T stick with it. I'm not sure what to eat to ensure that I'll lose the weight. I'm calorie obsessed . . . and the more calories I take in the worse I feel about myself. That's why it was easier for me to just not eat at all or to throw it back up because then I wouldn't have to worry about it. I want a healthy diet I can STICK with . . . and when I see my friends eating that big juicy cheeseburger and fries . . . I just don't want to sit there depressed saying that I could be eating that right now if I wanted to. I watched Dance Your Ass Off, and I became a really big fan. When I saw how hard they were working to just become healthy I thought . . . ya know . . . maybe I can do it . . . if I just try. But it's easier said then done . . . and when you don't have that motivation it makes it 10 x's harder. I do work out . . . and when I

don't see results I stop. I feel like it's wasting my time when I don't see myself changing. I know it takes longer than a week to start seeing results . . . But I just don't know if I'll EVER get there. I just need some wise words of advice right now, because I truly don't have anyone I can talk to about this. It's just tough, especially being in high school.

Thank you SO much for your time.

Sincerely,

K. F.

March 23 at 9:58 P.M.

. .

Dear K. F.,

I am going to write you a nice long reply to your very open and honest letter—I'm under a deadline at work, so this is just a quick response because I know how hard it is to be so revealing and it's scary. I understand the heartbreak you're going through on every single level. Your self-loathing and body-image issues, your food/ weight obsession and the way you starve then binge—all of it. America does a terrible thing to its young women—especially the average high school girl is faced with an almost impossible ideal that they're told they should meet or else they're worthless. You should know a few things:

—That ideal is a physical impossibility. Stick-thin with giant boobs is only achieved through very expensive plastic surgery. And usually with cocaine or meth use.

—Your idea of what is a beautiful body will change as you grow

136

older and get a better idea of what is desirable. The body that you say is congratulated where you live is probably only the envy of other girls.

—And I'll write you more about this one later. Stop starving yourself. It doesn't work—your body will always get the message that it needs to be stuffed and it is exactly what is creating your obsession with food. When your body is starving it cannot think of anything else except food going into it. You also wreck your metabolism and therefore the next bite of food that you put into your mouth makes you blow up like a balloon. Eating good food regularly and doing a physical activity that you enjoy—regularly is the only "secret"—diets don't ever, ever work. EVER. I only have one thing to say if you ever doubt me, think back on this and believe . . . Oprah.

Or Kirstie Alley—if anyone has access to the best and most up to date, expensive treatments, equipment, trainers, etc.—it's those two. Doesn't work.

Here's what works—accept your body. It's beautiful, healthy and I bet it's real cute. What's wrong is only your confidence. That's it. It's a quantum physics thing—when you feel good about yourself, you look good.

I created the show Dance Your Ass Off just exactly to deal with the problems you're facing. Please do take comfort and inspiration from the fact that there are many, many people who have gone through what you have—they are picking up what the message in my show is all about—Just be the best version of you.

Best and we'll talk more,

Lisa Ann

• •

Dear Lisa Ann,

You made some good points that I DO understand . . . It's just hard to take it in and believe it all at once. I mean I realize that I shouldn't be binging and starving . . . I know it's bad for me, and I'm telling you the truth when I say I haven't done it for about a month and a half. But I have noticed that my eating habits have changed . . . not for the better but for the worse. I just feel like when I'm eating, I have to go overboard because I'm thinking "oh . . . this is my last meal before I starve." Knowing I'm not going to starve myself . . . but I think it's so that I don't feel bad when I overeat. I don't understand why I feel SO guilty after I eat a meal. I feel horrible about myself. I don't enjoy eating . . . I don't deserve to. I know I shouldn't be striving for perfection because no one is perfect . . . but I can't help to think what I would feel like if I were super thin. Obviously I have a very negative mindset right now. It's weird though . . . because other people think I'm a very confident person and I carry myself well . . . but deep inside I'm hurting. I don't know if I can accept my body . . . it just doesn't seem realistic to me to ever accept it until I'm tiny. Maybe things will get better . . . I don't know.

It is hard for me to talk about. I'm always telling my mom that I want to lose weight . . . and of course she says "You're already skinny." But she's my mom . . . she's not gonna tell me I'm fat. I don't think she'll understand exactly what I'm dealing with because she eats and eats and doesn't care about being "healthy." I mean, she eats vegetables and fruits and she's not overweight or anything . . . but she just doesn't get how I'm feeling. I'm very excited for your book. I think it'd really open my eyes if I were to go hear you speak. I just wish things were easier for me. Sometimes I don't even feel

like getting up in the morning. I set goals . . . and then I break them. And then I start all over again.

I know you're busy so if you don't respond right away, I'll understand! I'm just glad you're here to listen.

Thank you for the amazing advice. I'm trying to take it in, I promise.

K. F.

We have to adjust our attitudes. Our young women shouldn't be in this much pain

Chapter 13

WOMEN AS COLLABORATORS & BEHAVIOR MODIFICATION RUBBER BAND—FREE GIFT!

Every time we body-snark, we drink the "Hate-Ade." We're like the Vichy French.[1]

We are our own worst enemies. So, why not be our own best friends? Why not treat strangers like you would your best friend or your sister?

Instead of making fun of the poor girl with toilet paper stuck to her high heel, stomp on it for her so she's free of it. She'll thank you. Just like she'll thank you when you point out she's got lipstick or lettuce on her teeth. That's a huge girl-to-girl contract. Or at least it should be. More important than rolling up on complete strangers to yank a tag or tuck in those oh-so-convenient hanger straps. Pointing out crap on another girl's teeth should be mandatory chick behavior. It should be in the manual.

You know how you work so hard to get your makeup just right for that expensive second dinner date. You're working that super-hot Dior lipstick that matches your super-hot dress. The dude is a definite "candidate." For *what* remains to be seen. Marriage? Possibly. Getting partially nude by midnight? Definitely.

1. See, during WWII the Vichy French were in cahoots with the Germans and . . . oh forget it.

You've been laughing and smiling and not burping in the middle of sentences. All great dating behavior guaranteed to make this guy raise his gaze from your rack occasionally and entertain the idea of taking you to Maui on his next vacation. And you're vibing him right back . . . The waitress is giving you a thumbs-up by her third visit with a wink behind the dude's back that lets you know that she'd jump on him in the parking lot if you hadn't seen him first. And then you go to the ladies' room and realize that you've had a big honking piece of spinach riding your incisor like a farmer on a John Deere tractor. And that super-hot Dior lipstick has spread out like it's trying to escape your face. No one in the joint did the universal sign for "Check your lips, honey." Unless that's what the waitress was trying to do with the thumbs-up—but she didn't say anything, did she? She let you giggle your way through your meal looking like a roughage-grazing Crusty the Clown. So not cool.

The manual should also include ladies'-room etiquette that all of us should live by. One should always compliment another girl's shoes while standing at the sink. Particularly if she's crying. If she's barefoot, a simple "Loved your last album, Britney" will do. You should also give the courtesy check for skirts stuck up inside tights, pantyhose, or undies. Drunk girls should always be offered wet paper towels. Verbal warnings regarding lack of toilet paper should be accompanied by an airline-hostess-style direction as to where one can find an alternative. "I used the seat liner" is always good. Or, "I have an extra Handi Wipe in my purse, but be careful—it stings"—also acceptable.

Loving each other isn't just a nice idea, it's necessary. We have enough help from the world letting us know all the many and varied ways we fall short. We should have each other's back at least.

It's not hard to do. First, start loving yourself a little bit—the rest will follow.

Here are some tips for a little self-love:[2]

Don't get on the scale if you're feeling fat. Why do that to yourself? Just resolve to eat better, move more, and weigh when you're not bloated. Or if you absolutely have to? Like the doctor won't take your word for it anymore? Just do what I call "Creative Weight Calibration." That's factoring actual body mass against everything else that's on—or in—you.

We all know the obvious ones: Shoes weigh a pound . . . clothes— duh. You figure out how much your poop must weigh, if you didn't go to the potty first. Of course you have, who hasn't? I'm just saying—take that a step further. Are you wearing self-tanner? Hair you bought at the mall? Think it through. If it's actual *matter*, it has a number value that shouldn't be counted as your ass. Your ear holes aren't pulling *themselves* down, you know. Those ghetto hoops are heavy! False eyelashes? Acrylic nails? How many fillings you got? And are they old-school metal? When was the last time you waxed? It all counts! And silicone weighs more than saline by the by—count it in! I bet you hit your goal weight before you climb onto that scale.

Don't buy clothes that are a tad too small, thinking you're going to lose that weight and they won't be tight anymore. It never works that way, and you'll feel compelled to wear what you bought and— instead of looking thinner—you'll look heavier because you're kind of busting out of your jeans. Unless the entire garment is con-

2. Not the kind that requires batteries.

structed out of Spanx. Spanx are miraculous. They should have an altar at St. Patrick's Cathedral.[3]

Change your hair and makeup at least every few years. We all know that girl who's still wearing the same hair and makeup she wore in high school. And it doesn't matter if that means you're looking like Farrah or Pat Benatar or Uma Thurman in *Pulp Fiction*—it's time to change it up, OK? Unless it's Miley Cyrus—then you've got a couple of months, anyway. But bringing the best version of you into the here and now is just plain common sense. Otherwise one day you're gonna wake up with a beehive and baby-blue eye shadow. Lose the shag, Mrs. Brady!

Make it a point to find positive things about yourself BEFORE you start the negative. Even if all you see at first is something you don't like . . . don't say it out loud. Wait until you find something you like . . . an earlobe, even—and say, "Hey. That's a pretty snacky earlobe, ain't it?"

Believe me, this takes practice. We're all trained to find the flaws first—in just about everything. So, to help remind you to stop the hate and spread the love, I'm including your very own Behavior Modification Rubber Band in every copy of this book.[4] Now, since almost all the colors have been used for various awareness campaigns already, how about rubber band colored? Why should the rubber band hate itself for what it is? What's wrong with yellowish beige, right? So just grab a normal, everyday, perfectly decent and

3. However, Spanx also weigh something. Quarter pound at least.

4. Not really. Yours isn't lost, quit looking for it. It's just a concept. Go back up and keep reading, it's actual psychology techniques used by actual professional psychologists and television "life coaches." So you know it's good. And a session with one of them would cost you at least four times the price of this book—so, again . . . look how you're saving.

helpful rubber band. Go ahead, I'll wait. It's in the drawer in the kitchen where you keep the take-out menus and keys that have no use whatsoever but you've never thrown out "just in case." Got it? OK, good.

Now, take your rubber band and slip it around your wrist. Every time you snark on someone—snap the rubber band against your wrist. Every time you snark on yourself—do it twice. That's no fun, is it? It takes a little extra effort to spin our critique towards the positive rather than the negative. Picking out the stuff in the mirror that bums us out is our first instinct. So when you notice that you're doing it . . . QUIT IT! Dial it back. Stop yourself midthought. When you're in "Jeez, what's up with my pores?!" mode . . . just— Back. Away. From. The. Magnifying. Mirror.

There. Now doesn't your whole face look a lot better? I mean, besides the red, blotchy portion of your nose that you were recently squeezing? Just make a point to—as soon as you notice that you're doing it—stop the self-snark and lay on the love.

"Wow, how could I have missed this cute chin dimple all these years? That is one adorable face. I bet there are tons of people who've wanted to lick that little spot but never had the nerve. You better work, chinny-chin-chin, work!"[5]

5. Obviously this is just suggested inner dialogue. Your personal soliloquy is entirely your creation. May I suggest at least one item on your top half—and one on your bottom. Just to break in the new habit—then branch out to the really obscure: "Nice incisors! You could be in the *Twilight* movie with those things! They're fangtastic!!"

HOW TABLOIDS SELL MAGAZINES—SPINNING HATE INTO PROFIT

Here's the deal: We love celebrities. Movie stars. Divas. Idols. Love to watch them and copy their styles and live vicariously through their hotness. Even more than that, however . . . we love to judge them and watch them fail in giant, delirious, public train wrecks. Then we feel superior and totally OK with our normal, nondesigner lives!

Think about how you feel when you're standing at the grocery check-out counter. You're harried and hectic and already pissed at yourself for succumbing to the two-for-one deal on Keebler cookies 'cause you didn't need to eat one bag, much less two.

Then you come face-to-face with the great equalizer: the *National Enquirer* (or *Us Weekly, Weekly World News* . . . whichever has more photos of "Stars Without Makeup!!"). And your life gets instantly brighter, better . . . saner by comparison.

Kirstie's too fat, Tori's too skinny!

How about this, *Star* magazine? Give us the five-pound window of what's OK with you.

And I say give "us" the window of what's acceptable because I am one of "us." Not one of "them." So I am allowed to be just as judge-y and superior as I want in order to feel good about myself!

Because even though I've been lucky enough to appear in great movies—in close proximity to International Megastars—I'm not a movie star. I'm what I like to call "Celebrity Adjacent." I don't have a movie-star face. I have more of a "Hey, did you go to Pacoima High?" kind of face. People look at me, they know me, but they don't know where they know me from. "Aren't you friends with Yolanda?" That's the face I've got. "How do I know yooouuu? Were you at Shaniqua's baby shower?" That sorta comment is my normal "fan reaction."

If I do get recognized, it's never when I want to be. If I'm in L.A. and I'm standing at Spago, very snacky in my knockoff Prada bag and shoes—that's not when I get recognized. Oh, no. It's always when I'm at Target, wearing skanky gym clothes, while I'm tucking my expired coupons behind a Tupperware display. Usually, I'm having a cell-phone fight with my mother: "I don't know why Laura always busts your balls, Ma. Maybe it's because you're annoying!"

THAT'S when someone will come up to me. . . .

"Hey I know your voice."

And I'm like, **"Oh yeah. I get that a lot. My voice is kinda familiar."**

"Why do I know your voice?"

"Umm . . . well . . . Do you have kids? Maybe you know me from *The Parent Trap*."

"That's not it. Do you shop at Ralph's in Studio City a lot?"

"Not really. Uh . . . *Shall We Dance? Bruce Almighty*?"

So, now I'm reciting my résumé, like a complete loser, in the middle of the Clearance Housewares aisle.

But this is what happens when you're "celebrity-esque." And I claim that status . . . quasi-proudly! I've got one foot on the red carpet and the other at Costco.

I know it's true because I spend a lot of time googling myself. I google myself all the time. I like to google myself. I've googled myself at premieres and charity events. I've googled myself alone AND with friends. I once stayed up until five in the morning googling myself "naked."[1] I've googled myself for so long I've got carpal tunnel syndrome. I don't care! I've googled myself silly! That's how I know I'm not a star.

You're a celebrity when you know your DUI will at least make VH1's *Awesomely Bad Bad Girls*. But I don't have to worry, 'cause I'm "celebrity-*ish*." Which means that when my oh-so-private, for-my-eyes-only, homemade video sex-ploits "accidentally" get leaked onto YouTube—nobody gives a good googa-mooga. Nobody cares at all. (*Lisa Goes to Tijuana*, check it out. I'm close to a dozen hits. And climbing! I do this fabulous trick with a donkey!)[2]

So my sex tape is never going to get me into the tabloids. But I will admit . . . I read the tabloids. And part of me feels terribly guilty about it. The Catholic part, probably. The other, rumor-obsessed, gossip-mongering part laps it up like a supermodel with an

1. Nothing came up, btw. There were tons of entries under "Lisa Ann Walter—Boobs," however. Also "cleavage."

2. I'm sorry, burro; they prefer *burro* south of the border—but who doesn't? Oh, and this is a complete fabrication. But look at how I'm trending now that you even thought I had a sex tape! Awesome! I mean, sad . . . that's very, very sad.

8 ball. I guess I have a love-slash-wait a minute . . . what is Paula Abdul[3] wearing now?-slash-hate relationship with all the celebrity rags. Just picking one up can cause mood swings of epic proportions. Say it's . . . Angelina "Homewrecker" Jolie on the cover. Well, I'm fine with any story that foretells the doom of her relationship with Brad.[4] Just because she collects kids like baseball cards and looks smokin' hot in a sari surrounded by orphans, we're supposed to forget the fact that she took somebody else's man before that someone else was done with him. I guess it's the Sicilian in me, but I forget nothing.

But what if the cover is, say . . . "Celebrity Cellulite"? Well, I LOVE to play Guess Whose Ass This Is as much as the next gal. You know the cover. Just paparazzi, digital zooms of some poor star's cheesy butt . . . I know it's wrong. I know I need rehab for it. But I can't help it. I'm just happy it isn't mine.

But then I realize . . . that's exactly the cover story I'll land when I go from Celebrity Adjacent™[5] to legitimate celeb. When I quit having to list my résumé for paparazzi on the red carpet and moms in the Tupperware aisle at Target . . . without a DOUBT I'll be in the "Worst Beach Bodies" edition—not the "Best Beach Bodies"—even though I have a pretty slammin' body and can still fill out a bikini quite nicely. But I'm not PERFECT. And that's what the Best Beach Bodies are—that rare bird of physical perfection. Matthew McConaughey, Hugh Jackman, Cameron Diaz, and Jessica Biel. They're perfect. I'd be on the page with the always adorable, probably premenstrual, slightly bloated Jennifer Love

3. She really does believe there's no such thing as too many ruffles, doesn't she?

4. IMO, his days are numbered with her. According to my friend Kate, her next husband will be a teeny-tiny Tibetan monk. And Brad will never see it coming.

5. I'm bedazzling the licensed T-shirts already, so don't even think about it.

Hewitt or perfectly lovely Mariah Carey—but in this case shot at an unfortunate angle.[6]

That's my nightmare, anyway. In my dream, I'm flipping through *Us Weekly* and am confronted with a close-up of my ass (which I hate) rising up from a lawn chair so not only is my cellulite exposed for the world to see—but I'm also branded with the waffle pattern from the lattice weave on my cheap chaise longue. I wake up in a cold sweat and can't get back to sleep. Not to mention, I'm no longer looking forward to the frozen waffles I was gonna have for breakfast.

So, mostly I think . . . Why do they have to be so cruel? Why does Cindy Crawford have to keep looking like she did at the height of her model-ness? She did her job! She made us all feel slightly less beautiful for over a decade! And she was even temporarily married to my boyfriend, Richard Gere![7] Does she have to have smooth, velvety thighs, too? At fifty? And isn't it enough that Alec Baldwin is crazy talented and funny and someone I'd be totally thrilled to have in my bed (even if I had to be on top 'cause, you know, fear of being suffocated)? Are you expected to have a six-pack AND perfect comedy timing?

And there are life lessons in the tabloids, too. Fairy tales and the Brothers Grimm used to be our idea of storytelling—now we have cautionary tales brought to us by *People* magazine. Take Britney Spears. I lay off the Britney now; she's had enough trouble. But I

6. Like sitting up in a beach chair, therefore forming a few tummy rolls. You know they wait hours for that shot. If I were a star on vacation, I'd never reach for anything. I'd sit my ass in a lounge chair and stay there until the sun went down. Or have a really hot dude pick stuff up and hand it to me. OK, I've decided—I'm going with choice B.

7. Shh . . . It's a surprise. I'm waiting 'til next Valentine's Day to tell him.

think we all learned a lesson from Britney's experience—to wit: if before your first date with a fella he has to call home to ask permission from his pregnant wife and baby? You just might end up bald and in rehab.

It's a wonderful warning. So many of us make the same mistake with cheaters, and it's great to know that even the most gorgeous, rich, and famous of us are not immune to that classic trap of womanizers. The one where we convince ourselves, "I can change him. He hasn't had my perfect loving yet. It has magical powers. It will cure him from cheating. Its fairy princess rehabilitative vagina. With mystical healing energy and sparkly love dust." Uh-huh. You'll be crying to all your girlfriends and bulk-eating Oreos inside of six months. So the tabloids are really doing us a public service if you look at it that way.

And poor little Lindsay Lohan. As I said earlier, she's going to come out the other side, so let's all quit judging and acting like we never, ever *heard* of this behavior before. C'mon, we all know people like this. We went to school with people like this. Some of us have folks like this staying on our couch right now. . . . Lindsay has had a rough time and everyone's all shocked. At first she was just a teenager doing a little partying.

Thank God no one was paying any attention to us back in the day. Our parents were loaded and having key parties at Parents Without Partners meetings; they couldn't be bothered with us. Back then, you could buy beer in your cheerleading outfit.

"Six-pack of Meister Bräu, please."

"Oh yeah? Quick! When were you born?"

". . . uhhhh. . . ."

"Aw, never mind, cutie. You need any rolling papers?"

Now everyone is all surprised. Why? It's like getting mad at the Killer Whale from Sea World who kills the trainer. It's a Killer Whale. It told you what it was going do. It's not a Cranky Whale. It's not a Woke Up on the Wrong Side of the Bed Whale. KILLER Whale. As for Lindsay . . . it's a Lohan. It's Irish. It enjoys a cocktail. 'Nuff said. She'll come around. I firmly believe it.

And when Miss Linds is all calm and sober—then they'll have to go back to waiting for her to make a stomach roll while reaching for the sunscreen in a bikini. Or they'll just move on to another target. Maybe . . . one day—while snatching the Bubblicious outta my kids hands and putting it back on the "racks of temptation" at the checkout line—if I'm very, very lucky . . . I'll be in a big, hit TV show or movie and it'll be MY lumpy behind that makes me pick up the rag.

That'll be both a wonderful . . . and a terrible . . . day.

Chapter 15

THE "F" FACTOR

Stripper is the new business degree from Wharton!

When I was a kid, women didn't have to be both PTA presidents AND pole dancers.

All of a sudden, we all have to be "do-able." All the time. Some jobs used to only require being presentable and clean . . . fashionable was a bonus. Like Doctor, Lawyer, Teacher, or Anchorwoman. If you watch Fox News now it's all scantily clad girls with giant hair tottering on platforms next to middle-aged, paunchy men in business suits. It looks like retro porn . . . or Telemundo.

Seriously, these girls trying to credibly detail Congolese atrocities are hard to take seriously when they're adjusting their thong while butchering names of foreign dignitaries through blow-job lips. Diane Sawyer didn't start out in a micro-mini, did she? But now—and it makes me sad, 'cause sexy is fun for everybody—I just don't want to hear about the latest from the Gaza Strip from the girl who looks like she rolled into work directly from a Grammy after-party where she was snorting blow off of T.I.'s junk. What strip are we talking about again? I was distracted by your nipple rings being visible through your *Playboy* racerbank tank.

I'm not saying they shouldn't dress like a tramp in their off-hours, but really—it's just too much pressure on the rest of us. I'm sort of comforted by the fact that she really isn't that good at reading the news, while simultaneously being horrified that her incompetence

is perfectly OK with everyone just as long as she looks like her last job involved pulling sweaty bills out of her G-string.

The roles were much more defined back in the day.

Madonna/Whore: It used to be a syndrome that guys had where they typed women into two categories—those who were wholesome, maternal figures they'd want to marry . . . and those they actually wanted to bang. You used to be able to pick either Whore or Madonna, you didn't have to be both. Now Whore/Madonna is a hyphenate, like actor SLASH producer.

You didn't have to be a pill-popping, molestation-surviving actress SLASH First Lady . . . You were either Jackie OR Marilyn.

You didn't have to be a Stay at Home Mother of Six SLASH Lingerie-Wearing Slave Girl . . . You were either Mrs. Brady OR Jeannie (who I emulate to this day. I want to live in that bottle and blink and snap my ponytail to clean the house and change outfits. All while being screamingly rack-tacular).

You didn't have to be the sensible best friend in hot pants and support hose with a baby voice SLASH the side-ponytail-wearing . . . uh . . . other best friend in hot pants with a baby voice . . . You were either Janet Wood OR Chrissy Snow. (But come on. You all know who Jack, not to mention America, wanted to do the shower curtain/dick joke with. The joke that was always overheard by Mr. Furley:

"Just stick it in, Jack!"

"It's too big, Chrissy."

Smash cut to bug-eyed Don Knotts outside the bathroom door. Barney Fife thought they were having loud, echo-y bathroom sex every other day.

You didn't have to be a twin-set-wearing Aussie cheerleading virgin SLASH thirty-eight-year-old high school senior gang bang fan . . .[1] You were either Sandy OR Rizzo.

Until the end of the movie . . . when EVERYBODY WAS RIZZO![2]

You were either Kate Jackson or Farrah Fawcett. You either wore turtle necks . . . or sported constantly erect nips. You either got info from a perp because you were smart OR seductive. Not both. You were either Meg Ryan OR Sharon Stone. You either were Sleepless in Seattle or Stabbing your Lover with an ice pick.

You were either Laverne OR Shirley. Laverne gave it up. Shirley didn't. And who went on to direct *Big* and *A League of Their Own*?

"THERE'S NO CRYING IN BASEBALL!!"

Now every guy expects the variety that is embodied by Angie Jolie. Unfathomably hot mother of . . . what's it up to now? Twelve? Thirteen? I think we can all picture Miss J screwing Brad senseless, garroting him with barbed wire, and then taking the kids out for FroYo bathed in his blood. "Come on, kids, we're all going out for Menchie's! Maddox! Put down the crossbow. Field training is Thursdays, you know that."

Ladies and gentlemen, I rest my case.

I blame Madonna. First of all, she's named Madonna.

And she's not.

1. Just for the record, Stockard Channing was then—and continues to be—my favorite. She had the cooler clothes, looked like she appreciated a group grope in a hoopty, and had better songs.

2. No one wanted to be Sandy—everyone wanted to be Rizzo. Even Sandy wanted to be Rizzo! She was Rizzo by the end of the movie. And Danny Zucko liked it. He liked it a lot!

She's the opposite of Madonna.

Tell me *that* didn't confuse a lot of men with Whore/Madonna complex. "Like a Virgin"? Not even remotely. I worshipped her. Still do. She wore her underwear on the outside and was surrounded by fabulousness.

Then she went and had kids. And continued to be a hot and sexy rock star. Then what are the rest of us supposed to do? It's cool that we're no longer pigeonholed. 'Cause I don't want people to think that just because I spit out a bunch of kids[3] I'm permanently stationed in front of the stove cooking a pot roast, sporting a frilly apron and a tight grandma perm. I still wear balcony half-bras. On occasion. Not while making pot roast, though. 'Cause it can bubble over and spit meat grease on your nipple. That only has to happen once. But the rest of us can't afford to be Madonna. Some of us Sicilian big-mouths have to be happy with our original accent.

Bless her heart, though. She went from an ambitious Detroit brunette to one of the most influential blondes in the Global Community. She pals around with Gwynny—sharing trainers and . . . I dunno . . . vegan cheese, tofu shit . . . whatever—but they look pretty good doing it.

But with all of that hot, famous, prolific and inventive, ahead-of-her-time talent . . . she still couldn't stay married to Guy Ritchie. For all that she loved him and I'm sure she tried, she was too much for that Lad Movie-Making Scot. This is how we know we've become so huge as beings that we are scaring the shit out of the menfolk. 'Cause you know Madonna knows more bedroom tricks than all four Trump wives put together. She's probably just too

3. I should live in a shoe.

tired to do them and too wonderful to put up with some asshole watching cricket matches and scratching his nuts.

For guys, it seems that, at some point, even the adorable, "who-wouldn't-love-her" Sandra Bullock (or Halle Berry, or Christie Brinkley, etc., etc.) is just the broad nagging him to pick his socks up and throw them in the hamper for a change. It's also true that ultimately we get tired of hearing these same guys bark at the Final Four with their hand down their pants. And at that point, if we have Madonna money, we start screwing young Brazilian underwear models. And naughty jock playboys. And whoever else we haven't screwed yet.

My point is: Madonna turned everything on its head with her ironic postmodern feminist sexuality . . . ness. We can never go back to being just a dangerous, naughty, and desired sexual plaything OR a nurturing, protected mommy figure. That's a lot of added pressure, not to mention wardrobe costs. But I think it's probably more fun. And I do like the bustier as daywear. So, Madonna, wherever you are:

Thank you and Fuck you.

Chapter 16

XXX SECTION: SEXY IS PART OF OUR POWER PACKAGE

I know I've been bitching about girls having to pretend they're into girls to compete for male attention. I'm all bent outta shape about preteens idolizing the hooker look-alikes on *Girls Next Door* . . . but I have NO PROBLEM WITH SEXY. SEX. SEXUALITY. And here's the really good news about it in relation to our self-esteem: it has almost NOTHING TO DO WITH HOW WE LOOK ON THE OUTSIDE!

I'm sorry I yelled. I just want to make sure I make this clear: I am a big fan of women and how we walk, talk, think, act, dress, pretend—and flat-out rock—our sexiness. And knowing that you're a sexy woman—that you're desirable—makes you sexy. It truly doesn't matter all that much if you're a Playboy bunny or Arianna Huffington. Sexy is sexy.[1]

It's one of the biggest bonuses—if not the biggest—of being a woman. In fact, compared to some of the ways we chicks are boned in the rest of life—like still only earning seventy-seven cents on the dollar compared to men—the multiple orgasms are a pretty good trade-off!

1. Here's another little secret: Men don't care nearly as much as we think they do about "perfect." They like us. Naked. In their bed. Everything else is just frosting on the naked-girl cake.

When Did Guys Stop Taking Pride in Being Great in Bed?

When did this happen? Was it gradual? Or did they have a mass cyber-meeting and agree that they no longer had to work so darn hard because so many girls seemed to be OK with technique-challenged, selfish sex? We used to balance the trading of sex with the expectation that we'd have a lot of orgasms in exchange for the *always guaranteed* really good one the dude was going to have. Now, it's a crapshoot whether you're going to get anything out of a sexual encounter except maybe a YouTubed homemade porn of your action viraled out without your knowledge. Not even dinner is necessary anymore.

But let's backtrack a bit just to get on the same page about our awesome, powerful sexiness. Why does the female orgasm even exist? I know, I know—we all start out as girls, then some fetuses have the XY and become boys and the little clitoris becomes a full-grown penis and the internal ovaries turn into external testicles and so the nerve endings that go into a pecker are all right there contained in the teeny-tiny pencil-eraser-sized mighty clitoris . . . blah, blah, blah. . . . A tiny, supersensitive area that some guys—once they find it—hammer away at like their lives depend on it. Anyone who's ever lived through an outside-my-jeans-only dry-humping situation can testify to how painful it is when a dude gets all motivated to "push your love button." Aggressively. Why do they do that? Why are they going at it like I'm a vending machine that took their change? Ouch.

It's probably their own natural aggression. If you've ever seen them work their "area," it's shocking that they don't yank it clear off! But percentage-wise, it's worse now than ever before. I blame video games. They're so used to zeroing in on a target and just going at it full force—they forget I'm not Super Mario Cart or a Wii Remote.

Yikes. Quit it. See, when your small motor coordination has developed to chase asteroids or get to the next Galaxy Level . . . one is apt to think of all small oval shapes as a target that must be hunted down and annihilated. But the clitoris[2] is NOT, in most cases, an asteroid.

But why do we have multiple orgasms? Is it because, even though men are bigger and stronger and can have their way with us (after a few cocktails and lies, of course), it's so much easier if we look forward to the activity? If we know we're going to have some fun . . . quite possibly a lot of fun . . . it's much easier to talk us into the deal! Fewer cocktails-less elaborate lies!

Think about it. It could be that females who had an "area" that facilitated easier orgasms were the ones that had more sex, therefore more babies—therefore propagating the climax-happy women peopling the planet today.

Maybe it's a stretch, but you all know how I love biological imprint and genetics—we could be the Darwinian winners in the Happy Genitals Lottery! We don't know! 'Cause they don't do government-funded studies about it. I would, but I don't have an NIH grant. And I'm not gonna go running around asking complete strangers about their clitoral size or sensitivity. "Excuse me, ma'am? This might sound rude, but how's your orgasm situation? Wait, officer—I'm just doing freelance research!" But I'm not going to be doing that. I'm just happy that I became sexually aware in a time where I felt absolutely owed at least one fantastic orgasm per "activity." And guys were determined to figure out how to help make that

2. Nipples are included in this category as well. Stand up and be counted, nipples! Oh. I see that you already are. Carry on.

happen because it meant they were likely to have more "activities" in the future.

Back in the free-sex, pre-AIDS era, guys had to know how to excel at oral.[3] I mean, be good enough for girls to brag to their friends about. Or they weren't going to get a lot of "activity."

And let me tell you something—all guys think they're great at it. Most of them think it's like church. All they gotta do is show up and kneel and that's enough. There is some actual technique involved.

In fact, this is as good a place as any . . . Let's figure out what the issue is and have our own meeting[4] so we can get back to where we were really powerful and satisfied in our sexuality, OK?

Here's the problem—I think . . . Some guys are just a little confused as far as the lady-parts are concerned. It's part of a large, erogenously charged "area." I like to call it an "area"—because there are other things going on down there. And they all feel good! It's like a party! It all feels good when touched. Especially when someone else is doing the touching! Because it's a surprise! You don't know what's gonna be touched next! My very best advice to fellas: work from the outside in.[5]

> **Outer breast—inner breast**
> **Nipple last.**
> **Outer thigh—inner thigh**
> **Outer labia—inner labia**
> **Clitoris last.**

3. I don't think I really have to specify that I'm referring to giving, not receiving. But . . . just in case. Because there probably aren't a lot of guys who need seminars on lying there with their eyes rolling back in their heads.

4. I'll bring the cookie bars.

5. Just like silverware at a fancy dinner party.

I stand by this as standard operating procedure for all women. There should be a manual imprinted just below our belly button. Wouldn't that be convenient?[6] I know that there are some women who like the rough stuff—no preamble—just twist like radio dials and stick it in . . . and that's fine for them. Or maybe for a particular session, just because you felt kinky.[7] But for the most part, the "area" needs to be finessed. Talked into it, as it were. And I think most women would appreciate it if guys would include the discussion above in their group training sessions. In fact, this is what they should teach in "Health Class." Forget the stuff about ovaries, they space out at that part anyway. Because no one ever said about a girl, "Hey, Man—D'ja get a load of her ovaries? Hot!"

In fact, I gave this very same advice to my son when he was fifteen. Now, wait—hear me out.

I was sitting at the computer in his bedroom playing Snood. Since then I've moved on through a series of mindless computer games that both soothe—and feed—my OCD. It calms me to play three hours of U.B. Funkeys mah-jongg for some reason. I have reduced my game playtime out of necessity and the threat of an intervention from the kids. I maintain that they just want to get onto Webkinz themselves. Anyway, I was on my final level of Snood, about to avoid getting killed on a really tricky part, when my oldest boy, Jordan, hit me with this: "So, Ma—what do I do if a girl wants to, you know—do the oral thing?"

6. Maybe flashing neon countdown lights that let a dude know when he's honed in on the right spot and he shouldn't move or change the rhythm or speed. 'Cause they do like to switch it up at just the most inopportune times, don't they?

7. Just remember, we don't come out of these little parties unscathed. When you pound a girl with jackhammer frat-boy sex, she generally gets a little party favor. Called a UTI (urinary tract infection). That's where we sit on the toilet and dribble a drop of pee at a time, painfully, for three days. So just consider beforehand if it's worth the trade. Or, as I like to say to my boyfriend, "You break it, you bought it."

Let's remember that—although I pride myself on being not just open-minded regarding sex but someone who's always embraced sex as an expression of joy as well as feeling really, really good[8]—he was my son. And he was fifteen. So I responded in a way that most mothers can relate to: with distinct alarm: "Who of your friends is trying to do this to you?!" As if someone was trying to talk him into igniting lighter fluid. Which had already happened two years ago, so I'm not just pulling that one out of my hat.

So, after getting over my initial shock and avoiding the urge to run away, I took up the flag and ventured forth: "I'm just not sure you understand how, for girls, this goes down—er . . . I mean . . . what it means to them." I'd love to say that I turned to him and spoke to him with concern in my face, but I really was close to beating my highest level of Snood. And it was easier having this particular conversation looking at Pinky, the Blue Snood, than at my former Jordy Pordy Pudding Pie soon to become Jordan the b.j. recipient.

I let him know that, no matter what they try to sell in that crazy music the kids all listen to, and the panels of *The Maury Povich Show* notwithstanding . . . girls do connect sex with emotion. They don't actually feel like "I wanna get mine just like the fellas! Hey, Yo! Hey, Yo! Come on, ladies! Woot! Woot!!" No. That's just a line that they've heard so many times, they've started to believe it's cool to announce that they're big sloppy whores with no emotional investment in who sticks it in them. Which is bullshit. Because any girl who is honest with herself will admit that if she gets good sex from a dude and decides he could possibly be mate material—hittin' and quittin' it on their part could most likely result in drunk dialing,

8. I missed almost an entire semester of my junior year of high school when I discovered masturbation.

stalking, and the slashing of both his and his new "ho's" tires. We get involved. We get invested. We fall in love. That's how we're built.

Again, genetic basis. There are plenty of stories of one-night stands that result in nothing, not even breakfast or a ride back to your car.[9] But that's usually when the sex sucks. I.e., you decided half-way into it that it was probably the mango-tinis that made your decision to kick your panties off in his GMC truck, and not his innate charm and good looks. But we always risk exchanging a few seconds of pleasure—OK, a good coupla minutes if the orgasm is intense—with the possibility of—oops!—pregnancy! We connect sex to love. Because that makes us more apt to take the whole possibility of dying in childbirth more seriously.

So I explained this to my son—without the dying-in-childbirth part because, you know, who wants that brought up in their first sex talk? I explained that no matter how many times a girl says, "Oh I'm gonna get mine! Let's just have fun!" It doesn't mean anything. If she has your penis in her mouth, she is going to believe that gives her at least leasing rights on you. And that Monday morning at school, if you act like you owe her money and switch hallways when you see her coming, her friends will start calling you midget-dick by lunchtime.[10] Or some such heinous behavior.

Moreover, I explained that since he didn't drive yet and had no reasonable place to plan "returning the favor,"[11] he'd better not

9. Fun, huh?

10. I know you already know this, but let me make very clear, right now, that my son does not have a midget dick. I don't want to hear him whine about me ruining his street cred for the rest of my life.

11. Let's face it, it's a lot easier for a dude to get a hummer, spatially, than a girl ... Another way we know God is a man. Ha ha, God. Oh, and while we're at it, let's discuss the placement of the clitoris OUTSIDE of and TWO INCHES AWAY FROM the vagina. Fun-NY!

consider being a sex pig. Because I wasn't raising a son to be sexually selfish and douche-y. And, plus, I added—he had no idea what he was doing at his age and that wouldn't be fair to the girl, either.

So, being Jordan—and my son—he threw this at me: "So . . . what do I need to know?"

Which is when I stopped playing Snood. And blushed. And simply said: "Work from the outside in."

He told me recently that I was right about every single part of that conversation and that he has respected me as an authority on the subject ever since.

I'm just glad he never wanted any more advice.

But I'm happy to give you all some: Be proud of your sexuality. It should be a self-esteem boost every single day that you know, as a woman, that you could always—and I mean always—walk into any room and there would be a line around the block of men who would want to sleep with you. Just 'cause they haven't yet. And you're wearing . . . ummm. . . . clothes. And female skin. And pheromones.

You're a woman—that's your power.

Deal with it.

LOVING YOUR BIG-ASS LIFE

Avoiding bad lighting, three-way mirrors, and that judgmental bitch in your head.

Chapter 17

HOW TO KNOW THAT YOUR SNACKY ASS IS HOT—FOREVER!

The quantum physics of how cute I look when I start thinking I look cute. And how everyone else thinks I'm cute, too, as a result.

My good friend Elaine Hendrix convinced me to watch the movie *What the Bleep Do We Know!?*—which she also starred in—so that I would stop hating my ass as much as I did. Her idea was that the quantum hate energy I directed that way actually added to the size and/or quality of my butt. So, hating my ass was counterproductive, was her point.

So, I watched it. And I learned that if you yell at a water molecule, you make it sad. It changes shapes. And if you compliment a water molecule, you make it happy. Huh.

At first, this didn't exactly help because I don't like science and it doesn't like me. But after watching that movie and thinking about the theories in it, I knew that not only do I have an unappealing ass—but I'm, in fact, personally responsible for it! Super. But it also meant that I might be able to do something about it. Just had to start lovin' on my backside a little bit. Send it positive energy instead of negative energy. Which is a lot harder to do than

it sounds. Just change your attitude about yourself. Just stop being self-loathing about the things you've spent a lifetime hating.

Just tell a meth head, "Just say no." "OK, right after this hit . . ."

S-u-u-u-u-re . . . Oh, and I also had to jettison my ex because . . . he was nothing but negative energy—particularly where my ass was concerned.

Basically the point is—changing your attitude is solving the problem. Because no matter what, all of these ideas about what you're supposed to be don't really count. All that counts is knowing that you're awesome and everyone else can go fuck themselves if they don't think so.

And that whatever it is you are was either all the rage at some point . . . or will be sometime in the future. Your job is to just act "as if" you are On. Point.

Just as you are. Right freaking now.

Chapter 18

THE RIDICULOUSLY ARBITRARY NATURE OF BEAUTY

Some days we are just crap and can't get out of bed because it's a bad hair/skin/ass day. On those days, we should really take into consideration that somewhere in the world the exact thing that you hate about yourself would get you a line of potential husbands—each bearing a goat—so long that it would wrap around your house (or hut) twice. And they would all be clamoring for your hand. Including the goats.

Throughout history and in most cultures the decision about what's "in" or desirable or hot is based on several things, but usually reflects the financial status of the family of the lady with bound feet, plate lips, pasty skin—you know, whatever denotes that she doesn't have to get up and do shit 'cause someone else is picking cotton, working in the factory, or dragging rocks to the pyramid.

It also is generally determined by the reigning "class" 'cause they historically have free time to come up with stuff like corseting (1600s—Dita Von Teese) or sunbathing/smoking (1920s to present) and other silly stuff that either makes you faint or riddled with cancer. But what's a fainting spell or a little malignancy compared to you and your cuteness? Apparently not much, because we buy into all this shit, and we always have. Oh, it didn't start with us. Let's take a walk down memory lane and beauty through the ages.[1]

1. This should be a ride at Disneyland—It's a Fucked-Up World After All. Get THAT song stuck in your head.

Ancient Egypt

Egyptian Beauty Secrets

Kohl-rimmed eyes. See—not a new idea—and still looks pretty good. And it's natural. Thank you, Cleopatra, for your contribution. You are forgiven for your part in the fall of Rome.

The most important of all fashion accessories in ancient Egypt was the wig. Long, straight, black hair that was so shiny you could see your reflection in it was the sweet spot because that helped you look young, hot, and energetic—qualities that make for a good roll in the hay.

To achieve this look, Egyptians didn't use their natural hair. No, they shaved their heads completely and created fancy, long, corn-row wigs with little adornments to cover up the bald. So it wasn't that they dug the bald look so much as they weren't too fond of the head lice. Now, these wigs were as obvious as Bill Shatner's rug, but they didn't care. In fact, it was the whole point. No self-respecting, wealthy Egyptian wanted anyone to think they couldn't afford a wig, so they were purposely elaborate and fake-looking. Much like Dolly Parton's.

Of course, they wouldn't be caught dead without their hair. Literally. They took their wigs to the tomb with them. Of course, they also took their servants. I hope the servants got to wear wigs into the afterlife at least.

If they DID keep their own hair (maybe these are the folks that enjoyed a little head lice), they also wore hair extensions. Creating a centuries-long love affair between black women and weaves. Go Cleo, go Cleo. Get your weave on, get your weave on . . .

Women who couldn't afford wigs kept their own hair and dyed it. They created an intoxicating and/or nauseating blend of oil and

boiled black cat or bull blood. Mmmmmm. . . . 'Cause that would make it . . . um . . . more black, I guess. And bloody. And very stinky.

Speaking of weird hair habits involving animal carcasses—your upper-class, well-connected—let's say "Pharaoh-Adjacent" Egyptians used to wear cones on their heads at special events. Not just any cone—like a pine cone, or a hat shaped like a cone. This cone was made of ox tallow. (You heard me! Ox tallow. That's hard ox fat!) And myrrh. They'd stick it to their big ol' wigs, and over the course of the party the cone melted on their head, which smelled "nice." Well, not the ox tallow so much. But myrrh has a pretty good reputation. It's in the Bible and everything.

So think of that next time you're gussying up for the holidays. When you're making your Snooky Poof,[2] stick an Air Wick solid in there. Or a sachet or dryer sheet or something. You and your kohl-rimmed eyes will walk in like an Egyptian and stay smelling sweet as a cone-head all night.

Ancient Rome

Roman women wore makeup (*cultus* in the Latin). These cosmetics started out being used for ritual purposes, but, presumably, somebody thought those priestesses looked pretty hot with their pink cheeks and ruby lips and said, "I gotta get me some of that."[3]

In any event, by the second century or so, Roman women of high class, as well as prostitutes, were using cosmetics on a regular

2. Hairstyle made famous by MTV's reality-star midget, Snooky—featuring a big teased hair lump on top of the head. I guess to make her look taller and more "klassy."

3. Much of human history can be boiled down to one group of people looking at some cool shit another group of people had and saying, "Hey. I gotta get me some of that!" From fire through the wheel right up to French-Tip pedicures.

basis. Rich women even had slaves to apply the makeup—which was expensive and had to be applied multiple times a day because nobody had thought to invent air-conditioning yet. Presumably, the prostitutes didn't have slaves to help them apply it, but did find opportunities during their "down time" (or UP time, more accurately) to keep up with the other Betties.

Pure, white skin was desired by the upper classes—again, because the lower classes were working in the fields and begging in the streets—and you didn't want to be taken for a field hand or a beggar. Problem was, native Romans weren't naturally fair-skinned, so whitening cosmetics were necessary to achieve the ideal. (See?! The ideal is unnatural, even in ancient Rome.)

Among the whiteners they used? Chalk powder, crocodile dung, and white lead. Now, I'm assuming that Romans didn't have any special immunity to lead and that, over time, some women might have regretted that particular choice. You know, right about the time your face starts to fall off. Oh, well.

Rouge was used, as was eye makeup. Apparently, lush eyelashes were a sign of chastity, as sex was believed to make your eyelashes fall out. (Man, that would have to be some kinda sex that knocks out your eyelashes! Go, Mark Antony!)

Dark Ages

Named after the Dark Ages when it was, in fact, dark. You want to know why they turned off the lights? Everybody was ugly. No chin, pointy nose, beady eyes—lots of inbreeding. See Prince Charles or his doppelgänger, Camilla Parker Bowles.[4]

4. I'm snapping my rubber band! I'm snapping it!

Middle Ages

I'm not trying to be mean, I'm just going off of the few paintings I've seen and they all look alike and they were just as fugly as the Dark Ages. Now to be fair, they didn't have time to get the best glamour shots. They were busy dying, mostly, this being the time of the Black Plague, named thus, presumably, to carry over the theme from the "Dark Ages."

Medieval Europe

Before the Renaissance, beauty was simple. Be clean . . . smell good, maybe weave some flowers in your hair for your wedding. They also liked to pluck their foreheads to get a higher hairline—makes me thankful for the lasers of today. Because, while tweezers are a whole lot cheaper, the idea of plucking the hairs from my head, one by one, in order to have a tad bigger face? That kinda sucks.[5]

Body-wise, medieval folks seemed to appreciate a well-rounded woman. Take Botticelli's *Birth of Venus.*[6] Venus isn't a stick figure, but she's not exactly Rubenesque, either. (Rubens was clearly a dude who liked a gal with meat on her bones. Good for Rubens.) She's got a nice, shapely figure which includes a sizable uterine bulge. Her hair, however, is actually quite Barbie-like.

Renaissance

Well, let's just take a look at the no. 1 pinup girl of the Renais-

5. Marilyn Monroe employed this technique to get her famously heart-shaped face. I, on the other hand, have a natural widow's peak. So there. However, I never slept with The President, either. NOT THAT I EVER WANTED TO, HILLARY! LIKE I SAID, BIG FAN!!

6. Or "Blonde on the Half Shell," as I've always called it.

sance—the Betty Grable of the fifteenth century—Leonardo's Farrah Fawcett Poster—the *Mona Lisa*.

Now, by today's standards . . . Mona's a bit of a beast. I know that's harsh, but really, if she walked into your T.G.I. Friday's at happy hour, who's gonna turn a head? Maybe somebody looking for their Italian grandmother? Because that's really what she looks like to me.

Her hair is flat; her eyes are kinda beady; her lips are . . . are those lips?! Her nose is . . . well, I do like her nose. But she's working on an extra chin and she seems round like a ball bearing. Probably a very nice lady—mildly amused by Leonardo, judging from the soft smile—but not a babe.

Much has been made about her hands, I understand. So delicate and soft. Yeah, well, they look a bit chubby with short digits, to me. Frankly, they look like MY hands and nobody tells me my hands are soft and delicate. Believe me, I'd remember.

Anyway, it's just a good illustration of how beauty standards change, is all. Lucky Mona Lisa to be around in a time when being a . . . well, a Mona Lisa type was all the rage.

Until the last hundred years or so the ideal female figure was . . . plump. At least, by today's standards. (Of course, as we've already established, today's standards are screwy.) It was equated not just with fertility but with financial largesse. If your bride showed up to the wedding fat, it meant she came from people that could afford food. That's what you were going for. If she had a nice little vegetable garden and a coupla, two, three chickens . . . bonus![7] There

7. "Coupla, Two, Three" ("three" is pronounced "tree") is Guido-speak for several. As in, "How many cannoli you want, Vinnie?" . . . "I dunno . . . coupla, two, tree . . . and throw in coupla, two, tree anisette toast—Ma likes dose."

are places in the world today that still promote pudgy as the femi-
nine beauty standard. Skinny reflects lack of funds and possibly
disease—not what you want when starting a family. This concept
of sturdy enough to breed, but pale as possible to announce to the
world that you were loaded enough to afford servants and there-
fore didn't have to toil in the sun, was pretty much a European
and New World beauty standard until the late nineteenth century.

Corseting: developed as visible proof of the wearer's wealth and
status. You couldn't very well be a scullery maid if you were laced
up so tight that you'd pass out scrubbing a floor. So the upper
ranks sported the tiniest waists. Catherine de' Medici (who came
from the very rich Medici family in Italy and she wasn't playing.
She was the mother or mother-in-law of three kings of France and
two who reigned in Scotland and Spain. At one time she had a child
on every major throne in Europe except for England. So she was pretty
bossy) banned any lady from court who couldn't suck it in to a
thirteen-inch waist. No shit. I wonder if there was some kind of blub-
ber checkpoint at big parties at Versailles. "Wait, wait, wait . . . fifteen
inches!?? Bitch, don't even think about getting into the Hall of Mir-
rors with that muffin top . . . that's right, keep walking . . . or should I
say waddling!"

They even started to make the corsets out of steel at one point.
How good did it feel to get undressed in those days? You know how
it feels at the end of New Year's Eve when you finally get your shoes
and bra off and you just sit on your bed and groan and scratch?
It seems the elaborate lacings either would deter people from get-
ting naked entirely (explaining the smell) or would be a good way
to talk people into nakedness as often as possible (explaining the
babies).

In the mid to late 1800s through the turn of the century, women

of wealth commonly corseted to the point of respiratory distress.[8] (It was not uncommon for women of the upper class to bind their waists with boning to achieve a desirable measurement of sixteen to eighteen inches.) Women wore fake bosoms (paper stuffed in the front of their dress) and bustles to denote big ol' T&A. The wasp-waist silhouette was the hallmark of the "Gibson Girl," who was kind of like the porn star of the turn of the century. Very exaggerated top and bottom, big giant Pam Anderson hair, teeny-tiny waist. They decided this was very "Romantic." Right up until about the thirtieth time you had to revive her with "smelling salts" for a "fit of the vapors" on her "fainting couch."[9] This is Victorian slang for shocking a chick awake with some ammonia when she passes out on the sofa after a heavy make-out session.

The Wacky Last Century

The 1920s served up female independence and naughty behavior as a response to the hideous reality brought on by the brutality of World War I. The flapper was the embodiment of frivolity, fun, and "Fuck it! We might die tomorrow! Let's drink!" The Jazz Age celebrated a fun-loving, free-sex feminine ideal. The women got looser and so did their clothes. Hair was bobbed, skirts got short, and stockings were rolled down. Chicks drank and smoked and wore French couture designed by Coco Chanel and gay men. They looked a little bit like the freedom-loving young men they partied with. Androgyny became desirable. The look became flat chested,

8. Medical problems caused by extreme corseting also include: cracked and deformed ribs, dislocated organs, disfigurement of reproductive organs which led to higher mortality rate in childbirth. 'Cause, hey, you can always get a new mom—not that you don't love her, but who wants one with a beer gut?

9. They actually had to invent furniture so the poor bitch wouldn't hit the floor. Or the knickknacks. Victorians had a lot of tchotchkes.

narrow hipped, long, lean . . . elegant. And tan! Women enjoy-
ing sports outdoors along with the men and being vibrant and
energetic was a reflection of the leisure time enjoyed by the upper
classes, such as yachting off Newport, golfing at the Greenbriar
. . . tennis in the Hamptons . . . badminton, croquet . . . Competi-
tive Iced-Tea Drinking . . . Your Boss's Wife Steeplechase . . . all
the things that define the rich. And all brought the skin a nice,
rich, brown color. Now pale skin was the mark of the sweatshop
worker and factory drone who toiled like mole rats without the
glory of sun upon their furrowed brow.

So dark skin became very cool except for on . . . er . . . people who
started out that way. They were still "out."

Lean stayed in vogue until right after World War II when Rosie the
Riveter had to get out of the workplace to make room for return-
ing soldiers and the fighting force needed welcoming by the bounti-
ful bosom of their nation . . . and Marilyn Monroe. Followed by Jayne
Mansfield, Mamie Van Doren, and many other names that remind
you of mammary glands. Oh, and white skin was back. Until the '60s
and Twiggy when skinny and tan came back to stay through the '90s.

The '70s—What the Hell Happened?

Twiggy and Jean Shrimpton were introduced in the '60s but CRAZY
skinny became the rage in the '70s. Diana Ross as Mahogany. She all
but disappeared behind the wardrobe and hair. Cher in Bob Mackie;
Liza in Halston; Lauren Hutton, Bianca Jagger, and Cheryl Tiegs in
a bowl of cocaine at Studio 54. Everyone was disco-dancing fueled
by tons of blow. I don't remember anyone discussing restaurants or
food in the '70s. I remember everyone smoking Virginia Slims. Or
Mores—which were browner and skinnier than the Slims. No one

started eating again until all of these people went through their round of rehabs, got jail time for SEC violations, or started a family. Then everyone became pigs. But before that I remember being in New York visiting my family around this time, and while I remember a lot of roller-disco and extreme glitter-glam eye makeup, I don't remember anyone talking about food. I remember watching *Saturday Night Live* back then (I was a toddler, of course) and seeing Gilda Radner and Laraine Newman just sort of . . . disappear over the course of a couple of years. My god, they got skinny. I used to wonder how Gilda held up her head.

But at least ALL you had to be was skinny. Nobody expected you to develop muscles and shit while you starved yourself. That ideal came in the '80s. That's right—0 percent body fat and give us some pumped-up biceps and quads and all that. Thank you Jane Fonda and Linda Hamilton in *Terminator 2*. And breast implants. Now everybody can have big tits—even girls who shouldn't have tits at all. It just ain't right.

The '80s—Let's Get Physical!

Exercise as a planned activity is historically not a female event. Having babies was quite enough exertion, thank you very much. Or field work, cleaning and cooking in pre-electric-appliance ages, or simply carrying around all those bustles and whatnot. Exhausting.

Exercise as a separate pastime is the result of having actual extra time to pass. It's "leisure" activity. So it's fairly recent for women to be expected to do it. And up until the last thirty years or so, even if they did do any exercise, it consisted of standing on a mechanically shaking platform with a wide belt around your butt. I'm not kidding. Google it. Or, watch the original *The Women*. (The only

one worth watching. No offense, but the second one is an abomination—almost sacrilegious, if you ask me.)

Watch Roz Russell do maybe six or seven leg lifts; or Joan Fontaine walk on her tiptoes across the floor; or both of them slide down a wall. That's what passed for exercise. At that point, we were the "weaker sex." The conventional wisdom was that exercise would wear us out. Ah . . . those were the days.

I blame Jane Fonda for making us have to actually work out until we hurt. I might forgive her for hobnobbing with the Vietcong—I mean, when I was young I was militant, too. But I can't forgive her for "Feel the burn!" Because we've been feeling it ever since.

Once Jane wore a bikini at forty in *On Golden Pond,* everybody wanted to know her secret. Well, apparently her secret was working out two or three hours a day and eating lettuce cups filled with asparagus and air. Oh, and bouts with bulimia, by the way. And bless her to heaven for coming out about that—I remember clearly when I heard about her struggle—total respect for Jane and her brave "Oh fuck 'em all, I lived through Vadim and Tom Hayden" attitude. But she looked good. So we donned our leg warmers and did our best to do "Rover's Revenge."

After that, all bets were off. See, Jane hadn't just gotten in great shape, she'd made a freaking fortune off her fitness empire. Much more money than she'd ever made making all those silly movies.[10]

10. I ain't hating on Jane's filmography. *Barefoot in the Park?* Still watch it every time it comes on TV. Her and Redford at their hottest. Rrrrrowwlll. And *Barbarella?* What's not to like? Get stoned and rewatch Jane's Brigitte Bardot impression. Fantas-tique! *Coming Home, Julia, Klute, Electric Horseman,* "I'ma gonna get me one o' those Keno girls—can suck the chrome off a trailer hitch." Classic. *The China Syndrome, 9 to 5*!!! GENIUS! Even *Monster-in-Law* was worth watching just to see Miss Jane take off the gloves and remind people how to DO it. It really is the pictures that got small.

What with her workout tapes and clubs and fitness gear and all, it was an empire. Truly. So, every Tom, Dick, and Body by Jake followed in her left-wing extremist-slash-blatantly capitalist footsteps.

And so the '80s body was born and we've all been trying to keep up with Jane ever since.

Chapter 19

CRAZY DIETS & EXERCISE TRENDS

*OR, How I Learned to Hate Starving
and Working Out*

I hate working out. I know there are some people who say, "Oh, but you feel so great afterwards." These are usually the same people who tell you how great it feels when you get the "runners' high." I have only experienced that once and it was at the hands of the trainer who ABC insisted I have because they didn't want to have the lead of their family sitcom be a big fat mamaluke. This was my ABC sitcom, which ran at 8:30, Tuesday nights, directly after the top-10 ratings hit for a decade, *Roseanne*. And that's all I'll say about that.

I was on what felt like a two-hour run in the boiling heat of an L.A. summer up through the Hollywood Hills and down a big stretch of Mulholland Drive and was on the way back home—my trainer yelling encouragement, taunts, and, finally, downright threats to get me to finish this torture. OK, let's just get one thing straight: I hate running. I loathe it. It hurts my knees, my tits, my lungs, and my very soul. I don't think human beings should do it unless there's a big animal chasing them. At least women shouldn't. Because of the tits thing.

Even when I was young—and a bit chunky—I hated it. We'd be forced to do a soccer cycle in gym class because I guess the U.S.

just got the message that the rest of the world did it. Plus it only involved a field of dirt and a ball. The nets were even optional. And my school was brokedy-broke-ass broke. Especially when it came to girls' athletics—Title 9 or no Title 9. We had to wear these jacked-up one-piece gym suits that were dark blue in the shorts area with an elastic waist that you stretched open to fit through, a light blue top part, and a neck that you stepped into to put the whole thing on. Delightful. I maintain to this day that if I hadn't been so reluctant to parade around in that getup in front of the rest of the girls—not to mention boys—I wouldn't have hated gym class so much and wouldn't have stayed fat for so long. I might've even gotten competitive with some of the sports.

But never soccer, I never saw the point. I hated running up and down the field because I CAN'T RUN. I'm slow. I'm athletic, but I have short little legs and they don't move fast. Unless there's music. So running up and down the outside of the field sucked—because if you think they ever let me play any position other than wing, you've never seen little chubby girls forced to play on a soccer team. So shut up.

I lived every bit of this hate for all things running—my derision of joggers, dismay of field hockey, disgust at all track-and-field events—as I crested that last hot hill in Los Angeles. I felt I might actually die. I contemplated why for the purposes of the network it was better for me to be thin yet dead instead of just a bit cushioned yet living. Would they make out better in terms of their bottom line through the insurance payout if I just dropped dead? And then I got it . . . that sense of exhilaration that comes when you know that, no, you won't die. You've come through the other side. You can breathe. You will live. The house is a mere couple of football fields away and you could sprint the entire length. I was a

gazelle. I bounded home and jumped up and down pink-cheeked and laughing. I drank some water and felt so . . . alive!

And I knew I would never — EVER . . . do that again. I don't ever need to have that much trauma and hurt when I work out. I don't even feel the need to work out. Because it involves the word *work* and, as a mother of four with a stressful job, I do that quite enough.

But I tried almost every trend there is on my quest to be physically fit before I smartened up and discovered that dance was what I love and the only thing I'm going to sweat while doing ever again in my life. Well, the only thing that's not horizontal anyway.

So all forms of running are out. But I've done nearly everything else. Let's take a little walk down memory lane:

AEROBICS. This felt a bit like dance class, except there was always a perky girl in front with a Madonna-style wireless mic on a headset barking perky encouragement. Her hair in a ponytail braid with a sweatband to boot. Striped unitard and leg warmers. Because there weren't enough accessories to complement a gym look back in the Excess Is Best '80s! But the perkiness made me want to punch her in the face so I had to stop before the cops had to be called.

JAZZERCISE. This was aerobics with a funky soundtrack. Janet Jackson makes any amount of sweaty perky housewives tolerable. I recommend.

STEP CLASS. The stupidest part of this whole trend was that people bought steppers to bring home with them. The time spent setting up a plastic step in the gym was stupid enough and would often result in at least one participant face-planting due to improper stacking. Which, don't get me wrong, is fun for everyone else. Not

so much when you do it. But lugging the step back to your house rather than just using a step in your actual house? Why? Plus I mostly felt like a dork going up and down on a step and sticking my butt way out. Stupid.

NAUTILUS AND CIRCUIT TRAINING AND FREE WEIGHTS— OH MY!

Sets.

Reps.

'Roids.

Get cut. Linda Hamilton in *Terminator 2*. Yeah, I could take on a cyborg. She made Sigourney Weaver in *Alien* look like a pussy. Or, in other words, a girl. Because she looked mannish. Great hair—arms like Bruce Lee. Is this what we were going for? I'm not saying I don't enjoy getting shredded, 'cause I pop muscle like a short-limbed Italian chick should. I could do the bodybuilding if I wanted. I do not want.

THE MACHINES. LifeCycles, Stairmasters, ellipticals, treadmills, VersaClimbers, rowers: You'd see people on them with all their gear. Earphones working, reading papers, hydrating like crazy. I just didn't like it. I got bored. Even when they started including built-in televisions. There's nothing wrong with it as far as cardio is concerned—if you like that stuff. I didn't.

SPINNING. Did it twice. Hurt my coolie. I don't want blisters, or worse—calluses—on my "area." That's hard to explain. "What you been doing with your punany? Shucking oysters?" "No, see, there's this new class where you bounce up and down on a tiny little bike seat . . ."

Next.

PILATES. Core work, supposed to make you look like a ballerina by stretching you on a machine. It reminded me of a medieval torture rack. I did stuff on the rack and with a ball and I never looked like a ballerina. Not even a little. Even if I put on a tutu. Not even close.

EXERCISE BALLS. You roll around on them. And sometimes do sit-ups using them. That's it.

SWEAT THERAPY / ACUPRESSURE / LYMPHATIC DRAINING MASSAGE. All of this stuff is crazy-ass money-sucking ideas compliments of Hollywood. Not that there's anything wrong with sweating out toxins.[1] But most of these deals just take time and money and don't change a thing.

COLONICS / MASTER CLEANSE. These are other treatments that get their launch out of high-end spas in and around the fancier places in the world, notably Hollywood. They are often formulated to help actors who want to be in great shape for their next film—or Producer Body-Fluid-Exchange Session. They are temporary and result in, at the very least, bad breath, fatigue, and dizziness—and, at worst, serious abdominal and ass pain. They are dumb. Eat lots of greens, you get the same result and a lot less rectal trauma.

TNT / KICKBOXING / TAE BO. Did all of it. TNT was taught by a guy named Heinz at Crunch gym in L.A. His story was that he formulated this combination of serious calisthenics and martial-arts training while he was in the service and I believe him. Allegedly he did this initially with Billy Blanks, who then came up with the kicky name "Tae Bo" and made a mint off of it. I will say that doing Heinz's class two times a week while also seriously limiting

1. "Toxins" is usually code for lots of vodka.

my diet got me in the best shape of my life. Practically no body fat and a tight, tiny ass.

So good that my ex-boyfriend went ape shit over how great I looked and decided he had to have me back. Then I got pregnant and he eventually broke my heart! All thanks to Heinz and his ass-tightening TNT regimen!

DIETS DON'T WORK: SURE. *NOW* YOU TELL ME.

I've tried so many that I'd be really hard-pressed to remember them all. I'm just going to do a brief outline of the ones that are less likely to make you think that I'm completely insane. But you've probably tried them all, too, so don't judge.

We've already discussed Weight Watchers.

ATKINS. This is where you eat many pounds of bacon and eggs and butter and heavy cream. But no bread. So if breakfast is your thing, this may be your diet as long as you're not too crazy about toast. No carbs of any kind. And no carrots. No high-sugar fruits or veggies at all. I don't know about you, but any diet that says I shouldn't eat all the broccoli I want is nuts.

NO WHITE FOOD DIET. Well, that's not too hard to figure out. I mean the obvious stuff—no fluffernutter sandwiches. Mayo's out. I lasted exactly one day without cream in my coffee. That was it.

NO FOOD AFTER 6 P.M. DIET. That's fine for farmers. But I'm a night person. And a former comic. I stay up 'til one o'clock in the

morning as a rule. That's a lot of hours spent with your stomach growling like a big ol' bear.

THE CABBAGE SOUP DIET. I like cabbage. No one else likes me when I eat it—but I don't mind it. After a week of it, though, your entire house stinks like not just cabbage but cabbage farts. And what's the good of looking good naked if no one wants to risk blowing themselves up when they turn on the gas stove in your house.

THE ZONE—30/40/30. Fats/Carbs/Proteins. It does have bars now. I gotta tell you, I don't normally eat a 40 percent carbohydrate diet. This was actually more than my norm. I got fat on that diet. I mean I got fat on all of them—but as a rule, after they ended and I went back to putting regular food in my body on a regular basis. This was a singular experience in that I actually gained weight while being *on* the diet. That's not a very good result.

THE FOOD COMBINATION DIET. You were only supposed to eat certain foods with other foods. Because some of those foods ate the fat in the other foods . . . or something. I don't really know. I could never bring myself to figure the entire thing out. After one chapter of that complicated yet somehow still mind-numbingly boring book, I lost the will to pay attention. And, seriously, who has time to play eHarmony with your dinner like that? My food is just going to have to play nice with the other food it's hanging out with. I can't referee my meals. I'm busy.

THE HOLLYWOOD COOKIE DIET. I haven't done that one. I've done the cookie diet. That's the one where someone breaks up with you and you power-eat Oreos until you fall asleep in front of the speakers blaring "your song" or you get distracted by the "undercooked pan of fudge brownie diet" or the "eating frosting out of

a can diet." Are those the same thing? Judging from the girl in the bikini in their advertising—probably not. But if the Hollywood cookie diet involves me eating only two cookies and then not eating anything else? I'm pretty sure it's not going to end well.

SLIM-FAST. I'm just going to say this once. Two juice-box-sized shakes during the entire day make it impossible for me to be sensible about anything, much less dinner.

THE GRAPEFRUIT DIET. This is the first diet I ever went on after Weight Watchers. I blame it for setting in motion a lifetime of metabolism fluctuations and a mind-set regarding food and denying myself sustenance that has screwed me up with my relationship to my body and how to reasonably sustain it for my entire life. That's a lot of responsibility to put on a poor little citrus fruit. But that's how I feel.

FASTING. This is my go-to weight-loss plan. It is not a good idea. It cannot possibly last. Even if you do it for months and fit into those size-2 Capri pants that are part of your cougar wardrobe for *Killers.* The minute you put that first normal bite of food in your mouth—your body shouts, "Hallelujah! Food! We busted out of the prison camp! Wait. Maybe this is a trick. Maybe this will be the only food we get for a long, long time. We better make sure we hang on to every single fat cell for as long as possible." That's what happens when you give your body the message that it's starving: the second you put food into it—it's like someone pulled the rip cord on the life raft. You blow up like a Macy's Thanksgiving Day Parade float. "Look, Ma! It's Underdog coming down Fifth Avenue!" "No, honey, it's just Lisa Ann after she got done starving herself for that movie."

Chapter 20

THE WIDE WEIRD WORLD OF BEAUTY: NAILS, HAIR, & BODY MODIFICATION

Nails

Cher. Streisand. Any lady who works at the DMV. These are the nails you remember.

Staining nails has some history with the ancient Egyptians and Chinese, who used henna to color fingernails. Because they had extra after they dyed their hair and probably the rich people took a look at the hands of the slaves who did the hair dying and went, "Ooooh! That looks cooool. How did you do that? I want my nails to be purple, toooo!"

But actual nail polish was invented in the 1920s by Charles Revson, you know—as in Revlon. There was a French makeup artist hired by Revson, Michelle Richard—a dame!—who had the big idea to use the same type of enamel they were using to paint cars to color fingernails. Because . . . ? I dunno—but when movies became colorized the concept really took off. As did the desire to have one's nails match one's lipstick. I don't know if it was magazine ads that pushed this along, but there's lots of ladies in those old Lux Soap ads where some chick is holding a hand up to her face and both nails and lips were the same vibrant Candy Apple Red. This way, you had to buy two products every time, unless you wanted to look like crap. See how they get you?

Then in the '70s acrylic took off and all of us could have super-long nails that we could stroke our lover's hair with like Streisand did in *The Way We Were*. Babs sure showed those nails off. She was always singing with gestures that featured how long and graceful her nails and hands looked. She was always gently patting herself or people standing close to her. If you stood next to Barbra in a movie, you were getting stroked, that's all I'm saying.

I bit my nails and always have. Probably always will. My mother still gives me shit about it. And I've used every type of fake nails there are: acrylic, ceramic, silk wrap gel . . . I bite them off, too. I finally just Krazy Glue the fuckers on using the press-on style. With the French tip already included. Five dolla—no holla. If I'm gonna bite them off, at least they're cheap.

I admire ladies with beautiful hands and nails, but I will never be one of them. I have hands that still look like a little baby's—dimples in my knuckles and everything. And short, fat fingers. My only comfort regarding my hobbit fingers is that if I wear big enough rings, it mostly covers them up. And now short, funky colors are in—so who cares? I'm in style this week at least. And if the super-long nails come back in, it'll probably be a sign that no one has to do any kind of housework or texting. You can't text with long nails. Or at least I can't. If you've figured out how to do it, you're a better person than me, 'cause I'll be damned if I can live up to my nickname, "Thumbs of Fire," with those fake things on. Forget about playing BrickBreaker. It's not happening. Long nails, at least on thumbs, is dead for now.

Hair

We'll do anything to our hair, let's just get that on the table. Two words: Marie Antoinette. Before she had it chopped off for being

a criminally selfish twat, that head was *decorated*. I mean, models of frigates and dioramas of battlefields and who knows what all. It was a wig, but still. I put in a clip-on ponytail that I buy at the mall and my neck hurts at the end of the night. I can't imagine holding up that Vegas Showgirl Headdress heavy hairpiece all through the castle for a big party weekend.

Anybody who's ever seen a picture of a woman getting a perm in the 1930s knows that we will do anything if we think it's going to make us more attractive, fashionable, or both. Seriously, those girls looked like they were hooked up to some kind of alien torture device. Or a weird Tesla contraption at the world's fair Frankenstein exhibit. And, I'm sure a lot of girls came out looking a lot more like a Looney Tunes character that stuck a finger in a socket than say . . . Jean Harlow with the perfect platinum wave. In fact, platinum, or—as it became known by the 1950s based on the number of actresses who sported that color who met with tragic ends—suicide blonde, is a very hard look to keep up. If you don't want to fry all your hair off, that is.

But walk by any salon today and you'll see women in a big picture window with foils wrapped into their hair and stacked on top of their head so that they can get "natural" highlights. OK—how natural is Reynolds Wrap? But we do it. And I will never understand the attraction to a salon with the big picture window. I prefer to have my beauty secrets kept . . . well, secret. Or at least not being on display like a window at Macy's during Christmas.

Platinum, suicide, porn blond—all of it turns you bald-headed. So then you need extensions because what fun is porn blond hair if you can't swing it around while you're working the pole. I experienced the trauma of complete bleaching when I did *Shall We Dance*. The night they flew me to Winnipeg to start work on that movie,

I got word that they wanted me to go to a local salon to get all the color bleached out of my hair. Now, I was thrilled to be cast in this movie—but I was no teenager and I'd had hair dying "incidents" in the past and I wasn't about to let some random Winnipegian (?) in what I called the Kansas City of Canada bleach the shit out of my hair, because it can turn green or fall out. Seriously.

So I told Production that they'd better fly my hairdresser up to Canada stat and he could do the dye job. 'Cause they wanted it white with a hideous tinge of yellow and, honey, that shit takes years to come back from. So with an additional three thousand bucks in my contract to "get my hair back" after production ended, we started on my crazy hair adventure.

I kept that yellowish/white—with increasing root involvement—until we shot the competition finale of the picture, when it was rebleached a total white. Now, I've never had the thickest or most luxurious hair to begin with and this kicked the shit out of it. I finished the movie, went back home to a husband who was cheating, and I was fat and with a tiny thin inch of white-blond hair on my head.

I knew I looked a little funky and I did what any reasonable woman would do. I got really expensive hair extensions and tried to start dying my hair back to a normal color. This doesn't happen all at once, you see. You have to do it in phases. So I got a more normal color of blond, went to a Japanese hair-extension specialist who put the real stuff in with a glue gun. Then they hurt and itched and fell out, pulling most of the rest of my sad, tired hair with it.

So I went to a different extension person—darker blond, more extensions (each time cost, like five hundred bucks, by the way)— and they fell out, too. But at least my hair was getting darker. Then I got a call that an audition I had done when I was in my long strip-

per extension blond hair phase had resulted in an offer to do the movie *War of the Worlds.*

The only glitch was that Spielberg wanted the girl he'd seen four months before with the crazy stripper hair.

So I had to dye it back.

It literally took me almost six years and probably fifteen thousand dollars to get my hair back to where I didn't need extensions to look like myself and not like myself going through chemo. It was especially difficult to have a big part of what people see when they meet you—your head—be sort of jacked up at this time in my life because I was going through probably the lowest place a woman can go in terms of her self-esteem. I had been cheated on repeatedly and then left by a guy who couldn't stop reminding me how unworthy, . . . un-do-able, . . . unlovable I was. If my hair had looked like it belonged in a Pantene ad I still would have been in huge depression mode, but the frizzed-out cotton candy on top of my head certainly didn't help matters.

The year after my husband rolled out of my driveway in a Mercedes (that I bought! Arrgh!) with the backseat piled high with his clothes, off to start his series of Homewrecking Whore and Asian Stripper-type serial screwing bonanza, I was blessed with the best hairdresser, a wizard with extensions—Ron Weiss—who put in the little metal clip extensions made of virgin hair and not ONE ever fell out or pulled out my hair. He also suggested that I use "wefts"[1] and was very careful with my hair color, and though he also took

1. Those are pieces of real hair that have clips on the top so that you can use them when you go out but unsnap them before your fella runs his fingers through your hair—which they always do when you have a weave—and get his hand stuck in your fake hair.

care of his share of "Adult Entertainers" and their pole-dancing, hair-swinging needs—he did the most refined and least slutty hair jobs I'd ever seen.

He also charmed me and complimented me and pseudo hit on me the whole time I was in his chair. We became good friends and, although he wasn't the only friend that told me I was hot as a pistol and good riddance to the dickhead that couldn't see it—nor was he the only man to send flirty energy my way—it was so integral to the beautification process that I always left the salon head high, shoulders back, hair swinging, spring in my step. "Look at me," my body language said, "I'm HOT." We women know the value of a good, supportive hairdresser.

He got me off the hair-extension crack pipe after a year and a half even though it meant several thousand dollars a year out of his pocket. He told me one day, after taking out a round, that my hair was thick and fabulous[2] and why didn't I see how I felt without them for a bit. It was like giving up a blankie to go to kindergarten, but I did it and it was great. A few months later—and just one month after Ron married the rekindled love of his youth after an eighteen-year separation—he died tragically while piloting his plane. I am so sad for him, his family, and his bride. And sad because we would so terribly miss what he gave us. He spent his life making all of his clients feel so beautiful, even when we didn't feel it ourselves. I miss him still.

As hard as my hair has been to deal with, I was told when I was a little girl by my schoolmates that I had "The Good Hair." That is what black girls called my hair as they were cornrowing it during story time in first and second grade.

2. He wasn't gay, though—he was a big lover of the ladies—the use of the word *fabulous* notwithstanding.

I didn't know what it meant exactly—but I learned how serious their hair-care regime was. It was always obvious when one of my friends had gotten her hair relaxed—I think there was one day a month that everyone's mother did it—like the third Saturday or something. Because a bunch of my African-American[3] friends would come to school all smelling like the chemicals they use to take the natural curl out of their hair. It sounded so painful, and when my friend Peaches had me over when her mom was using the hot iron on her, I could not believe the smoke coming up from that little girl's head and how close a red-hot implement was to her face. That's serious commitment to the concept of hair beauty. Then Afros became the rage and my favorite look in all of the history of black hair started: the wearing of a gigantic "Power to the People" fist hair pick stuck into the back of one's 'fro. God I was jealous! Their hair was so BIG and they got to decorate it with a physical expression of anger and pride and claiming of their beauty and history. All in a 99¢ Only store plastic hair comb. Between that and Soul Train, I wanted to be black sooo bad.

The most interesting part about our relationship with our hair is our decision about where we want it and where we don't. We spend at least as much time trying to get hair off as we do putting more on. Depending on your ethnicity and the cultural standard where you happen to live—sometimes more.

Middle Eastern techniques for hair removal are as varied as they are painful. I guess that while naturally a bit more hirsute, Middle Eastern women—and Indian women and Afghani women—all hate that they're hairy, because they are the inventors of some of the most creative depilatory systems in the world.

3. Although that was still years away from being. We were just newly onto "black." As in, "Say it loud . . . I'm black and I'm proud."

Threading is the technique where they put a thread on a hairy area and roll it so it snags on the hair and yanks it out. It's available at kiosks in malls all over America these days. I don't know if I really want to be sitting in front of Claire's Accessories squirming and yelping in full view of a throng of shoppers, though, do I?

Sugaring—also known as "Persian waxing"—they make a paste out of sugar, add some other stuff like lemons and cornstarch, honey, molasses, and other sticky junk, and slap it on arms or whatever and it sticks to the hair and pulls it out. It works similar to waxing, but doesn't also pull several layers of skin out. So that's good. I also imagine that it smells delicious which would definitely improve the experience of having one's hair yanked out at the roots.

But I think that thick, glorious dark hair is gorgeous and maybe they shouldn't worry so much about the body hair. In fact, my Uncle Don always said that guys should look for women with more body hair. It means more testosterone which means a higher sex drive. And he's a doctor, so . . .

The gold standard for optimum hair placement has to be Asian women. They have gorgeous, silky, lustrous hair where we all want it—and virtually none where we don't. I've been told, by people who make the hair-product commercials, that they almost always use Asian models for the lifting and slo-mo dropping of the cascade of hair. It's awesome. And then, body hair? Nada. They have to be pretty thrilled with how it all turned out. Personally, I don't have a lot of body hair but not a lot of head hair either. And I'd really like a little more of both. I always felt a little weird for having sparse "area" hair. See how we look for things to have problems with?

This leads me to another question: Who decided where we're supposed to have it and where we're not? And when was that decided?

And do we get to vote? And is everybody going bald eagle these days? Because I've been talking to young women and it's not just them—but the dudes, too!

Not to go off track or anything, but am I the only one alarmed at this trend? I mean, yeah—the itching, the razor bumps, the expense and the effort involved . . . that's a drag. But the fact that we're creating an entire country full of people who are quite used to lovers who look like children? Is no one else concerned?

I'm not calling in Chris Hansen quite yet—but, personally, I don't wanna boyfriend who looks like one of my kids. That's just me. Ya'll do what you want. I think a grown man should look like a grown man. And I don't wanna hear anything about how it keeps the odor down or whatever. Anybody ever heard of soap? A little water? Some elbow grease, a washcloth, and some scrubbing bubbles, perhaps? Come on. If I ever get met with that little surprise party at pants-drop time—I'm gonna tell the dude to get on his Big Wheel and pedal on home. And not to come back until his area grows in.

"EXTREME" BODY MODIFICATION—In the eye of the beholder.

Body modification seems to be what humans like to do—in some form or another. I mean, some global beauty practices seem strange to Westerners, but lip plates, or binding feet, are not far off from the downright mutilation that kids are sporting on Melrose Ave—who's to say what's "weird"?

OK, that's a judgment, I know. *I* call it self-mutilation. If you were born after 1980 you probably call it "piercing."

I will cop to the fact that I have pierced ears. But, I am completely old-school because I've only got one hole in each ear. That's it.

Never went up the side of the lobe so I could add more studs and such. All I need is one pair of earrings a night.

Today, they'll pierce anything. And I mean ANYTHING. Nipples are nothing! Tongues? Ha! Girls will pierce that labia they just had reduced. Guys pierce the heads of the penises.[4]

But, this is how any fashion works. People do what other people do. This is what explains the mullet, blue eye shadow, and pants that don't cover your ass. For the record, I'm so glad this trend is on the wane. Why would pants not cover the ass? In fact, at some point you've got to stop calling them pants and start calling them socks.

It also explains why everybody of a certain age has tattoos and pierced everything. Because they saw their friends do it. Nobody wakes up and says . . . you know what I want? I want earlobes you can fit string cheese through. Hey, while you're at it? Put one of those gigantic holes in my nostril as well. The ones that came with my nose—they just aren't enough for me.

How did it start? Who was ground zero? Somebody that other people perceived as cool got a tattoo. And it must have been a really bitchin' tattoo. It didn't say "Mom" and it wasn't a rose.

I can't say who, but I'm sure it wasn't Popeye.

What I DO know is that, at some point, tattoo removal is going to be Big Fat Business. Why? Because once your Thorns with Skull-Flower tramp stamp starts to wrinkle you won't be so thrilled about the carbon-dating effect of a trend that tells the world you're sixty.

4. For the record, I always thought the plural of *penis* should be *peni*. Like *cacti*. But I'm not in charge.

I do have some really great ideas for fake tramp stamps that sport bumper-sticker philosophy. I call them "bum stickers." I'm going to write them on my hot girlfriends with Sharpies and send them into crowded bars wearing low-rise jeans. Then I'm going to follow them with a flip cam and record the reaction. For instance:

✦ *Drive it like you stole it!*

✦ *Don't laugh—it's paid for.*

✦ *If you can read this—I can slam on my brakes and sue you.*

✦ *Honk if anything falls off.*

✦ *My other ride is your mom.*

✦ *If you're not a hemorrhoid—get off my ass.*

✦ *Shit Happens.*

YouTube, baby!

What people choose to do—permanently—to their bodies is always amazing to me. I fully realize that some of the decisions I've made while influenced by booze—or, worse, youth—were just plain boneheaded. My ex-husband Sam once used a portion of his college tuition money to get a very large tattoo while absolutely SHWASTED. When I first saw it, I had a lot of questions. Like what was behind his desire to have a bicep-sized black panther adorn his body? His answer was entirely reasonable to anyone who's ever stumbled, shit-faced, into a tattoo parlor. He couldn't afford the tiger.

Someone once suggested that I should get a tattoo and couldn't understand why I didn't want one. I told him that I couldn't think

of anything I'd want to put on my body that I'd still be excited about in a few years. "What about your kids' names?" he asked. I told him that although I had a few, I was pretty sure I could remember them all without a crib sheet. Although, who knows, down the road when grandkids come and my memory starts to go—it could come in handy.

The point is that WE decide what's beautiful and what's weird and that can vary to the extreme not just according to different points in history or between countries but from block to block. You don't know what your neighbor's hiding under their business suit.

We've got those "crazy" Burmese women who grow their necks longer and longer by adding ring after ring so that pretty soon they look like Audrey Hepburn had sex with a giraffe and had a baby because that's "beautiful." Chinese women used to bind their feet—literally fold their toes up underneath the soles so that they could wear itsy-bitsy, teeny-tiny shoes that could easily hang from a rearview mirror here in the States. But look at the shoes we're stuffing our pigs into right here at home!

We decide pretty arbitrarily what's an "improvement" and what's "Holy shit, why would she do that?!" I mean, I like that I can use a little Botox here, a little Juvéderm there—I got some nice cheek-bones and those frown lines are pretty much gone! But I take one look at Jocelyn Wildenstein—or the Catwoman, as she's popularly known—and I say, "FREAK!" But if I'm honest, we're really just talking degrees, aren't we?

A round, voluptuous bosom is a good thing—until it's, like, "What are those, volleyballs under her skin? Doesn't that hurt?"

I think what we've learned here—if I may be so bold—is that some-body is always making this shit up as they go along. Whether you're

walking like an Egyptian with an ox-fat hat melting into your ears or cinching your waist so tight your eyeballs bulge out depends a lot on where and when you're born, right? So if it's up to somebody, why the hell don't we just leave it up to ourselves?!

I say let's decide what's hot and what's not—based on our own best selves. I know. It's radical. It's so radical, it's likely to get me arrested for sedition. But, it does seem ... um ... practical.

COUGARS ARE THE NEW HOT ASIAN

That's true this week. It may not be true by the time this is published, however. Because, as I've been pointing out for three chapters, whatever is in style right now will be completely different in a year or two. So if whatever it is that you are isn't cool—hang in! Because everyone's gonna wish they were you at some point in your life.

Case in point:

When I was growing up I got teased for having big lips and a big butt.

Now what, bitches?

Every woman in Hollywood pays big bucks for trout pout and I just saw ass pads advertised on TV. I almost started crying. They were even being modeled by a gorgeous Asian hottie. Asses are in. Saint Marilyn of the Monroe—they're officially back. All I had to do was wait 'til mine was halfway to dead—but they're back. And mine is still high and firm! Shit, I could probably bounce a quarter off of it with a few thousand squats. I'm totally thrilled. But it came at the expense of my self-esteem because up 'til now whoever decides these things decided that big asses were definitely not hot.

On top of that, I'm cougarlicious. I don't hate the phrase or find it predatory or insulting. If the word means I'm sexy to hot guys

and I remain employable, what do I care what you call me? But two years ago everyone was showing the hot Asian girl as the go-to default sex symbol. Now it's us—ahem—experienced chicks. So next week it's whatever you are—and then it'll spin back. What they tell us in commercials—does it reflect what everyone's doing? Or is it the other way around?

I started hearing the term *cougar* ten years ago when I was working in Vancouver right after I had the twins. One morning in the "works" trailer, one of the makeup ladies was saying that she and her friends had gone on a "cougar hunt" the night before. I asked what that was and she said that's when older ladies ("cougars") would go after younger men. Oh. OK.

I didn't really give it much thought until after my divorce when I started going out to nightspots and noticed that I was being heavily pursued by young—like stupid young—guys. I guess there was some rumor going around in their meetings or frat houses, or wherever they hang, that we had mad technique and they should all get them some. This went along with the MILF mystique, which was probably born out of the jack-off sessions inspired by their mom's friends 'cause, let's admit it, we do look pretty good. I mean, this ain't your mother's forty. The flip side is not entirely the same, though. I was always attracted to men my age. When I was twenty so were they. Thirty . . . OK, I could go up to forty, but that was about it . . . and so on. What does a kid have to offer me? I mean besides not needing Viagra?[1]

I was out at a great gay/mixed nightclub here in L.A. called the Abbey with a bunch of friends including celebrity pro dancer Louis

1. I am dating a delicious younger man as we speak. Not Lifetime Movie younger . . .
but younger. However, I lie about my age—so eventually he'll catch up.

Van Amstel. He was in rare form and we were grinding, he was getting his cocktail on, lots of action, lots of dudes strolling by checking us out. There was one young, cute guy who kept making the trip past our little corner, and each time, he'd try to stop and chat me up.

Finally he made his play and, having a boyfriend, I just tolerated him and told him not to waste his drink money on me, I wasn't going to sleep with him—so he should probably cruise elsewhere or he was going to wind up blaming me for boning him on not getting laid that night. He was also similarly direct and asked me, point-blank, where he could meet "girls like me." I asked him what exactly he meant by that.

"You know, hot girls . . . who . . . um . . ."

"Are old?"

"Well . . . yeah . . . you know, not old . . . but . . ."

"A cougar."

"Yeah."

"Well, do you think just any chick over forty is gonna be begging for it? 'Cause I'm pretty smoking—so if you just are going for 'sure-thing-desperate,' start at sixty, sweetheart. This is L.A. We *all* look good."

"OK," he said.

I was starting to enjoy this eager young man who wasn't overly hurt that I'd just told him he wasn't that big of a bargain to snag a woman twice his age. I decided to really give him the advice he asked for:

"Well, you probably shouldn't look for women at a mostly gay bar."

"Should I go to Firefly?"[2]

"Nah, the girls there won't give you the time of day unless you can help their career. What do you do for a living?

"Oh, I'm in the industry. I work at—"

"And be careful with your answer. They don't care if you're an assistant at an agency."

You could see the wheels turning: " —um . . . I'm in the industry . . . and I'm a . . . producer!"

"Aren't we all! Go get 'em, tiger!!" And I turned him back into the throng of young hotties dancing around us and shoved him towards his cougar-banging future.

I wish him a fond farewell and the best of luck in his search.

This was not my experience just two years before, however, when literally every single young unattached dude in Los Angeles had to stroll into the latest club with the latest Asian girl on their arm. It was sort of racist in a very fetishy, objectifying way. If I were an Asian chick two years ago, I'd be like, "What, you don't want to be the last one on your block not to bag one? I'm not gonna walk on your back and smile while covering my mouth, asshole." But I guess everyone likes it when they're the flavor of the week. I'm glad my flavor is coinciding so nicely with my age.

Next year will probably suck, though . . . but maybe the wheel will spin in *your* favor!

Or . . . we can all just recognize how stupid these "trends" are, and just go right ahead and like ourselves individually. Too radical?

2. A restaurant in the San Fernando Valley close to all the big studios and known for the heavy industry clientele.

Chapter 22

THE MOVEMENT

Here's where we bring the focus back to where we started: being "ass-tastic."

Let's not pretend that we are immune to other people's opinions of us. And when I say "other people" I mean guys. And when I say "us" I mean: how we look.

What I'm proposing is this: Why do they get to choose what's good or bad? Take back control!! Let's make this thing work FOR us— not against us, huh? If we all got together and put a different angle on body issues—like really highly paid political spin doctors—we could enjoy our lives a whole lot more. Or, at the very least, the occasional two-scoop sundae with hot fudge and caramel . . . ooooh . . . excuse me for a minute . . .

Sorry. I'm PMSing. I'm back now.

OK, look. We all know that all our body issues aren't going to change overnight—but in the meantime, there are things we can do to claim our dignity and stop the madness. First off, let's all just take a second and recognize that some of the things our bodies do are just downright miraculous and, Judd Apatow movie jokes notwithstanding, we should start bragging about our shit just like men do. Men's bodies do horrendous stuff, too, but they tend to be OK with it. Except for their penis not working, and going bald . . . everything else, they embrace! Hell, they brag about it. Gravity affects them, too, you know. One day, they sit on that bowl

and balls hit water. Gravity escapes none of us. But they don't kill themselves over it! They claim it! "Hey, honey, check it out. Look at 'em swing. I'm gonna take the boys out for a walk on a leash . . ."

Every time you get ready to self-inflict on how you suck . . . think about how a guy would be all satisfied and victorious if he owned the same body issue. Think about it: if guys gave birth, they'd brag even more than we do about how big their "area" got shoving that meteor-sized head through it.

"Dude! It was HUGE! My doctor said he'd never seen labia stretch that wide! It's *still* almost that big, man, . . . look!" Then they'd spend the next half hour pulling their tits down as low as they could go, measuring their nursing-distended nipples, and exaggerating the current width of their vagina. "Holland Tunnel? YOU WISH, ASSHOLE! More like the Delaware Water Gap!"

They'd have multiple-orgasm contests. Like with National Divisions and Energy Drink Sponsors. "Stay tuned for the International Come Cup Final Four . . . next—on ABC . . . brought to you by Pure Pink Fusion Juice . . . The Replenishing, Refreshing Drink of Champions . . . Pure Pink: For World-Class Orgasms."

We need to have pride in the fantastic mechanics and wonderment of our delicious bodies! We tend to be ashamed of our basic selves, whereas guys just dig that stuff about them. For instance:

Women tend to get embarrassed talking about masturbation. They get very shy and don't want to admit they've ever done it. Maybe it's because we don't have good names for it like guys do. Guys have great names for it! Creative, inventive, fun names like "shaking hands with the bald-headed champ." C'mon, that doesn't sound dirty or shameful! That sounds like an entertaining weekend activity! That's why we need to adopt that strategy. Claim the

event! Celebrate it by coming up with cute names for it, so we can brag to our friends! "What are you doing this weekend, Marge?" . . .

. . . "I'm wettin' down the Slip N Slide!"

. . . "Oh, I'm just . . . feather-dusting the Oval Office."

. . . "Detailing the ol' 'Vulva.'"

. . . "I'm finger-painting my Georgia O'Keeffe."

Claim it, I say!

Embrace our differences, be arrogant and sassy and bad-ass. That's the great thing about guys. They can rub a watermelon-sized gut, reflected in a full-length mirror in unforgiving light, and still be able to say with complete conviction: "You want all of this, don't you baby . . ."

Gotta love it.

But that's part of the charm of the self-confident. So the more we're ashamed of how we're intended to be—by nature—the harder it is to be powerful and sexy.

But I have a plan. A plan to reclaim our basic human right to be a woman—to have a woman's body . . . the way nature intended . . .

OK, here it is—the promised groundswell movement guaranteed to aid you in claiming all the splendor and wonderment that is you—just as you are.

Spread the rumor. It will work. Pass it on. Here it is:

I believe that God had a plan. Men are supposed to be hard and muscled. Women are supposed to be soft.

Guys are supposed to be tough and sinewy to kill the mammoth.

Bring meat home from hunt. Ug.

Girls have to have a little fat on them. Because fat allows you to make milk. Feed baby.

So that's Nature. Men: hard. Women: soft.

So if a guy wants you to be lean, hard, and muscle-y—like, you know—a *Man* . . . he's gay. That's the movement. Who's in?

Now, believe me, I've got NOTHING against gay men—hell, I marry them. But straight guys are usually really invested in everyone knowing that they're straight. Like, really.

So if a guy is shaming your roundness:

"Baby, maybe you shouldn't have that cake, 'cause . . ."

"Oh, I shouldn't?"

"Yeah . . . your tummy's getting just a little soft."

"Oh. So you want me to have a six-pack? Like a cage fighter? How about I grow a penis, too?"

"Hey, hey, hey . . . wait a minute . . ."

Seriously, if straight men start thinking skinny women make them look gay—watch 'em start fattening you right up: "Get in the car, honey, we're headed to the Hometown Buffet!"

It's pretty dumb, if you think about it—their dedication to having bone-thin women on their arm. What's that about? "I want my woman starving and weak like a baby bird so I can control and dominate her and feel like a big strong man"?? What the . . . ? Do they want us to starve to the point of weakness so they can parade

skinny women around to their friends? How does that make them the winner? Their chick is the skinniest on the block?

Then they don't understand why we're in such a bad mood all the time. Uh . . . we're hungry. We need to *eat*. If they were giving their bodies only half of the food it needed, they'd be bitches, too.

They're all confounded by it: "Baby, why you being so mean? I mean, it's been a while since you . . . you know . . . how 'bout a little . . . you know . . ." ("You know" is code for "oral." Just like, "Come on . . . it's my birthday . . ." is code for "anal"[1]). Then they don't understand why we're not in the mood. Put some chocolate syrup on it, watch us go! Then they'd be bragging about their chocolate-loving, voluptuous wife. They'd be all, "Your wife is the skinniest? Well, my wife has energy and is calm and happy. Oh. And she BLOWS ME ALL THE TIME! I win, HA-HA."

Also, throw this in:

If they're worried about your ass—it's 'cause they're afraid it makes their junk look smaller. If they have a problem with your "size"—it's probably 'cause they have a problem with their "size." Mm-hm. Start throwing that around town!

You all mark my words: THIS WILL WORK.

If guys think girls will announce that they're not only *straight* but *hung* and satisfied orally . . . it's DAIRY QUEEN FOR EVERYONE! Guys will start viewing big women as the new "must have" accessory. Big girls will be the new iPhone!

1. Which always kills me. What do they think we have? A birthday cake up there?

Chapter 23

HOW TO SAY NO TO THE
SELF-HATE PITCH

OK, so now that you're hip to all the triggers of your self-loathing, and how products and advertising and our youth culture coaxes you into spending your hard-earned dollars on stuff that's supposed to make you look like you just spent a week in the Caribbean . . . except it costs the same as a week in the Caribbean but you don't get to suck down even one piña colada while overlooking a crystal-clear turquoise ocean . . . here are the words they use to get you to skip that sun-drenched vacation:

Words you hear:

Luscious
Soft
Carefree
Smooth
Firm, flat, toned
Fresh
Silky
Lustrous
Thick (only for hair and lashes—not for thighs or waist)
Youthful, rejuvenating
Glowing
Luminous
Vibrant, vivid
Tighten, contour

"Scientific" words include:

Antioxidant

Enriching

Collagen[1]

Exfoliating—which is the new "sloughing." 'Cause that sounded gross and sort of lazy. By the way, it also works. But so does salt and sugar, and they're almost free.

Nano-technology, micro-beads, micro-particles . . . your whole *micro* family.

Any form of "serum." Preferably in a glass-tipped vials you have to break to use.

Hydrating, nourishing, emulsifying

Amino peptide complex

Anything "pH balanced"

Words they hardly ever use to sell you stuff:

Dry

Flaky

Scaly

Gristly

Greasy

Loose

Flabby

Raw

Protruding

1. Which only works if it's injected into your skin because collagen is in the dermis level of your skin, not the epidermis, which is the part that's visible. And even if it's injected it doesn't work. I learned that while selling cosmetics. Also the only chemical ingredients that work in moisturizers are squalane and allantoin. Read your moisturizer ingredients before you shell out a month's worth of groceries on shit that doesn't work. That sentence just paid for this book.

Pointy

Boney

Stringy

Crusty

Yellow

Old. Or anything that suggests "old." The closest they come is "classic." And that's normally reserved for cars or Coke.

So, instead of spending wads of cash on stuff that just sounds food, I'm offering some swagger-building tips—and they won't break the bank!

13 Ways to Improve Your Self-Esteem That Don't Cost You a Dime

+ *Always be seen with decrepit old men—you'll look young and beautiful in comparison. Think how well this works for those Girls Next Door. Who DOESN'T look beautiful next to Hugh Hefner? . . . The Crypt Keeper? Clint Eastwood? I'm just sayin'.*

+ *Keep a recent photo of Meg Ryan or other plastic-surgery cautionary tales on your bathroom mirror to remind you of what could happen.*

+ *Four Words:* **Push-up. Bra. Construction. Site.** *You don't even have to look good to get a response. Just wear sunglasses, square your shoulders, and toss your hair. Then count the whistles.*

+ *Start frequenting your local gay bar. Both gays and lesbians are much more effusive about how fabulous you are. And you'll get free drinks!*

✦ Watch a lot of trash TV. I recommend Maury and Springer. Because unless you're on your third "Mystery Baby Daddy" and your stretch pants are straining to keep all of your ass contained inside of them, you'll feel like a Kardashian! . . . Oh . . . wait . . . well, you'll feel better anyway.

✦ When you get your check cashed, get all singles. Carrying a wad gives you that Oprah swagger! Just don't get side-tracked at Chippendale's.

✦ Budgetary-influx generators. Just a fancy way of saying grocery coupons. Never underestimate the power of military-style euphemistic bullshit! If it's good enough for our government, by God, it's good enough for you, missy.

✦ Designer clothes are expensive, but labels are cheap. Carry scissors to the mall and don't be shy. When your jacket says Donna Karan, you feel just a little sassier! However, just once you should save up and spring for some La Perla panties. There ain't nothing on this planet that will make you feel better than a pair of fifty-dollar drawers. If you have to take a second on your condo for the bra—do it. Whatever it takes. Trust.

✦ Quit slouching. Not necessarily funny, and I sound like your mother—but it's true and it works. Stand up straight. You'll lose five pounds, gain a cup size, and walk like you know you're the shit and everyone else better know it, too.

✦ Get up off your ass and help an old lady cross the street once in a while—or help her get her groceries in her car. It's good for your soul AND your quads. Then make sure you

*accidentally let that information slip as much as possible
for the rest of the day.*

✦ *Read the* **New York Times** *book reviews and spout off.
Preferably with a French phrase. The same one will do for
every book—just make sure you use it at different cocktail
parties. Oh, and learn this follow-up: "Well, that's just
subjective, isn't it?"*

✦ *You never have to buy an issue of* **Cosmo** *again to be the
"Best Lover He's Ever Had." Just remember this phrase:
"Oh my goodness, I don't know if that will fit." Then start
mentally picking out jewelry.*

✦ *A really gross pimple becomes a lovely beauty mark with
just a touch of waterproof mascara!*

The stupidity of some of these products that they convince us we
need and will make us happy and beautiful is so outlandish that
some of them seem made up. The Abdominizer? Do you need a
piece of plastic behind your back while you do a crunch, really?
It's like a broken bucket car seat. If something is helping you do a
sit-up—it's not really working, is it? Isn't that what the ab muscles
are supposed to be doing? That's kind of the entire point. But
they sure sold a lot of them, so what do I know?

I got to thinking, if they can sell us fen-phen, battery-operated
muscle-stimulating exercise girdles, and caffeine-based cellulite-
reduction creams—why not get in on some of that snake-oil dollar?
I like money as much as the next person. And if any of you see these
products advertised on an infomercial at 3 A.M.—call my twenty-

four-hour litigation hotline and I'll cut you in on a percentage. 'Cause someone will probably wind up doing these, too.

....................................

Dear Orly Nails,

I'm writing with a request for a product that you don't seem to offer as of yet, but one that I think may be the "next big thing" in nail "accoutrement." That's French. As is "cuticle." I looked it up.

I'm a big fan of how my fingernails smell after I chop garlic. The smell stays on for days. Not only because I don't like to overwash my hands (I don't want them to look old like my grandma's) but because, I believe, garlic smell tends to linger. Particularly on nails. I often find myself enjoying the smell on my fingers while watching a movie or within the privacy of my "cubicle" (not French).

My tendency to fixate on one certain sensation usually winds up with me in a rut. In this case, a garlic-scented rut. I would like to suggest that we work together to create a line of "Flavo-Nails" to satisfy your customer that is like myself. An unapologetic finger-sniffer.

In fact, I'd love to have a variety of, not just scented, but flavored nail polish as well. (I got the idea from the wallpaper in Willy Wonka. But that should be our secret, don't you think? As "co-inventors"? I mean, we don't want a lawsuit.) Anyway, I love to lick my fingers, but I'm trying to lose weight, so I don't want to put real food on them. Plus the peanut butter keeps making my steering wheel sticky.

The only problem is I don't know where you get the smell/flavor from without using the actual oranges or fish or whatever. Maybe you could talk to the Jelly Belly people as they seem to have access

to all the flavors. Do you know anybody over there? Maybe we could ask them.

Looking forward to working together—and to enjoying a different assortment of smells and flavors on my fingers in the near future,

Cathy Utley

P.S. I'm reserving the right of full ownership until I hear back from you in what is sure to be no time at all. You should know that I also have OPI's email address. I'm not interested in Sally Hansen as they don't strike me as being a forward-thinking and modern organization. Even if they write me back now, I wouldn't work with them.

.......................................

Dear Mr. Eli Lilly,

Love your name! But, then again, I really respond positively to L's.

I want to start off by saying I respect your company and all that you stand for. Although I'm not sure what you've invented lately—I see your name on lots of my meds, so I know you're good.

I'll get right to the point, because I know you're busy making lots of things that improve the lives of many people besides my friends that enjoy your Cialis.

I want you people to cure cellulite.

I have done the math and I've spent what could reasonably be considered the gross national product of a really poor country—like Somalia—on my thigh-cheese.

I have a few suggestions, just so you don't think I'm putting the entire burden on you—Eli. And I hope I can call you Eli. I don't want to seem forward, but I've already been very vulnerable with

you about my leg condition. I never want to appear to be just a whiner—always carping about the problem but not offering a solution. So here's the thing I've been working with that has gotten me the best results:

Cat pee.

I know the smell is unpleasant—and just so you don't think that I'm weird and just started with cat pee for no reason—understand that I was desperate and had tried almost every personal grooming item, household cleaning product, and organic foodstuff available to me over a very long weekend.

The "Aha!" moment came when I noticed that the rug where one of my cats likes to pee most often (it's not his fault—he's smaller than the other five, so he's usually forced out of the litter box) had lost its textured pattern! It literally "smoothed" out the grooves and wrinkles! And I said to myself, "Hey! I bet that would work on skin! It's a lot softer than this carpet!" I literally said that out loud to myself. It's a good thing I live alone.

So I did try it on my wrinkly, textured thigh meat and guess what? It's really evened out the texture! Like by . . . oh, I'd guess, maybe 30 percent! Anyway, a lot more than that stuff I bought for ninety bucks at Dillard's that promised "a noticeable improvement" and also a free tote bag. What I got was a ninety-dollar tote bag that I can hold in front of my fat, lumpy legs at the beach. Though, the tote bag did cover about 30 percent of my thighs, so maybe that's what they meant.

Thanks for getting right on this, Eli—I can't wait to also buy some of your Cialis to use once I get my body to where I wouldn't mind someone seeing it naked.

Cathy Utley—future thong bikini owner (fingers crossed!)

Dear Eli,

I've come up with a great name for our cellulite cure using cat urine (which sounds better than "pee." I ran this by a couple of people at my bingo night, and they tended to respond negatively to "pee" as a body treatment. Except the Russian lady. Apparently, they use pee for everything. But I want to scoop them à la the "Space Race." I want Eli Lilly to be the John Glenn of the War on Cellulite. (Or Buzz Aldrin, if you prefer. I know he didn't do anything first, but he has the cooler name.)

Anyway, the name is "Feeline Good." (Get it?)

I love the name, and feel that goes a long way to marketing the product, but I am running into a number of challenges regarding our joint venture.

First off, we're going to need a lot more cats than I have. I only have two thighs, and it takes six cats to keep up and I'm giving them water four times a day.

I figure you guys have the facilities for a lot more cats. But, fyi, the shelters won't let you take more than four or five at a time before they want to know what you're using them for. (Don't get me started.)

Also, not everybody has Berber carpet that their cat has peed on to rub on their legs, so we'll have to figure out how to get the cats to pee where we want them to—so far I haven't had any luck with that. So you guys need to get on that because we need a way to get all of it to sell to the department stores. That's called a "Universal Delivery System." (Thanks Wiki!)

Also, if you could get your chemists to figure out a way to get the smell out of cat pee, that'd be really good. I mean it doesn't make

much sense to get your body to look good enough so it doesn't make a guy want to throw up—if the smell does.

If you could get back to me as soon as you've ironed out those kinks I'd appreciate it as I have an outdoor wedding event next weekend that might involve bike shorts.

Signed,

Your partner, Cathy Utley

· ·

Dear Eli,

We've been through so much together that it saddens me to have to write to tell you that you should stop all testing and development on "Feeline Good." If orders have been placed to your company from Dillard's—you should just tell them that I said never mind.

It turns out that the 30 percent reduction of cellulite I'd attributed to the cat pee was actually more a factor of my light bulb being out in my bedroom.

So, the bad news is there's no end in sight for my thigh cheese.

The good news is I found my eight-carat Joan Rivers Collection "Amethyst-ish" Cocktail Ring amongst the dust bunnies under my chaise longue.

Thanks for always being there for me,

C.U.

· ·

Dear Lexus,

I'm writing to you because I have a product idea that I think could be an accessory option in your upper-end package.

I almost always run late for work. (It's that darn Fox and Friends. Not so much the Fox, but the Friends.) Anyway, when I show up to work without makeup, I get poor reviews. Not to mention the fact that I think it is unfair to my co-workers to subject them to my actual face.

Putting on my makeup in the car is a way to solve everyone's problems. However, it is illegal. Well, if not illegal, other drivers give you dirty looks so it's just as bad.

So, my idea is called the Sneer Guard. Much like a sun visor, it would fold down from above—but on each side of the driver's head—in the shape of and painted like a human profile, thus creating the illusion of a driver paying attention to the road. This way, I could apply my lip liner and mascara in peace, without suffering the judgment and verbal abuse of foul-mouthed fellow drivers.

You could offer this as part of a premium package aimed at the ladies. Research shows that women lead the way in major household purchases, of which cars are surely one, along with dishwashers, retractable awnings, and customized rascals, just to name a few.

Oh! Another idea for women would be a bedazzled cup holder, and an attachable "steering wheel book snuggie" TM (That's trademark, but I don't know how to make it small) for when we find ourselves in boring traffic and Nora Roberts is just going to waste in our purse.

We could call the package the "Vagi-hicle." Unless that's too clinical and then I'd just go with Pussy Wagon.

Yours in Christ,

Cathy Utley

● ●

Dear Home Depot,

I had the opportunity to wander through your boulevard-sized aisles last weekend and it occurred to me that you don't have a lot of products to attract the ladies. Sure, there's some stuff I like and will stop to take a gander at on my way to pick up my CFL light bulbs (you have a much better price point than Target, so kudos. "Price point" means how much it is, fyi). I like the paint colors and I enjoy the kitchen displays. I like to stand in them and pretend they're mine. I did get a "look" from one of your surlier customer-relations assistants when I put on the oven mitts on a previous trip—but overall those are my favorite areas. I mean, sure, there's rugs and some lawn furniture—but mostly it's a lot of lumber and PVC pipes.

So I was very excited when it occurred to me while working with some of your smaller hardware items that there was a line of products that is comprised of inventory you already have in stock—but that is geared towards us gals.

It is a beauty tool that I like to call the "Fat Clamp"—mostly because I haven't thought of a better name yet. It works on the same principle as a dress cincher. You know those elastic dealies that people wore in the '80s? Except this would pull the actual fat. You could use alligator clips on each of your hips and connect them with some twine—or, in extreme cases, a bungee cord—to pull the problem areas back and out of sight.

This could also be used on thighs, with smaller clips. I've had the best result using ratchet clamps for the larger areas like postpregnancy bellies, but they do tend to severely restrict blood flow. Your manufacturers should get on that ASAP, as I did get rather faint in the plumbing department while doing a test run.

I'm sure they could come up with something less binding and pinching but still just as effective. This could be combined with a winch to raise up large behinds. You could probably even find a way to use some of that PVC pipe. You have lots of it on aisle 9. I will admit that I've had a problem with long-term wear as the attachments get really sore after about twenty minutes. Even sooner with the ratchet clamps. The longest I've gone with the clamp hoisting my belly is from Power Tools to the Lighting Fixture Department. Which is also lovely, by the way.

I've also had a few incidents resulting in blood blisters, so it's not perfected as of yet, but I feel very confident in our mutual development abilities. Your customer-relations assistant did make me purchase the one that he saw cause one of these minor wounds. I guess the Home Depot has a "You bleed on it; you buy it" policy. But, no big deal—as soon as we're in business together, I can write it off on my taxes. A small price to pay for providing such a service to flabby folks the world over, in my humble opinion.

I would be very interested to hear your thoughts on Velcro and sustainable hemp for the crunchy granola crowd in our next conversation!

Formerly Fluffy Fan,

Cathy Utley

• •

Dear Hoover,

I have long been a fan of your work. When I say, "You suck," it's a compliment, take my word for it! Ha-Ha LOL. I think you are the name when it comes to all things vacuum related. And that is why I am making you my first stop for sharing an idea that's just waiting to explode.

But first, let me give you a little insight and background into what inspired my "Eureka" moment. Which, I realize, is also a vacuum brand—so no offense intended. It's merely a turn of phrase. I have never owned a Eureka, nor have I written to them. Yet.

I am not what you'd call rich. I'm not considered beautiful. I do enjoy some of the finer things in life, however, and have always been clean. One of the main reasons I'm such an avid customer of your products. At least that's what I put on my Match Dot Com profile. You'd be surprised how many ex-, and not-so-ex-, cons respond to cleanliness.

What I'm trying to tell you is that I like to visit high-end department stores every so often and on a recent trip to Neiman-Marcus I was thrilled to learn that expensive stores that cater to pampered women with large disposable incomes have cafés where they meet and discuss numerous interesting topics. I don't know if you've ever been to one of these "lunch rooms," but they are full of really, really pretty and thin ladies that give each other the secrets of their otherworldly—sometimes downright alien—attractiveness and eat exactly the same thing as each other.

They all seem to order iced tea and salad and they look eerily like one another. But they all look so much like the ladies on the television in sequined gowns pointing to game-show prizes that I was mesmerized and knew that I must learn their magic. I sat at various tables for close to four hours drinking several gallons of iced tea, occasionally moving to a new table when the nearest table would notice me and lower their voices or ask to sit in another section.

The secret seemed to be . . . and I could hardly believe it myself . . . oxygen.

It turns out that oxygen is not only necessary to breathe, but if you get extra of it on your face, it turns you beautiful. The "oxygen facial" was the term that I heard most often, but there were also oxygen bars and oxygen-infused soaps, lotions, and even candles. How you get oxygen into bars, I have no idea and we might need to include Hershey in a group partnership for that—but the oxygen facial was the thing that I knew only you great air experts over at Hoover could create for those of us who want to look like the beautiful ladies who have time to linger over uneaten salads.

This is where I am so far: When I went home the first thing I did was grab your Duros Power Nozzle and hit the reverse button that blasts air instead of sucks. The next thing I did was to use my emergency eyewash and empty the dirt container and then try again. Then the air came out a lot cleaner. I aimed it at my face and it seemed to be getting a lot of oxygen on my face. I felt that it was not circulating the air around my face as much as it should and I didn't want just one stream hitting me head-on. After all, I don't want just one part of my face to be beautiful and rich. I would really like for my entire face to get the benefit of your youth-producing oxygen.

So that's when I grabbed my dog's cone collar and snapped that bad boy on. I stuck the hose up through the neck and except for the chafing of my neck and choking feeling, I thought I got lots of oxygen on my face.

I think that you could probably make a home oxygen kit that would help other future lovely ladies such as myself while also being affordable to those who can't afford spas—not to mention those without pets from whom they can steal medical equipment. My dog has chewed a portion of his toe off, but I feel

the comparable benefits to his mistress are more than worth his trouble. I will replace the cone as soon as I make another vet visit, don't worry!

I truly believe that the wonderful beautifying effects of this "oxygen" will be the answer to many prayers of women the world over who have been just waiting for the day when someone, anyone would give us the secret ingredient to being gorgeous. Who knew it was something that surrounds us . . . for free . . . all the time!? The exciting news for my favorite appliance manufacturer, Hoover—not Eureka, I swear—is that you can still make money from it!

All you have to do is create an attachment and call it the Oxygen Facial Feature. It's really just a dog cone with a hose running through it—but no one needs to know that! This way, women can feel beautiful—or, at the very least, that they're doing something about being ugly. And you guys can continue to operate a factory in the United States instead of moving to China like everything else . . . unless you're already in China. In which case . . . um . . . well, who doesn't like lo mein? But, whatever, you still make really great vacuum cleaners and I like the cut of your jib.

I am only hoping to keep the patent in case Eureka decides to rethink its position on this incredible opportunity. I'd like a percentage of the profit and a choice of your steam cleaners as my dog had an allergic reaction to the ointment on the toe that he chewed off and it resulted in an unfortunate bowel incident.

With great hopes for making the world "Hotter by Hoover" and our Oxygen Facial Feature.

Cathy Utley

The Best Version of You: The Good Stuff

OK, that was fun. However, I bet that some of these products really exist. Or they're on their way to being mass-marketed. Personally, I'm looking forward to the Fat Clamp infomercial airing at 3 A.M. When I wake up in a cold sweat on Thanksgiving night—panicked about my pie consumption and slipping into a stuffing-induced paranoia regarding my post-holiday weight class—it'll be great to have something to lull me back into a soothing sugar coma until after New Year's dinner.

The ridiculousness of some of the things we all put ourselves through in order to be "perfect" is not too far off from some of the silliness above. I claim all of my efforts. I laugh about some of them (Cookie Diets) and cry about others (the time, money, and energy I spent trying to change a perfectly luscious butt).

We are all on a mission to feel good and it is not going to stop anytime soon. Sometimes we just confuse feeling good with looking good. I know! It's so weird! It's not the same thing!! After a lifetime believing that "Beauty Equals Pain," I'm ready to give it up, though. Not the high heels or the bunions that go with them. And not the clip-on hair . . . well, not a whole lot of the beauty-aid extras, honestly. But here's what I'm ready to give up—I am ready to give up how bad I feel that I'm not perfect.

Perfect isn't the girls in the Vicky's Secret catalogue That's perfect airbrushing.

Perfect isn't the ladies you see on television or in movies. That's good writing, good lighting, and PR.

Perfect isn't the rich women who run corporations or tell us how we

should be to be more wonderfully like them. That's a nice idea—but there's only one Oprah and I'm not her, nor am I ever likely to be and I'm OK with that!

Perfect isn't happening, for me. I'm pretty freaking cool, though. I'm totally rocking the Best Version of Me.

But giving up being perfect doesn't mean entirely giving up, either! I don't want to make it sound like I'm suggesting to just throw in the towel and let your armpit hair grow. It's not working your way through all "31 Flavors" or pulling up to the buffet at Sizzler like it's a trough. I'm not planning on thinking I'm perfect with out-of-control gray hair and stained sweatpants from Goodwill. I'm still gonna work it. I'm just not going to give up FEELING GOOD for looking good.

Part of feeling good involves having a cross selection of good stuff in your life. So I recommend surrounding yourself with a few nice things. I also think treating your body well is absolutely necessary.

+ *One fifty-dollar pair of panties, as I've said—ain't nothing like it.*

+ *Maybe some high-thread–count sheets (always a sale somewhere).*

+ *Indulging in luxurious baths when you can grab twenty minutes. The 99¢ Only store has lavender products, too.*

+ *Regularly moving so that your body stays limber and working and makes you say to yourself when you pass that storefront window reflection, "Yup. That's my snacky ass. It's right there, bouncing behind me. Whoever's following me sure is lucky."*

And it means feeding it—the good stuff. I'm never going to give up the joy I get from cooking and eating good food. I just make it "The Best Version of . . ." zucchini muffins. Or Christmas dinner. Or Spaghetti Sauce and Meatballs . . .

That's the final free gift you guys are getting from me—don't tell anyone you have it. It's a family secret. And you know how Sicilians guard their secrets. But you guys are my friends now, so here it is:

Bonus Recipe

Life is tough. And overpriced. As well as overscheduled.

Between the job and screeching around to five or six after-school activities while screaming reminders about homework assignments and shin guards, cooking dinner is the last thing anyone wants to deal with. A bucket of chicken starts to feel like a pretty darn good idea. I know. I've been there. The Colonel is a gigolo. A silver-haired, smooth-talking, finger-lickin' succubus who takes our money, our self-esteem, . . . and just a little of our soul every time we're seduced by the lure of quick, greasy, naughty goodness. Each time we promise ourselves, "This is it. This is the last time." We know we're lying. We'll be back. For more of that big pimpin' taste.

He knows it, too. He's got us.

We have to fight back. The only way to do it is to have that good stuff waiting for you at home. That's right. A fridge stocked with Tupperware tubs full of good home cooking. "But who has time?" you ask.

That brings me to the Working Parent's Savior: SUNDAY KITCHEN-PALOOZA! Three hours out of your week to CELE-BRATE THE ITALIAN MAMA THAT LIVES INSIDE ALL OF US.

Here it is:

OK. Here's what I know—*Nana's Sicilian Sauce* is good stuff and it tastes good on anything. Now, sharing this recipe with you is one step removed from breaking the *omertà*[2]—but you bought the book, so I feel I owe you a favor. Now one day . . . and that day may never come . . . I'll need a favor from you—but for now . . .

The Sauce!

Get yourself four large (28 or 35 oz.) cans of PLUM tomatoes.

Rule Number One: Making quality tomato sauce—use quality tomatoes. And one little can of tomato paste—Contadina is good. You only need the one can of tomato paste per pot of sauce.

Open all of your cans. And wash your hands. Actually, wash your hands first—then wash the tops of the cans before you open them, 'cause you don't know what kind of rodents are river-dancing on top of 'em in the warehouse. (There. I just channeled my mother.)

Mince (or just mash with the side of a large knife) at least six cloves of garlic. More is better—depending on if you care about your breath or your flatulence or anyone close to you caring about your breath or your flatulence.

Rule Number Two: A good sauce needs a good, HEAVY-BOTTOM sauce pot. Seriously, it has to have a *really* heavy bottom so the stuff doesn't stick, get brown or bitter.

2. The Sicilian code of silence specifically regarding criminal activity. Like racketeering. Or putting plastic on lampshades (this should result in several code violations of Interior Decor Standards and Practices).

Rule Number Three: NEVER USE A METAL SPOON. ONLY WOOD. This is crucial.[3]

Put like, a tablespoon of good-quality olive oil[4] in the bottom of that big sauce pot. Turn heat on high, add chopped garlic, and— now this is crucial—DO NOT BROWN. (See HEAVY-BOTTOM pot, above!) If the garlic browns it will turn your sauce bitter and the only thing bitter allowed in my kitchen is me. Or my mom. Or my Aunt Iola. OK—all the women in my family.

Anyway, you just sizzle it 'til it's nice and fragrant—which is when someone comes in the house and says, "Oooooohh . . . what are you making?!!"—and before it has a chance to get brown and nasty (just yellowish and smelly). Then you add the can of tomato paste.

Rule Number Four: The proper (or at least the smarter) way to open tomato paste: Open both ends of the can. Throw one end out. Use the other end to push paste through, like a push pop. Or a tampon tube.[5] Then you use your WOODEN SPOON (see Rule no. 3) to mash up the paste with the oil and garlic. Quickly. DON'T BURN IT. Or my nana will come to get you like Freddy Kruger in an underlit children's camp inexplicably populated by topless teenagers.

Add a little water to make it easier to stir and then add your cans of tomatoes—which you can squish with your hand before going into the pot. (Don't give me that look, just squish 'em ya cake-eater. I told you to wash your hands!) Then put one layer of dried basil on

3. I don't know why—I don't know physics. It has something to do with acid in tomatoes plus metal equals nasty-ass retirement home s'getti Wednesdays.

4. *Good-quality* means whatever is imported from Italy at Costco.

5. This is the stuff you never find in a cookbook—your mom has to show you.

top of the pan—I don't know how many tablespoons that is—just one flake thick across the whole top of the pot. Jeez—it's cooking, not uranium enrichment.

(Note: The following should be read with a Brooklyn accent.) Cook for an hour—good hour, hour and a half—then you add your meats, cook for anothah good hour, coupla two, tree hours—yeah—it comes nice. Oh—you godda stir it every coupla fi-teen, twenty minutes, so's it don't stick.

(Back to regularly scheduled accent.)

"Your Meats"

OK, this next part is completely up to you but I, personally, like a good meatball. I like meat. I like balls. So meat AND balls, what's not to like?

You, yourself, might wanna add pre-sautéed ground white-meat turkey.

Which is fine. If you wanna ruin your sauce. I think there's nothing wrong with lean beef and pork—You heard me! PORK. It's the other white meat. You can cook the fat off. Watch . . .

Get a pound each of lean (85 percent) ground beef and pork. If your store doesn't have lean pork already ground, get a package of lean loin boneless chops, hike up your cleavage, and march yourself over to ring that butcher's bell and tell that man in the white coat that he'd be your hero if he would please grind that up for you—and now? Before you get back from the produce section? He'll do it. That's what those guys live for.

Then you add those two meats along with:

— 3 **eggs**

— 1 bunch of **WASHED chopped curly parsley** (or "Italian" whatev . . . I think the regular has more flavor)

— at least 2 cups of **Progresso Italian bread crumbs**

— a shitload of **powdered garlic** (NOT GARLIC SALT. Good googa-mooga. You don't need extra salt when you have cheese. Cheese is salty enough. Thanks, Mom.)

— and a coupla handfuls of **grated Romano** (there's your cheese). And not the stuff in the green can. That's not even cheese. I don't know what it is, but my boyfriend tells me that they did a study in his Organic Chemistry class at UC Berkeley and it has the same chemical components as plastic. No shit. Like plastic cups and Saran Wrap. And I don't think our bodies can process that.

So, you squish all that stuff together with your very capable hands (THAT YOU WASHED AGAIN AFTER THROWING THE CANS IN THE TRASH . . . thanks again, Mom) and make balls about the size of . . . well . . . balls. (I'm talking normal, everyday balls—not some kind of Ron Jeremy, circus-sideshow balls.)

Then you put them on a broiler rack on top of a cookie sheet, throw 'em in the oven at about 375, cook the crap outta them (that's like thirty minutes) so all the fat drains off, and throw 'em in the sauce when it's "meat time." You can also use just the chunks of pork cut up and cooked in a little olive oil and garlic. But pork is key for good flavor. Trust.

You can also use sausages (look, they even make low-fat Italian sausage—hot or mild—out of chicken these days. Go nuts. But make sure they have fennel or they ain't the real deal. And cut the mild ones in half, the hot ones in quarters so people know the difference or your pansy-ass guests afraid of red pepper will whine at you and go running for water). Book Two will include a recipe for braciola—old-school. You're not ready.

While the meat is in the sauce, bubbling away—and in between stirring and wiping the gravy splatter from the stove (they say gravy in N.Y., Jersey, Staten Island, and Long Island. I don't know why, but maybe 'cause it "comes nice")—start your spaghetti squash.

Pretty simple:

+ *Take a giant spaghetti squash—the ones that look like yellow footballs.*

+ *WASH IT. 'CAUSE . . . YOU JUST DON'T KNOW.*

+ *Crack the small end on the counter to "split."*

+ *Stick a large knife in the split and separate to "halve it."*

+ *Scare yourself shitless when knife pops out of squash, nearly blinding you.*

+ *Call closest strong male to do the stupid fucking thing.*[6]

When it's safely "halved," use whatever's handy to scoop out disgusting jack-o-lantern-carving pumpkin-type innards. WASH THE

6. If you don't have a strong male around, that's what eHarmony is for. Guys love it when you ask for their big, strong help (like when you ask the butcher to grind the pork). You wanna hook up? Tell a guy you need his burly muscle strength so you can make him something delicious to eat. Then email me with the wedding date: misslisaannwalter@gmail.com.

INSIDES, TOO—'CAUSE . . . Well, you know . . . geez, Mom, I know! I'm not twelve!

Get a roasting pan, put about an inch of water in the bottom, and put squash halves face down (that's the carved, open side) into pan, pop into the same 350–375-degree oven for, like, forty-five minutes, 'til they're starting to turn brown at the edges.

Take out of the oven, use a fork to pull out, and place on counter.

Then, and this is very important: DON'T TOUCH IT! What are you crazy? It just came outta the hot oven! That's like when you go to eat and the waitress says, "Be careful, that's a hot plate," and every yahoo feels compelled to touch it anyway 'cause we're morons. Listen, I was a waitress for ten years. Yeah, that's right, proud of it. And I know why the plate's hot. 'Cause I left it sitting on the "line" under the heat lamps while I grabbed a smoke and talked to my boyfriend about who's picking up the Meister Bräu for the party later (this was a few years ago, so don't judge me). I KNOW it's hot. I'm not kidding. Unless you've waited tables for a decade and have asbestos hands like I do—DON'T TOUCH THE SPAGHETTI SQUASH! Wait about fifteen minutes, finish wiping the splatter from the stove, the backsplash, the dog—whatev . . .

Throw a handful of that grated Romano cheese into the sauce and stir it (that's instead of salt, remember? And no other seasoning, OK? No onions, oregano, none of that stuff). Then turn it off and let it . . . just . . . be.

Then you scrape out the insides of the squash into a bowl. With whatever's handy—I like an ice-cream scooper! Then you put it on a plate, add a whole buncha sauce (or gravy, if you're in Hackensack), a little bit of grated cheese, and eat. You'll probably only be able to finish half. Enjoy, you're full. You're not feeling guilty. It's good.

ACKNOWLEDGMENTS

Mom (aka, CG, Nana): For thinking everything I do is much better than it is—and much better than anyone else could possibly do it. I'm going to put the world on the phone with you so you can explain to them how awesome I am. For teaching me to love old movies and reading when I was three—thank you.

And for still beating me at *Jeopardy*—you are the Queen.

Michael Broussard: Idol-maker. Cover Genius. There was no reason for you to get behind me—except that you liked me and thought I could tell this truth in a funny way. I found a kindred spirit. You are all heart and passion. Thank you for turning your magic on me.

Nora: You are my voice. In every writer's room. When I needed a line, or an opinion grounded in actual fact or a judgment-free supportive ear. This book could not have happened without you. I wouldn't have believed it could happen. You are my partner. But not in a sexual way.

Nancy Hancock: You're smarter and know more words than I do. And, more important, in what order they belong. I say that to no one. Thank you for lending me your extraordinary, talented mind. Your ass is also quite talented. (White pants . . . Jus' sayin'.)

Michele Wetherbee: Many people have told me, "I'd buy that book by its cover." Thanks for staying on message and for your wonderful eye. And for all the fun we had on shoot day. You are truly "hands on" (tee-hee!).

The HarperOne Team: Thank you for being so supportive and for guiding this novice through the rigors of launching a book. I feel semi-initiated into a really elite club. When does the paddling and forced drinking begin?

Laura: You are the best big sister—but, more important, best shopping buddy and reality-TV-watching partner a girl could have. It's too bad everyone else is getting old while you continue to be younger and more beautiful than ever. Sucks for us!

El & Dee: For being part of the O.G. team. We pretended anything was possible—and made most of it come true.

Jilly S.: The best place to sleep in NYC—with the most supportive, tolerant friend (and the greatest coffee!) and Jack W. from Queenstown to taking care of CG—you are the balls.

Julie S.: For being my friend even when I was a disappointing selfish twat. And staying my friend even when I was a sober disappointing twat. And being my friend now.

Elaine H.: For being an awesome red-carpet/charity/swag-bag partner in crime. And all the other times we hold each other up in this freakshow.

Rosa: For making me laugh—always—lending me your "writer's retreat" and not blaming me for killing Beau.

Nancy: For having the most unique and entertaining way of communicating of anyone I've ever met. I can't wait to see what you come up with next.

Elaine M.: Has it been this long since we were children? You still have a dancer's body and the heart of a teenager.

Pammy: You have grown into a hell of a woman—and a phenomenal writer. I'm inspired by you.

Jen: The most sensible, sweet little sister in the world. I say it to the ground.

Joe: The most carefree and full of fun of all the Walter kids. You are stuffed with love.

Allison Leslie: For getting on board and doing exactly what I asked you to do . . . acting as if I had a book long before I actually had one. Thank you so very much for your tenacity.

Whoopi, Roseanne, Phyllis Diller, Rosie O'Donnell, Kathy G., Margaret C., Janeane Garafolo, Kate Rigg, Felicia Michaels, Wanda Sykes, Carole Leifer, Wendy Liebman, and all the broads who have inspired me and made me laugh and think we are the biggest badasses around.

. . . and for being so nice when you didn't have to be:

Thank you.

And George Carlin and Richard Pryor too: Without their albums to learn from, I would've been Rita Rudner (Rich, Thin, and with my own Theater in Vegas. . . ? . . .Wait. What?).

Tom Greenberg and Jon Moonves: For continuing to believe in my crazy schemes. I'm glad ya'll are on my side or you'd be really scary.

Allan Stephen: For letting me have meetings with Roseanne and for being my friend even though I'm not a star, and picking up my kids even though you risked being arrested for loitering.

Louis Van Amstel: For making me move my fat writer's ass in your LaBlast Dance Class.

Rockin' Raul: The other most entertaining person on the planet.

Tania McComas and Sean Flanagan: The prettiest hair/makeup team—and they <u>like</u> me!

Massood and Lisa Christie/Ashley: My cherry team.

You all made me beautiful. Thank you.

Kudos to:

PAPER

All the writers and reps who brought me to the party and worked so hard on my behalf.

PLASTIC

Dr. Raj Kanodia: Nose, wrinkle-removal, cheekbone enhancer.

Sherry Sanctivictores: Skin Smoothing, Complexion Perfection.

Dr. Nikolas Nikolov: Final Flawless (slightly reduced) Boobs.

Christian Louboutin: My biggest inspiration (besides my kids) for working so hard.

Nicole Paxson Cosmetics

Girlactick and Stop Staring Clothing—I love me some Lady Moguls!

And, certainly not least of all:

Robin: For loving me completely . . . until I did too.